D0768816

Prints
of the
West

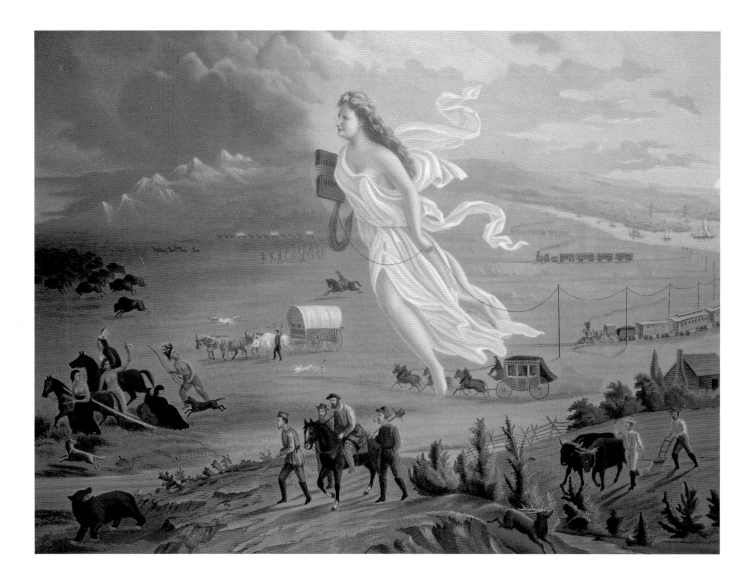

Publicist George A Crofutt commissioned Brooklyn artist John Gast to paint American Progress *(chromolithograph, 1872) to symbolize the American seizure of the West. It shows a female floating westward with the Star of Empire on her forehead. In her right hand she holds a schoolbook, while with her left she strings telegraph wires, and thus civilization, across the continent. Indians and wildlife yield to the onslaught of miners, farmers, settlers, stagecoach, and railroad.*

PRINTS
of the
WEST

RON TYLER

FULCRUM PUBLISHING

GOLDEN, COLORADO

For Paula

© 1994 by Ron Tyler
All rights reserved
No part of this publication by be reprooducted, stored in a retrieval system
or transmitted in any form or by any means, electronic, mechanical, photocopying,
recording or otherwise, without the prior written permission of the publisher.

LIBRARY OF CONGRESS CATALOGING-IN-PUBLICATION DATA

Tyler, Ronnie C., 1941–
 Prints of the West / Ron Tyler.
 p. cm.
 Based on the collection of Western American prints in the Library of Congress.
 Includes bibliographical references and index.
 ISBN 1-55591-174-9 $39.95
 1. Prints, American. 2. Prints — 19th century — United States. 3. Prints — 20th
century — United States. 4. West (U.S.) in art. I. Library of Congress. II. Title.
NE962.W48T96 1994
769´.49978 - dc20 93-50794
 CIP

Fulcrum Publishing
350 Indiana Street, Suite 350
Golden, Colorado 80401 USA
Printed by Sung In Communications Co., Ltd. in Korea
0 9 8 7 6 5 4 3 2 1

Designed by Ellen McKie

CONTENTS

ACKNOWLEDGMENTS

*V*irtually every print curator and dealer in the country has helped with this book in one way or another, because it has been a long time in the making. The late Mitchell A. Wilder, first director of the Amon Carter Museum in Fort Worth, Texas, introduced me to the world of Western American prints when I became curator of history there in 1969. While assisting historian Don Russell with my first exhibition assignment, "The Wild West: A History of the Wild West Shows," I was fortunate to meet Edgar Breitenbach, Alan Fern, and Milton (Kap) Kaplin of the Prints and Photographs Division of the Library of Congress and first became aware of the Library's vast print holdings. I continued to work with them and other members of the Library staff as I assisted with the organization of other print exhibitions such as John W. Reps's "Cities on Stone: Nineteenth-Century Lithograph Images of the Urban West" and Peter C. Marzio's "Chromolithography: The Democratic Art."

The extraordinary print collection at the Library of Congress reflects the importance of prints in shaping the nineteenth-century concept of the West, from the heyday of lithography before the Civil War to the glowing chromolithographs that trumpeted Manifest Destiny. Western prints are found in many different collections at the Library, but I have relied primarily on the Prints and Photographs Division, the Rare Book and Special Collections Division, and the Geography and Maps Division. I am greatly indebted to many curators and reference specialists for their assistance, especially Jim Gilreath, Clark Evans, and Robert R. Shields of the Rare Book and Special Collections Division and Bernard Reilly and Harry Katz of the Prints and Photographs Division.

I am indebted to the many dealers and connoisseurs who shared their knowledge over the years. Of particular assistance were Jake Zeitlin of Los Angeles, Warren Howell of San Francisco, Fred Rosenstock of Denver, and Kenneth Newman of New York, all of whom generously opened their collections and files for research. In addition, I focused on a few of these artists and themes in organizing two North American Print Conferences, Prints of the American West in 1979 (published by the Amon Carter

Museum, 1983), and, in 1988, Prints and Printmakers of Texas conference (published in 1994 by the Texas State Historical Association).

More recently, William S. Reese of New Haven, James and Judy Blakeley of Washington, D.C., Richard Fitch of Santa Fe, and Dorothy Sloan and Michael Heaston of Austin have been of invaluable assistance in my pursuit and study of Western prints.

In Austin, Don Carleton and his fine staff at the Center for American History, University of Texas at Austin, especially Kathryn Adams, librarian, and Ralph Elder, head of public service, facilitated my research. Milan Hughston, librarian, and Melissa Thompson, registrar, of the Amon Carter Museum in Fort Worth, Texas, provided much needed help, as did Judy Blakeley and James von Reuster of the Old Print Gallery in Georgetown, Washington, D.C., who must tire of curators' continually thumbing their collections but seldom buying.

William H. Goetzmann of the University of Texas at Austin and George B. Ward of the Texas State Historical Association endured many discussions of the ideas herein and read the manuscript and made welcome suggestions and corrections. Lorraine Atherton cheerfully edited out as much of the confusion and hyperbole as time permitted, and Ellen McKie worked the pictures and text together in a comprehensible and beautiful package. Finally, Bob Baron, John H. (Jack) Kyle, and Mark Carroll of Fulcrum Publishing proved to be the most lenient of taskmasters, always focusing on the end result rather than the expired deadlines that seemed to pass unnoticed.

I am finally responsible for the contents of this book, but it never could have gotten to this point without the cheerful assistance of these and many others who provided help and encouragement over the years.

PRINTS
of the
WEST

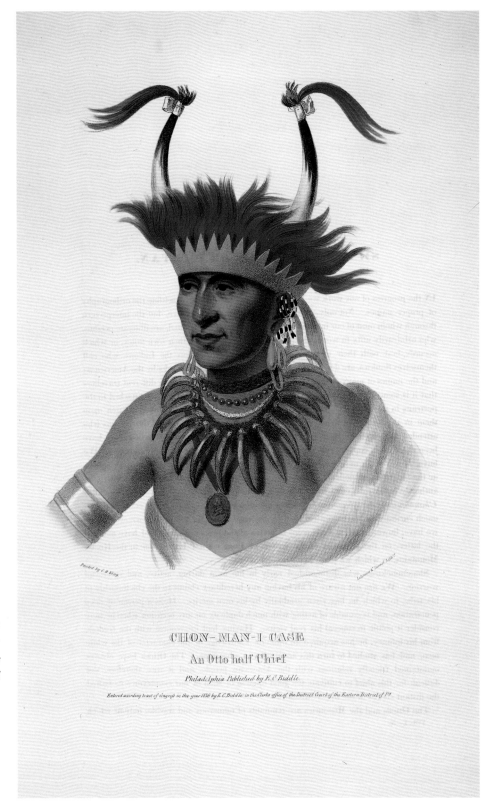

CHON-MAN-I-CASE

An Otto half Chief

Philadelphia Published by E.C Biddle

Entered according to act of Congress in the year 1836 by E.C.Biddle in the Clerks office of the District Court of the Eastern District of Pa

Chon-Mon-I-Case was a great warrior who entertained the members of the Long expedition with stories of his exploits in 1819. He sat for his portrait two years later, decorated with the spoils of his conquests, including the perfectly matched pair of buffalo horns on his head and the claws of the fierce grizzly bear around his neck. Lehman and Duval after Charles Bird King, Chon-Mon-I-Case, or L'Ietan, an Oto Half-Chief *(hand-colored lithograph, 1836), from McKenney and Hall,* History of the Indian Tribes of North America.

INTRODUCTION

\mathcal{F}ew images are more familiar than the American Indian warrior. James Fenimore Cooper provided the classic character in Uncas, the last of the Mohicans, who, "graceful and unrestrained in the attitudes and movements of nature," came to symbolize European primitivism to a large international audience. His "dark glancing, fearless eye, alike terrible and calm; the bold outline of his high, haughty features, pure in their native red," and "the dignified elevation of his receding forehead, together with all the finest proportions of a noble head, bared to the generous scalping tuft," made him seem a "precious relic of the Grecian chisel," "an unblemished specimen of the noblest proportions of man." Later authors would add colorful daubs of face paint, an eagle feather headdress, and, perhaps, a buffalo skin shirt to complete the image. Even if we cannot claim complete authenticity for such a formulaic depiction, paintings and prints of this noble savage have been ubiquitous since the mid-nineteenth century.

Such was not always the case. During the latter half of 1832, German Prince Maximilian of Wied-Neuwied, an experienced naturalist en route to the wild interior of North America to study the Plains Indian people, traveled from Boston to New York, Philadelphia, Pittsburgh, down the Ohio River, and on to Saint Louis, all the while searching the book and print shops for "good representations" of the Plains Indians. "How much was I astounded," he later wrote, "that I could not find in all the towns of this country, one good, that is characteristic representation of them, but only some bad or very indifferent copper-plates, which are in books of travels!"

There was no lack of written information about the early West. Maximilian probably read the firsthand accounts of explorers like Jonathan Carver, Meriwether Lewis and William Clark, and Zebulon Pike, Cooper's popular Leatherstocking tales, or perhaps John Bradbury's or James O. Pattie's journals of their travels. But, like images of Indians, other pictures of the West were scarce and of poor quality, even in these groundbreaking books. Maximilian could have seen the crude portraits in Carver's book or one of the spurious Lewis and Clark journals, or Peter Rindisbacher's more authentic but stylized prints in the *American Turf Register* and the *Casket.* He no doubt studied

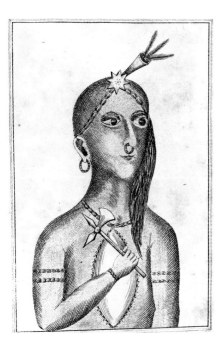

Mahas Queen *(engraving, 1809), from* The Travels of Capts. Lewis and Clark, *opp. p. 48, was even less realistic than Carver's pictures.*

the journal of the Stephen H. Long expedition, which was published in 1823, and might well have counted the modest engravings after artists Samuel Seymour and Titian Ramsay Peale among the "indifferent" ones that he found. In fact, few Western pictures of substance or quality reached the public before the lithographic revolution of the 1830s and '40s.

Philadelphia artist Bass Otis is generally credited with printing the first American lithograph in 1819, probably importing the entire process directly from Europe. The first lithographic firm in this country was established two years later when William Barnet and Isaac Doolittle, who had studied the process in France, set up shop in New York. Lithography spread steadily along the coast, with entrepreneurs and printmakers opening shops in Washington in 1822, Boston in 1825, Philadelphia in 1829, and Baltimore in 1835.

From that timid beginning lithography caught on because it was an easier and less expensive method of producing a superior picture. Heretofore, the most popular means of making multiple copies of an image were engraving and etching, both laborious processes that required that a printmaker engrave or etch the artist's design into a block of wood or sheet of metal. Lithography also results in prints that are so similar to the original drawing that many artists referred to them as multiple originals rather than copies. Some craftsmen continued to make engravings and etchings, of course, but within a decade lithography became the best, least expensive, and most common process of printing multiple copies of sophisticated pictures.

Lithography is often explained in simple terms, but it is a deceptively complex process. It was invented by Bavarian Alois Senefelder near the turn of the nineteenth century. Unlike etching and engraving, which print from raised or recessed surfaces, lithography is a chemical and planographic process—that is, the printing surface is flat. As a result, it is the most autographic of all the printing processes, because, simply put, the artist's drawing on a soft, porous block of limestone can be inked and reproduced in thousands of copies.

The lithographic stones, the best of which are still quarried near Senefelder's home in Solenhofen, Bavaria, are cut into various sizes and thicknesses, depending upon the size of the press and the image to be reproduced, and then ground (one stone against another, with increasingly fine layers of sand mixed with a few drops of water in between) until the desired smoothness and texture, or grain, is obtained. Rather than depend upon an engraver or etcher, the artist may then draw directly on the stone with a greasy or waxy crayon. When the drawing is complete, the stone is bathed with gum arabic and nitric acid to fix the image. The drawing will then accept a greasy ink, but the blank areas of the stone, when dampened, reject the ink. The printer places the stone in the bed of the press and lays a piece of paper on the stone. The stone passes beneath a fixed scraper blade, which applies immense pressure to the print, but only to a thin area at a time so as not to crush the stone. The lithographer then "pulls" the print from the stone and repeats the process. A good lithographer can produce thousands of copies of a print from the same stone, and the stones may be saved for years and reprinted many times. After the printing is complete, the lithographer can regrind the stone and use it again.

Most lithographs were printed in one color, usually black. Sometimes atmospheric effects were added from a second or third stone to tint the sky or color the foreground

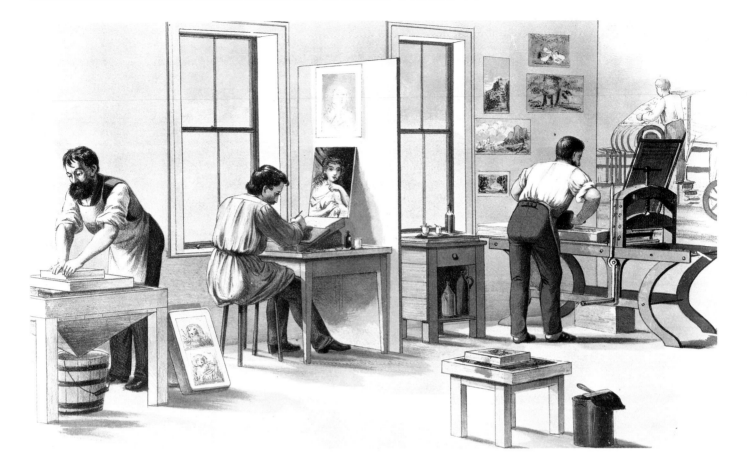

of a scene. Additional color was added by hand, usually by teams of colorists who passed the prints from one to the other, each one coloring in a certain portion of the image. No one knows who first printed in color, but Senefelder experimented with it and established many of the guidelines. French, German, and English lithographers further developed it until, by 1840 some American lithographers, such as William Sharp of Boston, had begun to print in colors. Unlike the single-color or tinted lithograph—with the image usually printed in black, a brown or green tint for the ground, and a blue tint in the sky—the chromolithograph is made up of at least three different colors that form the picture itself, rather than simply tinting the image. Some of the more complex chromolithographs, such as Thomas Moran's views of the Yellowstone, re-quired many more stones and colors.

That is not to say that lithography was the only method used to produce pictures in America during the nineteenth century, for wood and steel engraving remained popu-lar for certain kinds of publications throughout the century. But with the spread of lithography to all the major American cities during the 1830s, published images in-creased dramatically in number and became cheaper at the same time. Steam presses were not in widespread use until after the Civil War, but lithographers still printed millions of images on slow hand presses so inexpensively that the editor of *Graham's American Monthly* declared in 1832 that the "cheapness of lithographic prints brings them within the reach of all classes of society."

Louis Prang showed the steps of producing a lithograph as well as the assembly-line techniques that evolved after the Civil War in Lithographer *(chromolithograph, 1874): First the stone is ground smooth (left), then a lithographic artist draws the image on the stone. A third worker is inking the stone for a hand-operated proof press, and in the background a modern steam press is shown.*

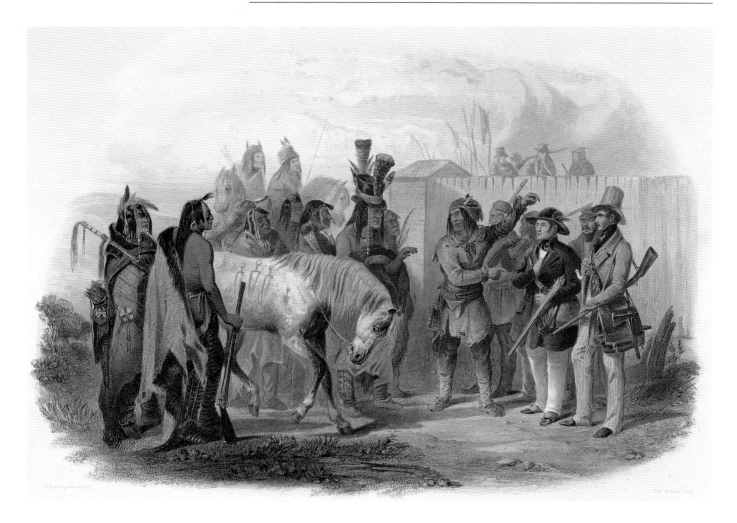

Prince Maximilian with Karl Bodmer (right) and his servant David Driedoppel (rear) being introduced to the Minnetaree chiefs at Fort Clark. Alex Manceau after Bodmer, The Travellers Meeting with Minatarre Indians, Near Fort Clark *(hand-colored aquatint engraving by Bougeard, 1840), from Wied,* Reise in das innere Nord-America.

The development of the penny press during the 1830s suggested just how large the lithographic market might be. Proprietors of what would be called tabloid newspapers today, such as Benjamin H. Day of the *New York Sun* and James Gordon Bennett of the *New York Herald,* combined an innovative news style and content with crude engravings. Day added more-sophisticated pictures to the phenomenon with the publication of the first illustrated extra in history when the steamboat *Lexington* caught fire and sank on Long Island Sound in January 1840. New York lithographer Nathaniel Currier printed a broadside of the accident for the *Sun,* running his presses day and night to keep up with the demand. Bennett continued the trend with timely illustrations of the war with Mexico a few years later. The installation of steam-driven rotary presses in October 1847 enabled his *Herald* to print 25,000 sheets per hour, reaching a much larger public at less cost per newspaper. *Harper's Weekly, Leslie's Illustrated Weekly,* and *Ballou's Pictorial* improved the technology and took it national during the 1850s. By the end of the century, process line engraving and halftone and color printing were common for the large, mass-circulation magazines such as *Scribner's, Harper's Monthly,* and *Century,* which carried Moran's and Frederic Remington's popular Western compositions, among others.

Public interest in the West grew at a similar rate. Early in the nineteenth century hope of finding a Northwest Passage inspired explorers. Then, the United States acquired the Louisiana Territory in 1803 and admitted a series of states culminating with Arkansas in 1836. Texas joined the Union in 1845. The United States acquired Oregon Territory in 1846 and, as a result of the war with Mexico, the Southwest in 1848. The discovery of gold in California in 1848 stimulated an unprecedented migration, leading to the admission of California as a state in 1850. The completion of the transcontinental railroad in 1869 and later precious metal strikes in Colorado, Montana, and the Dakotas, among others, increased the interest in the West. The popular discovery of Yellowstone, Yosemite, and the Grand Canyon seemed to confirm that the West was, indeed, a land of spectacular vistas as well as agricultural and mineral wealth.

As heirs of the eighteenth-century tradition that one historian has called the "literature and art of fact," expeditionary artists were on hand to record and interpret all those events. From every exotic corner of the globe, artists brought back pictures that they intended as precise illustrations to accompany factual descriptions of what the explorers saw, and lithographers and engravers printed and disseminated these images in unprecedented numbers, through newspapers, broadsides and individual prints, and books and portfolios. Between 1843 and 1863, the federal government alone published almost thirty different illustrated survey reports relating to the trans-Mississippi West containing a total of approximately 24.5 million prints (see chapter 5). That count includes neither the maps in those publications nor the illustrations in government publications that do not relate to the trans-Mississippi—such as Alexander Dallas Bache's Coast Survey, the Naval Observatory publications, Matthew C. Perry's Japan expedition, the Northern Pacific expedition, William F. Lynch's report on the Holy Land, and the reports of Lieutenants William L. Herndon and Lardner A. Gibbon on South America—or those in the thousands of privately published books.

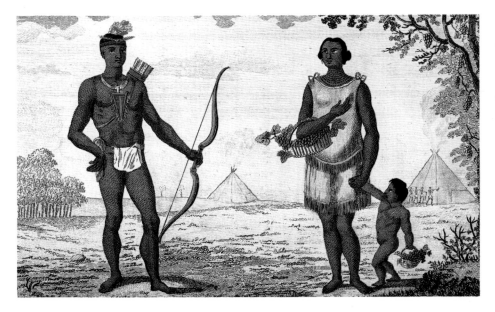

This Sioux family portrait after Jonathan Carver, A Man and Woman of the Neudowessie *(hand-colored engraving, c. 1778), could have been one of the "indifferent" pictures that Maximilian saw. From Carver,* Travels Through the Interior Parts of North-America, *opp. p. 230.*

Although not all of the artists who painted the early West created "art of fact," some, such as Karl Bodmer, surely did, for his precise landscapes, natural history illustrations, and excellent likenesses are of much documentary value despite the culture-laden veil—both ours and his—that influences the way artists depict a subject and the way we view it. Not only is the portrait process itself foreign to Indian culture but recent historical and anthropological studies have also demonstrated the shortcomings of many Indian portraits—some artists dressed the sitters inappropriately, for example, or did not depict facial and physical features correctly—for not all artists had as much ability or scholarly discipline as Bodmer. Even with Bodmer's work, however, the problem of interpretation still exists. A historical cliché holds that there is nothing so mute as a fact, that it must be interpreted, and that is the case if we hope to make any use of that fact—word or image—in our understanding of the past.

To understand and interpret a picture, both its context and the perspectives of the artist and the viewer must be considered. The spread of European Romanticism to America during the early nineteenth century, for example, altered artists' understanding and depiction of civilization and nature, changing their perspective and deeply influencing exploration art just as the genre began to flourish in America. Artists schooled in European Romanticism, who shared Henry David Thoreau's view of the universality of all living creatures, would have been much more likely to depict an anthropomorphic bear or buffalo than would have an artist who labored in the tradition of eighteenth-century Scottish empiricism or a later, nineteenth-century scientific illustrator. A Romantic artist familiar with the ancient monuments of Europe and the Mediterranean would have been more likely to make a ruined Pueblo site in the Southwest look like Stonehenge, Indian warriors like Greek gods, or the Rocky Mountains like the Swiss Alps.

Bodmer's pictures seem to be some of the best and most accurate visual sources we have on the Plains Indians and their culture, and Prince Maximilian's accompanying two-volume narrative explains their context in detail. But if we were to change our perspective, if we were to look for Anglo-European attitudes toward the Native Americans in Bodmer's Indian portraits, we might be surprised to see how readily they are revealed. From the fifteenth century on, artists variously depicted Indians as exotic specimens, noble savages happily living in nature according to nature's laws, or fearful and uncivilized enemies. When the fledgling American democracy replaced their ideal world, for example, Indians quickly found themselves in conflict with its expansionist policies, and artists pictured them as savages, threats to the God-fearing frontiersmen establishing their homes on the frontier. When the threat disappeared, Indians were shown as a people with no future, remnants of a doomed and disappearing race. The same principle is true for landscape painting. Artists of the Hudson River School, believing that the hand of God was revealed in nature, painted moral scenes that attempted to show good and evil and the triumph of the morally superior. Convinced of the aridity of much of the West, some artists depicted deserts, while others saw mineral-rich land, and still others realized that irrigation would turn the land into some of the most fertile in the country. One man's primeval wilderness was another's timber stand. Knowing this, we can more properly interpret these Romantic images, but we should realize that their context is quite different from the more literal eighteenth-century tradition and from the later, more scientific one.

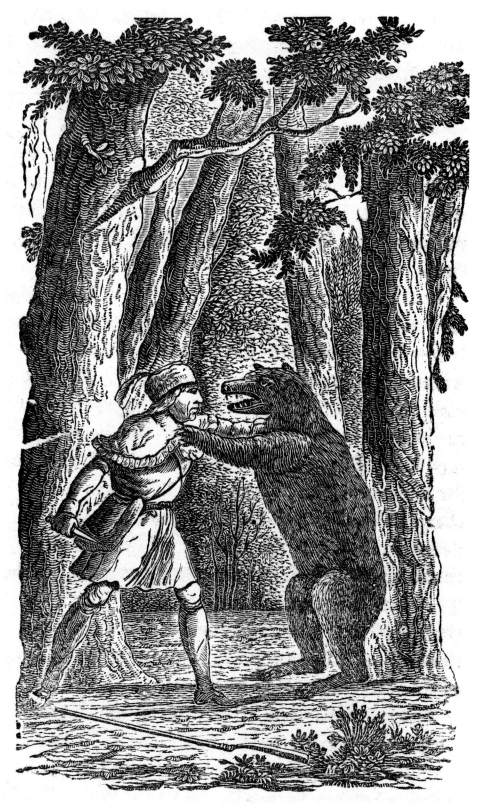

Daniel Boone's alleged exploits became so popular that they were mythified by unknown artists in works such as Daniel Boone Fighting a Bear *(engraving, 1856), from Timothy Flint,* The First White Man of the West, *opp. p. 71.*

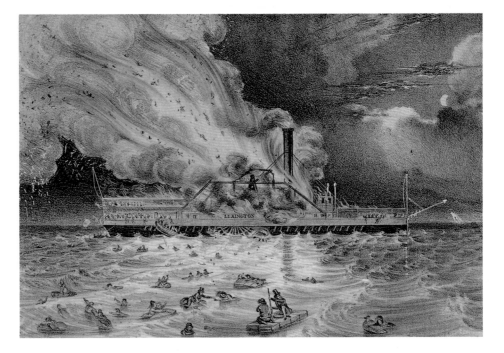

Nathaniel Currier's print after William C. Hewitt, Awful Conflagration of the Steam Boat Lexington in Long Island Sound on Monday Eveg. Jany. 18th 1840 by Which Melancholy Occurence, Over 100 Persons Perished *(hand-colored lithograph, 1840), adorned the first illustrated extra of the day.*

Most Western images are easily understandable, at least in a superficial way, and many have taken on mythic and iconic qualities, perhaps beyond the artist's intent, because they embody widely held values and beliefs. For example, Charles Deas's and William Ranney's heroic images of the trapper, or Westerner, drew on a tradition that began with the powerful myths that resulted from the American struggle with the wilderness and nature and the Romantic belief that Indians were nature's noblemen. Chester Harding was one of the first artists to tap this deeply held feeling with his portraits of Daniel Boone, which James Otto Lewis and J. B. Longacre engraved. The tradition continued with similar portraits of other hunter-naturalists such as John James Audubon, moved westward with Deas's and Ranney's trappers, and culminated several decades later with the familiar figure of the American cowboy at the hands of Charles M. Russell and Frederic Remington.

Finally, many images that are based on firsthand experience or a thorough knowledge of the character, site, or situation are in fact artificial, aesthetic constructs. Just as historians readily acknowledge that fiction can sometimes come closer to the truth of a situation than history, artists usually attempted to rise above mere facts to achieve a greater expression of the truth. As Thomas Cole, the founder of the Hudson River school of landscape painting, put it, "If the Imagination is shackled, and nothing is described but what we see, seldom will anything truly great be produced, either in Painting or Poetry." Relying on their extensive knowledge of the West, Charles Deas and George Caleb Bingham typecast the Western trapper and the river boatman as symbols rather than specific individuals, in typical rather than specific situations. Albert Bierstadt and Moran did the same for the Western landscape. Moran's famous disclaimer of 1881—"I place no value upon literal transcripts from Nature"—is a problem for anyone who would insist upon the literalness of his landscapes. "My general scope is not realistic," he continued. "All my tendencies are toward idealization. . . . While I

desire to tell truly of nature, I did not wish to realize the scene literally, but to preserve and to convey its true impression." Still, his pictures reflect firsthand observations and contain much specific information of historical value. He asserted that the rocks in the foreground of his painting *The Grand Cañon of the Yellowstone* (1872) "are so carefully drawn that a geologist could determine their precise nature" and invited Dr. Ferdinand V. Hayden to confirm the scientific details of the painting before it was finished.

That these powerful images have colored our vision of the American West is undeniable. To measure and understand their influence is more of a problem. They are valuable for what they tell us about particular details of Western frontier life and for what they tell us about the mythic American vision of the West—two very different things. On the one hand, we recall biographer Thomas Carlyle's comment that he "often . . . found a portrait superior in real instruction to half a dozens written 'biographies.'" More recently, pictures have been called "devastating as hidden persuaders." On the other hand, they have often simply been ignored by much of the public, and cultural historians outside art history have only now begun to study them for what they might reveal. But the pitfalls are real. It is a mistake for casual viewers or historians to take them too literally—they *do* generalize and mythify—but it is an equal mistake to dismiss them as historical documents or artifacts because they also operate on the level of myth.

This book is based on the enormous and distinguished collection of Western American prints in the Library of Congress. It is also based on the compelling idea that the publication and distribution of some of the most beautiful, significant, and influential images in our history had a great deal to do with what we have come to think not only of the American West but of the country as a whole. It is my conviction that pictures, even historical depictions, because of the increasing quality and ease of transmission, are becoming ever more widespread in our culture and, therefore, more influential. But as historians attempting to study nineteenth-century America, we must not be fooled by the ubiquity of certain images today, for often they were not so easily available, and in some cases not available at all, to our nineteenth-century counterparts. Bodmer's delicate watercolors, so well known today, were lost from view until after World War II, when Prince Maximilian's descendents decided to sell them. What our predecessors usually saw were the printed copies, and as the prince observed, they were sometimes of "indifferent" quality, with the difference between the original work of art and the published print sometimes as great as the difference between the painting and the object or person depicted.

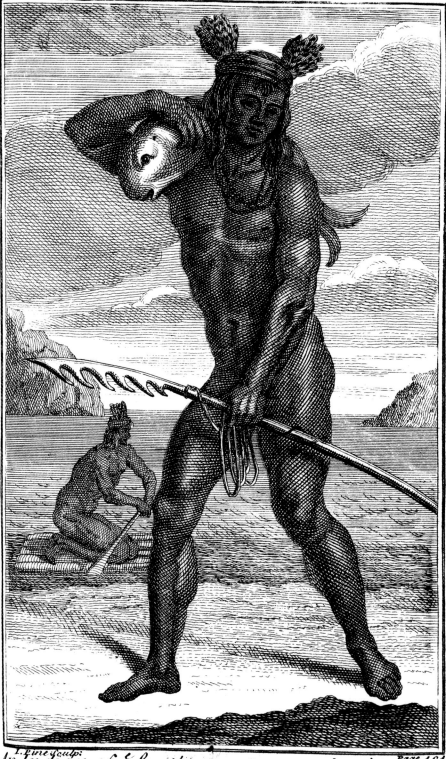

The fishermen of southern California (engraving by I. Pine, 1726) pictured in George Shelvocke's Voyage Round the World by Way of the Great South Sea, *opp. p. 404, were probably a London engraver's imaginative visualization of Shelvocke's descriptions.*

I. Pine sculp:

Page 404

An Indian of y.ª Southermost parts of California as Returning from Fishing & another on his Barkloó

THE GREAT WEST

Fascination with the West predates European discovery of trans-Mississippi America by centuries. To the ancients it was the place where departed souls went for rest and tranquility, and where fallen heroes found the Elysian fields. Medieval maps showed it to be a fabulous land of gold and spices, and Alvar Núñez Cabeza de Vaca, a member of a Spanish expedition caught in a storm and wrecked on the coast of Texas in 1528, "ever held it certain" that by "going towards the sunset we must find what we desire."

The West has long defied precise boundaries. To some it is the New World, to others, North America. Historian Frederick Jackson Turner defined it as a process that began on the east coast of North America and moved westward with the frontier. Others prefer to think of it as a geographical region, such as the Trans-Mississippi, but often disagree as to its boundaries and climatic characteristics. "Few people even know the true definition of the term 'West;' and where is its location?" the artist George Catlin observed in 1841; "phantom-like it flies before us as we travel, and on our way is continually gilded, before us, as we approach the setting sun." In fact, the West has become so fixed in the popular mind today that it is frequently used as a metaphor for America itself. Turner suggested the possibility, and recent books such as *The West of the Imagination,* by William H. and William N. Goetzmann, and *The West as America,* edited by William H. Truettner, have confirmed that interpretation.

This study will focus primarily on published pictures relating to that great mass of unexplored and virtually unknown (to all but the Native Americans) territory west of the Mississippi River at the turn of the nineteenth century. The effort to find a Northwest Passage between the Atlantic and Pacific oceans, erroneously (and perhaps duplicitously) reported by both the French and Spanish, led to publication of the first images of the West. Ever since Sir Francis Drake raided what he called "the backside of America" in 1579, French and Spanish cartographers believed that he had discovered a northwest passage across America. Increased trade and communication with the East would have been possible if such a passage had been found, and several navigators of other nations prosecuted the search. Rumors circulated about a chain of lakes and

La terra de Hochelaga nella Nova Francia *(engraving, 1556) was long thought to have been made from a sketch that the explorer Jacques Cartier brought back from his 1535–36 voyage and, therefore, was the first published eyewitness view of North American Indians. Scholars now consider it imaginary. From Ramusio,* Terzo volume delle navigationi et viaggi nel quale si contengono le navigationi al Mondo Nuouo, *pp. 446–47.*

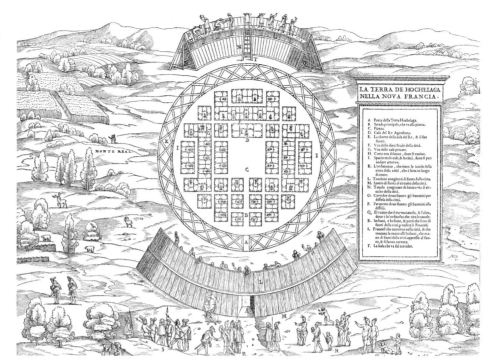

Delisle *shows an imaginary northwest passage on his 1752* Carte Générale des Découvertes de l'Amiral de Fonte. *From the Beinecke Rare Book and Manuscript Library, Yale University. Reproduced by permission of Yale University.*

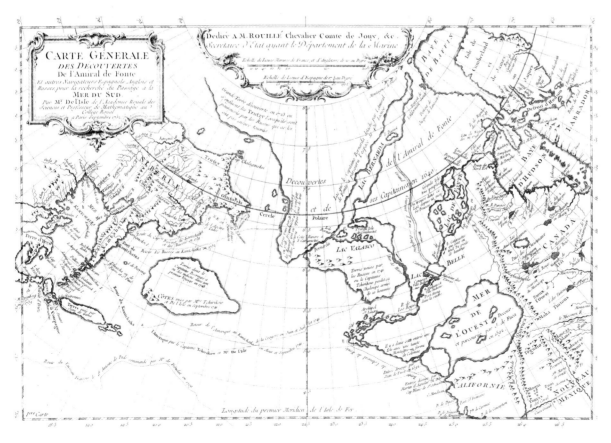

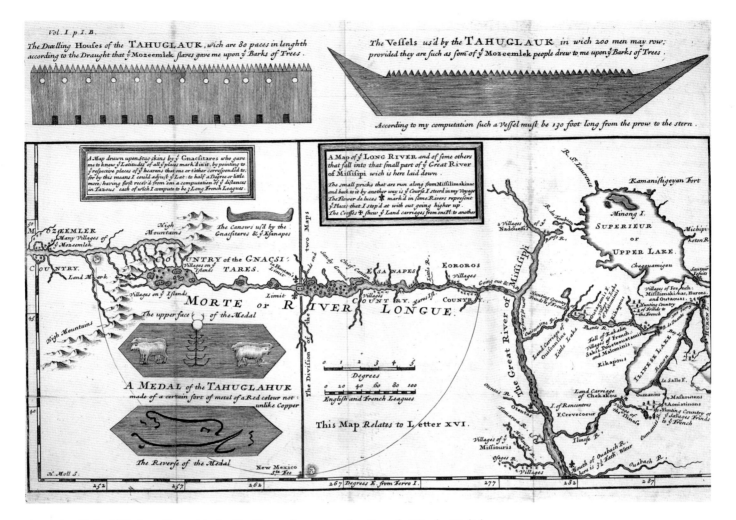

rivers that linked Hudson Bay with the Pacific, and cartographer Joseph-Nicolas Delisle even depicted it on a map in 1752. Several navigators had tried to find it by sailing into Hudson Bay and other inlets on the Atlantic or Arctic side of the continent, but to no avail.

A second motive, according to historian Fernand Braudel, perhaps even the primary objective, was "to obtain new information about geography, the natural world, and the mores of different peoples" in an age of scientific enlightenment. Here the artists were often of great help. The findings of these expeditions were usually published in large and handsome atlases, portfolios, and books, which circulated among the political, social, and scientific elite of Europe. Sometimes the images received even wider distribution when they were reprinted in different languages and less expensive formats. Governments supported some of the publications; commercial publishers, patrons, and private subscriptions sustained others. The illustrations were woodcuts or copperplate engravings and etchings, depending on the funding available.

The first such publication long thought to contain an eyewitness image relating to North America is Giovanni Battista Ramusio's *Terzo volume delle navigationi et viaggi nel quale si contengono le navigationi al Mondo Nuouo* (Venice, 1556). A sketch of the

The Baron de Lahontan's rumors of the "Rivière Longue," or Long River, gained such credibility that cartographer Hermann Moll finally drew a map of it for the 1735 edition of Lahontan's New Voyages to North America.

Thomas Harriot viewed the natives of "Virginia" (present-day North Carolina) as noble savages and compared them to the Picts, ancient inhabitants of Britain. Theodor de Bry after John White, The Towne of Secota (engraving, 1590), from Harriot, A Briefe and True Report of the New Found Land of Virginia, *pl. 20.*

Every explorer to go west encountered the ubiquitous buffalo, here depicted in a woodcut (1554) by an artist who obviously had never seen the creature. From López de Gomara, La historia general de las Indias.

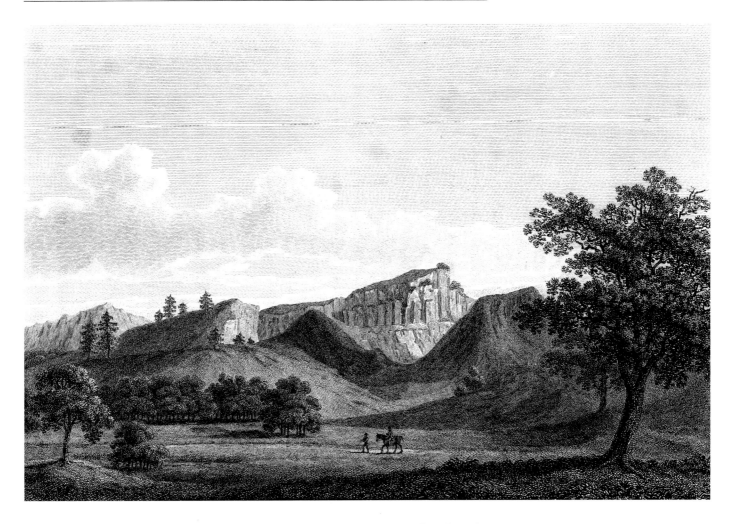

Iroquoian village of Hochelaga, near the site of Montreal, has been attributed to the explorer Jacques Cartier but is now considered to be imaginary, for the Iroquois did not build forts with smooth boards, as shown. The first book to contain eyewitness prints of what is today a portion of the United States is Thomas Harriot's *Briefe and True Report of the New Found Land of Virginia,* illustrated with engravings after John White's 1585–1588 watercolors of North Carolina's coastal Algonquian people and published by Theodor de Bry in Frankfurt in 1590. Bry published engravings after French artist Jacques Le Moyne de Morgues's paintings of the Timucua Indians of Florida the following year. Similar books flourished during the eighteenth century as explorers ventured into every corner of the globe. By the turn of the nineteenth century a collection of such books of natural history and science was the mark of a gentleman's library.

Even though English settlements had been established up and down the east coast of North America by the eighteenth century, the first pictures of the West were not produced by overland travelers but by artists who accompanied naval expeditions that followed the Spaniards to various ports along the west and northwest coasts. The Spaniards, of course, had played along the coastlines of Texas and California throughout the first half of the sixteenth century. Francisco Vásquez de Coronado ventured inland to

To British explorer George Vancouver this "most extraordinary mountain" inland from Monterey, California, "presented the appearance of a sumptuous edifice fallen into decay." Vancouver speculated that it might have been from such "similar phenomena" that mankind received its "architectural knowledge." T. Pouncy after W. Alexander after J. Sykes, A Remarkable Mountain Near the River of Monterrey *(engraving, 1798), from Vancouver,* A Voyage of Discovery to the North Pacific Ocean, *opp. p. 334.*

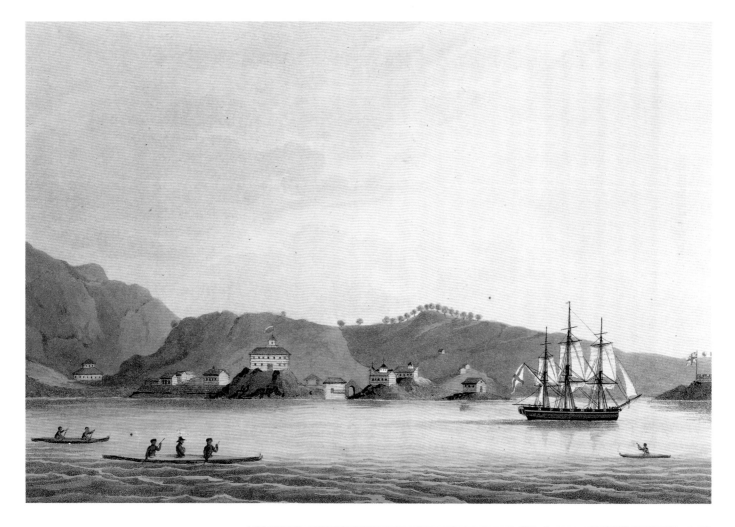

The Russian explorers extensively documented the northwest coast of America, beginning with Vitus Bering in 1741–42. Lt. Yuri Lisiansky sketched this view of Saint Paul's Harbor on Kodiak Island, off the southern coast of Alaska, in 1805. His ship, Neva, *shown at the right, was one of the first two Russian vessels to sail around the world. Clark after Lisiansky,* Harbour of St. Paul in the Island of Cadiak *(hand-colored engraving, 1814), from Lisiansky,* A Voyage Round the World, *opp. p. 191.*

John Webber drew one of the first eyewitness views of the northwest coast of America. S. Smith after Webber, A View of the Habitations in Nootka Sound *(engraving, 1784), from Cook,* A Voyage to the Pacific Ocean, *atlas, pl. 41.*

discover the Grand Canyon of the Colorado and Palo Duro Canyon on the Prairie Dog Town Fork of the Red River in 1540–1542 while searching for the mythical Cibola. Juan de Oñate conquered the Pueblo country of New Mexico at the turn of the sixteenth century and established a mission at Santa Fe in 1609, but no artists were present on any of those expeditions. The first pictures of the trans-Mississippi West came from English buccaneer George Shelvocke, whose story of a sailor who killed an albatross inspired Samuel Taylor Coleridge's *Rime of the Ancient Mariner.* Shelvocke included two realistic and intriguing portraits of California natives in his 1726 publication, *A Voyage Round the World by Way of the Great South Sea,* likely nothing more than a London artist's interpretation of some passages from his narrative. One showed two men returning from a fishing trip, and the other depicted two different costumes for the women of California, one of fur and the other of feathers.

The first eyewitness prints of the western coast appeared more than half a century later in *A Voyage to the Pacific Ocean* (London, 1784), a record of Capt. James Cook's last voyage, from 1776 to 1779. Cook was the most famous of the British circumnavigators, sailing around the world in 1768–71 and into the Southern Hemisphere in 1772–75. He embarked on his third voyage in 1776, just before news of the American Declaration of Independence reached England. Influenced by Delisle's and subsequent maps, Cook took a large contingent of scientists and artists, including John Webber and William Ellis, to assist in the search for the hypothetical Strait of Anian. His effort, like Drake's and Shelvocke's, would be from the Pacific side.

After passing the Cape of Good Hope and calling on some familiar South Pacific ports, Cook swung northward to the Hawaiian Islands, which he named the Sandwich Islands in honor of the Earl of Sandwich, First Lord of the Admiralty. He landed on the Oregon coast, at what is today Cape Foulweather, on March 7, 1778, and proceeded up the coast, hoping to find the passage and sail through to the Atlantic. Fog shrouded the Strait of Juan de Fuca, the most likely candidate, from him as he moved northward. He sighted Mount Saint Elias on May 1 and followed what is today Cook Inlet until he realized it was not the passage. He finally worked his way around the coast of Alaska and, in the summer of 1778, passed through the Bering Strait, even crossing the Arctic Circle, before ice in the Beaufort Sea forced him to turn back.

Cook had not found the Strait of Anian, but he had verified the existence of the Bering Strait, documented the northwestern corner of the continent, and opened the way for future explorations by George Vancouver and others. His findings for science were even more important, and what he did not describe, artists like Webber and Ellis related in hundreds of drawings, which became splendid illustrations in the lavish publications that documented the voyage. Cook's odyssey ended abruptly and mysteriously when he returned to Hawaii. A series of incidents escalated into a confrontation with the Hawaiians, a fight broke out, and Cook was killed.

While Cook was charting the South Pacific, Jonathan Carver led the first overland expedition in an attempt to find the Northwest Passage. A colonel in the colonial forces during the recent war with France, Carver had taught himself map-making and surveying in Boston so that he could "explore the most unknown parts" of the "vast acquisition of territory" that had fallen to the victorious British. His opportunity came in 1766, when Arthur Dobbs, governor of North Carolina, persuaded Maj. Robert Rogers, commander of the British post at Michilimackinac (in present-day Michigan),

Louis [Ludwig Andrevitch] Choris documented the west coast of America, from the tropics to Alaska, while serving as artist on the Russian Pacific Ocean expedition under Otto von Kotzebue from 1815 to 1818. This view is one of several drawings that he made of the San Francisco area. Franquelin after Choris, Vue du Presidio Sn. Francisco *(lithograph, 1822), from Choris,* Voyage pittoresque autour du monde, *pl. 2.*

to assist in the endeavor. Rogers had learned from the Indians of a river called the Ouragan, which he believed flowed from a "pyramidal height-of-land" into the Pacific. It sounded enough like the "river of the west" described by Canadian explorer La Vérendrye that it caught Carver's attention. Rogers instructed Carver to proceed west to the Falls of Saint Anthony (within present-day Minneapolis), noting all the Indian towns, counting the inhabitants, and making maps and plans along the route. Carver got no farther west than the Sioux villages on the Minnesota River and, of course, found no Northwest Passage, but he had traveled farther inland than any other British explorer.

In 1769 Carver went to England to find a publisher for his journal. Failing to secure the expected government assistance, he took a job making maps for publishing houses to earn a living. With the financial support of Sir Joseph Banks, who had been head naturalist on Cook's first voyage and was now president of the Royal Society of London for the Improvement of Natural Knowledge, Carver managed to publish in 1778, two years before his death, a heavily rewritten account of his travels. It contains a handsome print of the Falls of Saint Anthony on the Mississippi River as well as portraits of Indians of the Naudowessie (Sioux) and Ottigaumies (Fox) tribes. The second edition, issued in 1779, added an engraving of a tobacco plant. Carver's book proved to be one of the most popular of all travel accounts, translated into several other languages and published in twenty-three editions.

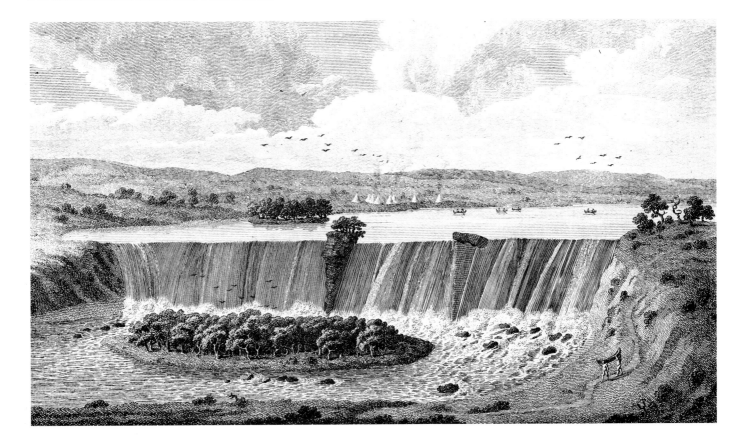

Matt Rooker after Carver, The Falls of St. Anthony in the River Mississippi near 2400 Miles from Its Entrance into the Gulf of Mexico *(engraving, 1781), from Carver,* Travels Through the Interior Parts of North-America, *opp. p. 70.*

The first American edition of Carver's book appeared in 1784, causing a literary controversy. Some accepted his findings, but others questioned whether he had made such a trip, suggesting that his book was little more than a patchwork of passages taken from other explorers' journals. But the journal proved informative if not actually useful to Zebulon M. Pike, Lewis and Clark (one London reviewer accused them of incorporating large parts of it into their own narrative), and perhaps even to Maj. Stephen H. Long. Six subsequent American editions published between 1784 and 1802 testified to the continuing popularity of the book.

More powerful than the pictures, however, was Carver's map, which illustrated his vision of what lay westward, beyond his farthest camp. Combining the eighteenth-century naturalist's preoccupation with unknown mountain ranges and the rumors that he had heard, Carver postulated the existence of the "shining mountains," the hub of the continent, from which rivers flowed in every direction. He was correct that a great chain of north-south mountains blocked access to the West, but he had not gone far enough even to place them accurately on the map, much less illustrate them for his readers.

It would be many decades before the American West would be fully explored and pictured for the American people, decades before its wonders would be documented and made public. But its grasp on the popular imagination was already firm. These early expeditions had extended the mind-set of eighteenth-century European explorers

*Although Carver did not reach the Rocky
Mountains, he correctly postulated the existence
of a continental divide from which all rivers
flowed and showed it on his map as the
"pyramidal height-of-land." From Carver,*
Travels Through the Interior Parts of
North-America *(1781).*

to America, had confirmed what sorts of "natural masterpieces"—the lone mountain, the natural bridge, the impenetrable desert, the primeval forest, the impassable river— they would seek to solve the mysteries of nature. Along with those relatively permanent elements, the artist-explorers also focused on transitory phenomena such as waterfalls, volcanoes, glaciers, and even fog and mists. Just as today's physicists search through the debris of collisions of subatomic particles for clues to the beginning of time, so the early explorer-artists sought, within the Romantic context, to purge the natural world of the contaminating European presence so as to understand its origins. The West possessed an abundance of masterpieces yet to be revealed.

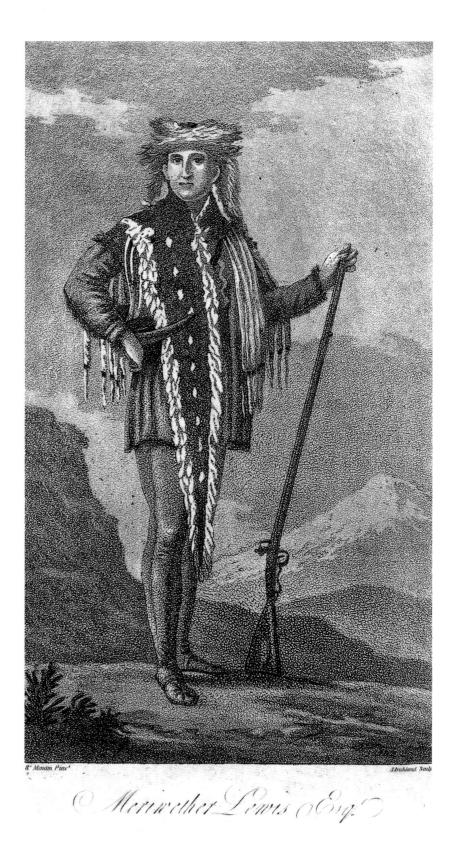

Meriwether Lewis, coleader with William Clark of the Lewis and Clark expedition, is depicted in the ermine-skin mantle that Chief Cameahwait of the Shoshoni presented him. Lewis gave the mantle to Peale's Museum in Philadelphia. William Strickland engraved the portrait, after Charles B. J. F. de Saint-Mémin's 1807 watercolor, for Analectic Magazine and Naval Register *7 (April 1816), opp. p. 329.*

S.t Memin Pinx.t S.Strickland Sculp

Meriwether Lewis Esq.

EARLY ARTISTS IN THE WEST

*A*s the nineteenth century dawned and ignorance still shrouded the West in mystery and speculation, former president John Adams recalled a verse from his youth, one supposedly carved on a Monument Bay rock by one of the members of the Plymouth colony:

> *The Eastern nations sink, their glory ends*
> *And Empire rises where the sun descends.*

Adams said he doubted the truth of this story but admitted that he had "heard these verses for more than sixty years." They apparently were engraved on something more meaningful than stone—his brain. "There is nothing . . . more ancient in my Memory," he concluded, "than the observation that Arts, Sciences and Empire had travelled Westward" throughout history.

President Thomas Jefferson seemed to share the sentiment if not the verse. He was aware of Cook's and Vancouver's voyages and of Carver's travels. As minister to France in 1786, he had supported John Ledyard's failed effort to cross Russia and find the Northwest Passage by traveling eastward. Later, as secretary of state, he commissioned the Frenchman André Michaux, a dedicated naturalist, to travel to the Pacific via the Ohio and Missouri rivers in 1795, but Jefferson withdrew the support when Michaux tainted the mission by trying to turn the settlers of the trans-Appalachian region against both Spain and the United States. Jefferson did not give up. As president, he was determined to send an American scientific expedition to the Pacific. He persuaded Congress to do it for commercial reasons, then explained to the Spanish ambassador that the trip was for purely "literary" or scientific purposes, an explanation that became largely unnecessary when the United States acquired Louisiana Territory from France in 1803. Jefferson chose his able secretary, Capt. Meriwether Lewis, to head the expedition, and Lewis in turn picked William Clark as co-commander of the Corps of Discovery.

Jefferson instructed Lewis and Clark to explore the Missouri River, then cross over the mountains to the Columbia, thereby locating "the most direct and practicable

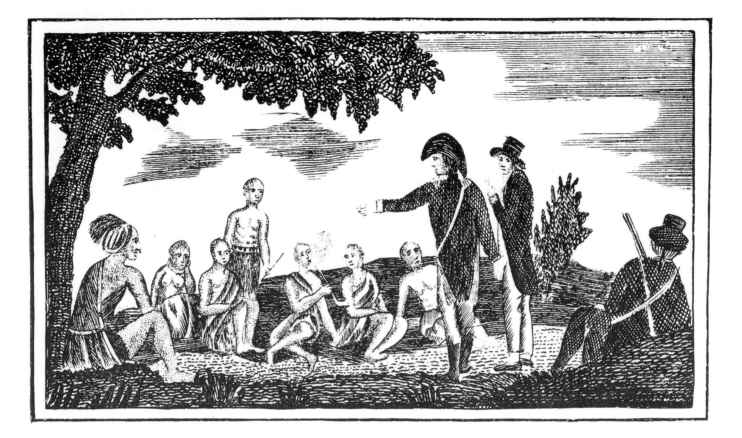

When Mathew Carey of Philadelphia took over publication of Gass's journal, he added six pictures to depict various incidents described in the text. Artist unknown, Council with Indians *(engraving, 1810), from Gass,* A Journal of the Voyages and Travels of a Corps of Discovery, *opp. p. 26.*

water communication across the continent." Having speculated on the West in his *Notes on Virginia,* Jefferson had many questions for Lewis and Clark to answer. They were to produce an accurate map of their route, study the Indians and their economies so as to facilitate trade with them, and observe the "soil and face of the country." In short, Jefferson wanted any information that would be of use to future settlers as the country continued its rapid expansion westward.

Departing by keelboat on May 14, 1804, Lewis and Clark went up the Missouri as far as the Mandan villages in present-day North Dakota, where they spent the winter. Next spring they continued the journey, beyond the Great Falls of the Missouri, across the Continental Divide, and down the Clearwater, Snake, and Columbia rivers to the Pacific. In 1805–6 they made their winter camp at the mouth of the Columbia and called the spot Fort Clatsop. They returned home the following September with extensive collections of objects, field notes, and maps but no pictures, for no artists accompanied the corps.

Unfortunately, by the time the official report of their findings was published eight years later, it was apparent that the information was badly needed. A critic for the *Quarterly Review* summed up current knowledge in 1809:

> *There are six degrees of latitude between the mouth of the Columbia, and that of the river by which Mackenzie reached the Pacific. Of the intervening space we know noth-*

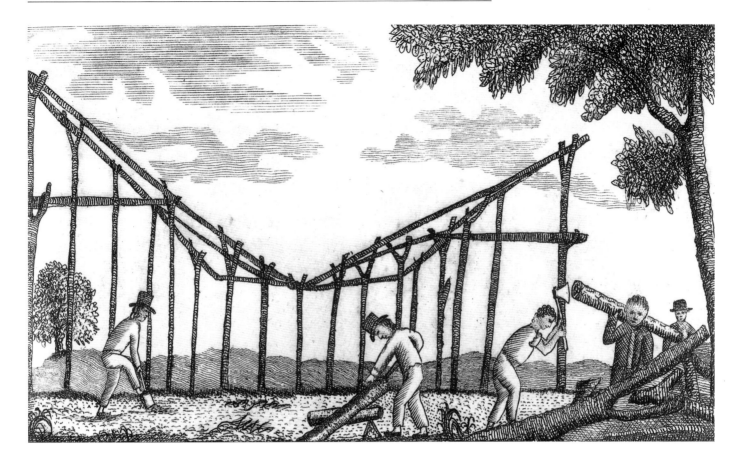

Artist unknown, Building a Hut *(engraving, 1810), from Gass,* A Journal of the Voyages and Travels of a Corps of Discovery, *opp. p. 60.*

ing but a few points of the coast. It is chiefly, however, about the country to the South of the Columbia and towards the mountains of New Mexico, that we are anxious to gain information; having convinced ourselves, both from the kindly latitudes under which it lies, and the accounts, imperfect as they are, of the adjoining countries, that in that interval will be found, not only objects of philosophical curiosity, but some of the choicest and most valuable settlements to the West of the Mississippi.

Shortly after his return, in 1807, Lewis contracted with a Philadelphia printer to publish the history of the expedition and announced a three-volume work to be titled *Lewis and Clark's Tour to the Pacific Ocean Through the Interior of the Continent of North America.* He intended the work to be well illustrated and also contacted several artists to make drawings. He talked with Frederick Pursh, a German-born and -trained botanist, about doing botanical illustrations; artist Charles Willson Peale, also proprietor of Peale's Museum, about making portraits of the animals (as well as becoming the repository for the corps' natural history collections); Alexander Wilson, the "father of American ornithology," who was then at work on his nine-volume *American Ornithology,* about the bird illustrations; Charles Balthazar Julien Févret de Saint-Mémin about the Indian portraits; and Irish-born engraver John James Barralet, an associate of engraver Alexander Lawson's, about doing the waterfalls of the Missouri and the Columbia rivers.

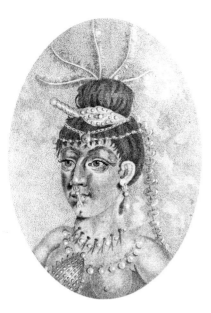

Because the official account of the Lewis and Clark expedition was so long in being published, various authors in addition to Gass took advantage of the opportunity to publish their own spurious versions. Artist unknown, Sioux Queen *(engraving, 1809), from* The Travels of Capts. Lewis and Clark, *frontispiece.*

As he was making those preparations, Lewis learned that some unauthorized accounts of the journey were nearing publication. Jefferson had suggested that he encourage members of the corps to keep journals of their own but had not anticipated that some of them would try to rush into print before the official report was out. Lewis denounced any such unofficial publications in a letter to the *National Intelligencer,* but in fact there was nothing he could do about them. David M'Keehan, a former teacher who operated a bookstore and stationery shop in front of the courthouse in Pittsburgh, was at that time preparing Sgt. Patrick Gass's journal for publication. Gass had been a member of the Corps of Discovery, and as M'Keehan pointed out in response to Lewis's letter, his journal might be unofficial, but it was "authentic."

The first of many publications on the Lewis and Clark expedition, the Gass journal was also rather dull. It showed that the virtually illiterate Gass must have had editorial help from M'Keehan, who probably rewrote large portions of it. Still, it contained information that no other diarist noted, such as the manner in which the Arikara and Mandan Indians built their earth lodges, perhaps reflecting Gass's experience as a carpenter. It received praise from the reviewers for "keeping close to the direct business of the story, and carrying it right on without ever digressing into a paragraph of reflection, or admiration, or wonder, or extended description, or triumph, or piety, or theorizing, or even explanation." The *Quarterly Review,* after having "looked forward to the discoveries of this corps with considerable expectation," complained that "our hopes were somewhat checked in the outset, when instead of sitting down to a magnificent quarto, with maps, plates, and 'all appliances and means to boot,' as we had a right to expect from a plan executed under such auspices, we took up a shabby octavo, the production of a mere underling, and without one chart to guide the eye, or assist the memory."

After a second American edition in 1808 (and a French edition that same year), M'Keehen apparently sold the rights to the book to Mathew Carey of Philadelphia, an Irish immigrant turned journalist and publisher, who added six "remarkably unconventional illustrations" depicting various events that Gass describes in his text and brought out the first illustrated edition in 1810. "Each engraving was a masterpiece exemplifying what a draftsman may accomplish if allowed to employ unrestrained imagination in portraying subjects about which he knows next to nothing," one critic later wrote, calling them "delightfully preposterous." Perhaps it was the quality of the images that kept Carey from identifying the engraver. Carey reprinted the book in 1811, then changed the illustrations slightly for the 1812 edition, probably only because he had to make new plates.

In the meantime, Hubbard Lester of Philadelphia had published a spurious edition of *The Travels of Capts. Lewis and Clark* in 1809, containing five portraits of Indians, all of which are rather crude and surely not based on any authentic portraits. Another fabricated publication, *An Interesting Account of the Voyages and Travels of Captains Lewis and Clarke,* published in Baltimore by P. Mauro in 1813, also contains several illustrations invented from whole cloth.

The official Lewis and Clark narrative finally appeared in 1814 after numerous delays. Lewis was the problem. After making arrangements for the publication in Philadelphia, he prepared to take office as the newly appointed governor of Louisiana but was delayed by business. He served only a brief time and died, probably at his own hand, a victim of depression and alcoholism, on September 29, 1809, at age thirty-five.

HISTORY

OF

THE EXPEDITION

139
2092

UNDER THE COMMAND OF

CAPTAINS LEWIS AND CLARK,

TO

THE SOURCES OF THE MISSOURI,

THENCE

ACROSS THE ROCKY MOUNTAINS

AND DOWN THE

RIVER COLUMBIA TO THE PACIFIC OCEAN.

PERFORMED DURING THE YEARS 1804—5—6.

By order of the

GOVERNMENT OF THE UNITED STATES.

PREPARED FOR THE PRESS

BY PAUL ALLEN, ESQUIRE.

IN TWO VOLUMES.

VOL. I.

PHILADELPHIA:

PUBLISHED BY BRADFORD AND INSKEEP; AND

ABM. H. INSKEEP, NEWYORK.

J. Maxwell, Printer.

1814.

Although Lewis had contracted with Charles Willson Peale and others to provide illustrations, his official report appeared in 1814 with no pictures. Title page from [Nicholas Biddle,] History of the Expedition under the Command of Captains Lewis and Clark.

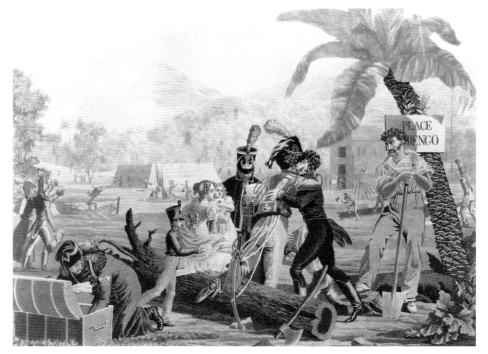

Romantic sympathizers in Paris published imaginary pictures such as Louis Garneray's 2éme vue d'Aigleville colonie du Texas ou Champ d'Asile (engraving, 1819) in an attempt to raise money for the French refugees in Spanish Texas.

His papers, including the journal of the expedition, were sent to President James Madison, who summoned Captain Clark from his post as superintendent of Indian affairs in Saint Louis to take charge of the history.

Clark talked with Jefferson at Monticello, then picked up the manuscripts in Washington and went to Philadelphia, where he saw the drawings that Charles Willson Peale had done for the publication and sat for a portrait. Feeling incapable of producing the history himself, Clark arranged for twenty-six-year-old Nicholas Biddle, a Philadelphia lawyer and literary figure, to undertake the task. After reading the journal and talking extensively with Clark, Biddle prepared a list of some three hundred questions to obtain further details. Clark also sent corps veteran George Shannon to work with him. Biddle finished his task in about a year, but publication was further delayed by the War of 1812, the deteriorating health of the person who was to write a volume on the scientific findings, and finally the collapse of A. and C. Conrad and Company, the firm that had contracted to publish it. Biddle then made arrangements with Bradford and Inskeep to publish approximately two thousand copies of *The History of the Expedition Under the Command of Captains Lewis and Clark,* edited by Nicholas Biddle and Paul Allen, in two volumes. They were offered for $6 per volume, but no illustrations were included, and they did not sell well.

While the important Lewis and Clark account went unillustrated, just four years later an ill-conceived and short-lived filibuster project near the coast of Spanish Texas inspired some superb but totally imaginary images in Paris. The French Bonapartist settlement of Champ d'Asile impinged briefly—and hopelessly—on the fringes of Spanish Texas in 1818, a time when the United States and Spain were negotiating the boundary line between Spanish territory and American-controlled Louisiana. The "field of refuge," as the Bonapartists called the colony, appealed to the French intelligentsia

who romanticized the New World. The organizer, Gen. Charles Francois Antoine Lallemand, a trusted aide to Napoleon, intended the settlement as a part of his overall plan to join with Mexican revolutionaries and take the Mexican crown for Joseph Bonaparte, thereby establishing a Napoleonic stronghold in Latin America. At the worst, Lallemand hoped to provide asylum for French refugees who, like himself, had fled the new Bourbon monarchy.

Two groups established Champ d'Asile. Brig. Gen. Antoine Rigaud sailed from Philadelphia to rendezvous with Lallemand at Galveston in February 1818. With the assistance of the infamous Jean Lafitte, they departed the following month for the mouth of the Trinity River. Surviving numerous hardships, approximately 150 officers and soldiers finally reached the chosen site near present-day Liberty and began construction of two small forts and several houses. Lallemand issued a proclamation disavowing any military aims for what he asserted was an agricultural settlement. The effort was never well organized, and its leaders suffered from the naive delusion that the few Spaniards in Texas would welcome them. Champ d'Asile ended ignominiously on July 23, 1818, when Lallemand ordered the dispirited soldiers to strike camp rather than stay and engage the Spanish force that he had heard was en route to expel them. Most of them returned to New Orleans.

In the meantime, publication of Lallemand's manifesto in France inspired liberals to characterize the filibusters as heroes and to raise money for their aid. Envisioning

Like Vancouver, Seymour felt that "these singular hills" resembled a "work of art" and called it Castle Rock. W. Hay after Seymour, View of the Castle Rock on a Branche of the Arkansa at the Base of the Rocky Mountains *(engraving, 1823), from James,* Account of an Expedition, *atlas.*

heroic war veterans safe in the land of the noble savage, artists, poets, musicians, and publishers joined forces to produce illustrated sheet music, theatrical performances, books, pamphlets, and prints of various kinds. Famous for his Napoleonic military art, Horace Vernet was one of several artists who produced drawings for the handsome lithographs and engravings depicting idealized scenes of the colonists at home in Spanish Texas. With no authentic published pictures of the interior of America to work from—especially of Spanish Texas—Vernet, Ambrose Louis Garneray, Ludwig Rullmann, and other French artists had to depend on their own resources to depict the settlement. Of course, none of the pictures bore any relationship to the real colony, but the combined efforts were much more sophisticated than the imaginative engravings being printed in America at that time and raised almost $15,000 for the colonists. The money was ultimately sent to the mayor of New Orleans to distribute among the veterans of Champ d'Asile.

As those mythical pictures were pouring from the Romantic press in France, the first artists to visit the Rocky Mountains set out with a small group of Americans under Maj. Stephen H. Long. Initially a part of the larger Yellowstone Expedition, Long's force included artist and engraver Samuel Seymour and naturalist Titian Ramsay Peale, of the Philadelphia Peales. The purpose of the expedition was to penetrate and occupy the western territory, to drive out the British fur traders, and to subdue the Indians. Secretary of War John C. Calhoun also instructed Long to obtain thorough and accu-

Seymour's View of the Rocky Mountains on the Platte 50 Miles from their Base *(engraving, 1823), sketched near present-day Greeley, Colorado, was the first eyewitness picture of the far West to appear before the American public. From James,* Account of an Expedition, *atlas. Courtesy the Center for American History, University of Texas at Austin.*

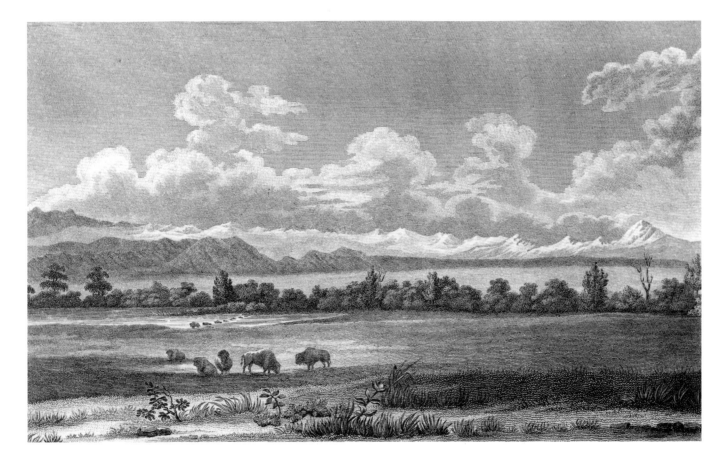

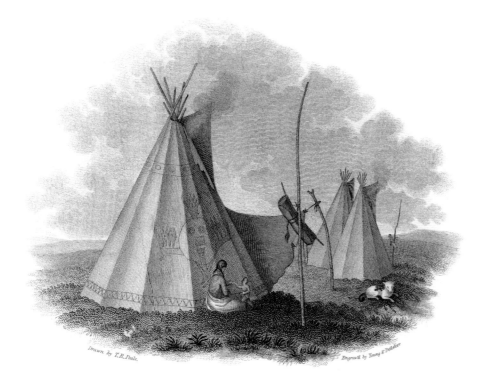

Drawn by T.R. Peale. Engrav'd by Young & Delleker.

The real man-made habitations of the Plains were much less imposing but no less interesting. "We were somewhat surprised to witness the sudden manner in which this plain became covered with their tall conic lodges, raised by the squaws, in perfect silence and good order," James wrote. Young and Delleker after Titian Ramsay Peale, Moveable Skin Lodges of the Kaskias *(engraving, 1823), from James,* Account of an Expedition, *atlas.*

rate information about that "portion of our country, which is daily becoming more interesting."

When the larger expedition stalled, Long set out on his own. He sailed up the Missouri, then followed the Platte and the South Platte into present-day Colorado, where Seymour and Peale became the first Anglo-American artists to see the magnificent Rockies. No doubt aware of the eighteenth-century fascination with heroic mountain chains, Seymour sketched several views of the towering peaks, including *View of the Rocky Mountains on the Platte Fifty Miles from Their Base,* perhaps suggesting that this rude and seemingly impenetrable mass blocked further access to the West. Upon closer inspection, however, these "immense" promontories along the Arkansas River exhibited details of their geological history that reminded the classically educated Long of more famous European sites. He noticed, for example, Castle Rock's "striking resemblance to a work of art. It has columns, and porticoes, and arches, and, when seen from a distance, has an astonishingly regular and artificial appearance." Nearby he observed "columnar and pyramidal masses of sandstone, sometimes entirely naked, and sometimes bearing little tufts of bushes about their summits." By associating classical architecture with natural forms, the Romantics believed that they were demonstrating the relationship between man's best efforts and God's.

From the top of the table rock they could see Pikes Peak, named for Zebulon M. Pike, who had traversed the area more than a decade before while seeking the source of the Red River, among other goals. Thinking that it was the tallest peak in the Rockies, some of the men climbed it for the sublime view from the top. Then they turned south and split into two parties. One group under Capt. John Bell returned by way of the

Arkansas River; Long returned via the Canadian, thinking that he was on the Red until it was too late to retrace his steps. The two parties rendezvoused at Fort Smith, the conclusion of the expedition.

Although Long failed to find the sources of any eastward-flowing rivers or a passage through the Rockies, and most of the scientific specimens and journals were lost when several members of his party deserted, his report still proved valuable. Seymour apparently made approximately 150 drawings (finishing 60 of them), which the *Daily National Intelligencer* of Washington, D.C., found to be "interesting and valuable sketches of the prominent features of the country." Peale also contributed several full sketchbooks. The *Intelligencer* reporter, however, was most interested in the Indian tribes that they encountered, "the aborigines and proprietors of the soil of the country, who were ignorant, not only of the existence of the People of the United States, but of the existence of a race of White People! It gives us an awful idea of the magnificent extent of the domain of the Republic," he concluded, expressing the hope that "this expedition … will form the subject of one of the most attractive works ever published in this country."

Henry S. Tanner immediately incorporated Long's extensive map of the region into *A New American Atlas* (Philadelphia, 1823), including a new name for one of the most picturesque peaks in the Rockies—Longs Peak—and a label for the region between the Mississippi and the Rockies that colored perceptions of the area for decades: the Great

When I. Clark engraved Seymour's View of the Chasm Through Which the Platte Issues from the Rocky Mountains *(hand-colored engraving, 1823) for the British edition of* Account of an Expedition *(vol. 2, frontispiece), he omitted the two figures, focusing more on James's description of the hills that closed in on the river, forcing the party to go over them.*

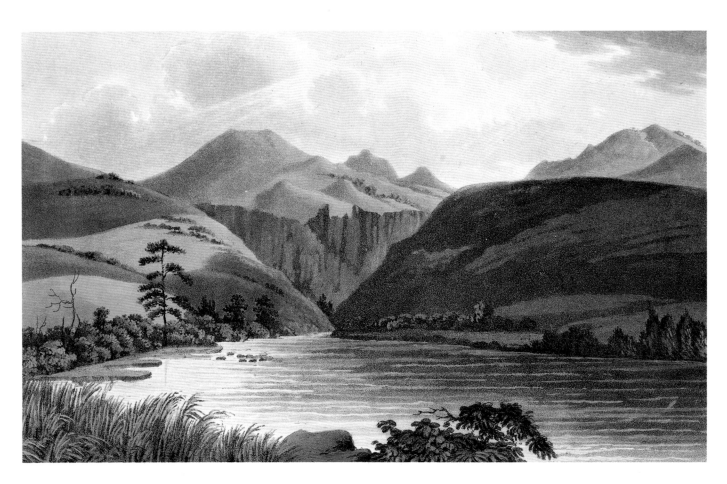

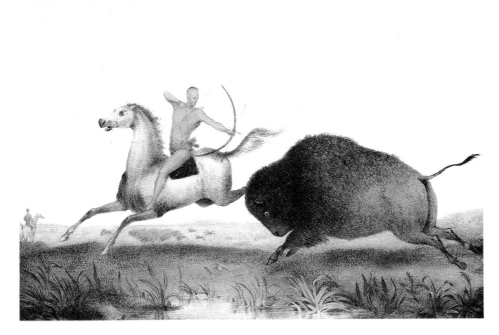

Few of Titian Ramsay Peale's pictures of the Long expedition were published, but this one became the classic image of an Indian killing a buffalo and one of the most widely copied of early Western images. M. E. D. Brown engraved Peale's American Buffaloe *in 1832 for the journal* Cabinet of Natural History and American Rural Sports *(vol. 2, pl. 15, opp. p. 169).*

American Desert. Pike had reached the same conclusion as a result of his 1806–7 reconnaissance, but Long defined the region in a way that stuck in the popular mind—a region "almost wholly unfit for cultivation, and of course, uninhabitable by a people depending upon agriculture for their subsistence"—and he usually receives credit for the characterization. Thomas Jefferson agreed, believing that the plains would serve as a permanent home for the Indians and a buffer for the republic, and James Fenimore Cooper relied heavily on Long's report for *The Prairie.*

The hopes of the *Intelligencer* reporter were fulfilled in that Long's publication was surely the handsomest American exploration journal yet to appear, but the *Account of an Expedition from Pittsburgh to the Rocky Mountains, Performed in the Years 1818 and '20* was a modest octavo, accompanied by an atlas including eight crisply printed engravings with generous margins and bound with Long's map of the region. The American edition included six views by Seymour, one by Peale, and Seymour's copy of an Indian painting. The English edition, also published in 1823, contained four additional views including (in most copies) two hand-colored landscapes not in the American edition. The views had been reengraved by more skillful English printmakers. By comparison with the Champ d'Asile prints, these are humble images (approximately 5 ½ by 8 ½ inches as opposed to lithographs and aquatint etchings of approximately 14 ½ by 21 ½ inches produced in Paris), but they were engraved by some of the best printmakers that America could offer: Alexander Lawson, Francis Kearney, William H. Hay, and Cephas G. Childs. When viewed in conjunction with Long's descriptions of the scenes, it is apparent that they are realistic and careful documents of the landscape and people that the expedition encountered.

In a review of the American edition, the *Daily National Intelligencer* speculated that

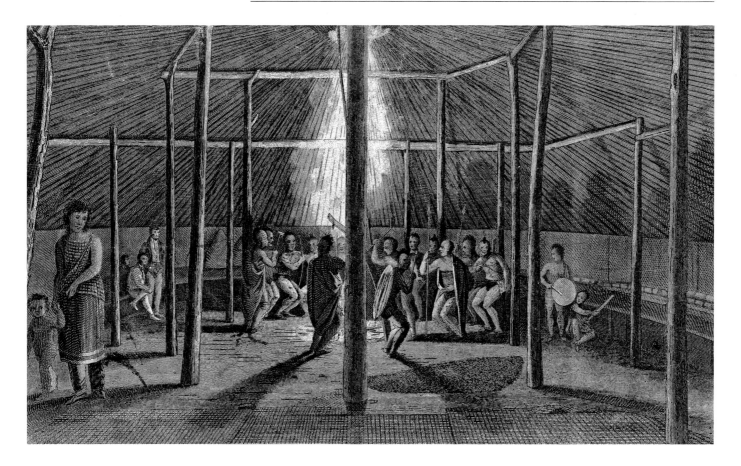

Together the American and British editions of the Long expedition report published only thirteen of the many drawings that Seymour and Peale made on the trip. A few of the pictures received wider exposure when they were reprinted in journals. C. G. Childs after Seymour, War Dance in the Interiour of a Konza Lodge *(engraving, 1823), from Atkinson's* Casket *11 (Nov. 1832), opp. p. 481.*

the report would "be of great value, on account of the interest of its subject and the authenticity of its facts." The *Niles Weekly Register* of Baltimore described the prints as "elegantly executed" and accompanied by "interesting information of the manners and habits of the Indians, and the geography, geology, botany of the regions traversed, with ample notices of its animals, natural curiosities, &c." Edward Everett agreed, in a review in the *North American Review,* that the engravings were "well executed," calling attention to the "scenes from Indian life and manners, and sketches from nature." Of the British edition, with engravings by I. Clark, the London *Monthly Review* said, "The style is plain and unadorned, and more nervous than correct or harmonious," but that Seymour's portrait of Indians was "a lively *coup d'oeil.*"

Because some of Seymour's original watercolors survive and can be compared with the published images, it is possible to identify changes that were made, perhaps at the suggestion of the artist, but more likely at the aesthetic and philosophical discretion of the engravers who made the plates. Seymour's rather loose watercolor of *View of the Chasm Through Which the Platte Issues from the Rocky Mountains* (1820), for example, contains an Indian in the left foreground and a member of the expedition across the river. The published version tightens up the image considerably but deletes the Indian and the hunter, transforming the scene from a friendly frontier encounter between races, civilization meeting savagery in the Romantic lexicon, to one emphasizing the precipitous chasm walls, which, you learn upon reading the text, the party could not

penetrate. Perhaps the engraver made the change to emphasize the party's confrontation with uncultivated, uncivilized, foreboding nature, shunning the suggestion that this rugged landscape might have been somewhat tamed by the Indian's presence. The images of the Long expedition may well mark the transition between eighteenth-century empiricism as represented in the published work and nineteenth-century Romanticism as shown in the original watercolors.

Thomas Doughty also used *The View of the Chasm,* again without the Indian and hunter, to illustrate "Letters from the West" in *Port Folio and New York Monthly Magazine* (March 1822), retitling it *The Rocky Mountains* and softening the impact somewhat by adding two deer in the foreground. Seymour's and Peale's prints were also reproduced in the *Casket,* the forerunner of *Graham's American Monthly,* so their influence went well beyond the official publications.

A bit of the mysterious veil shrouding the West from public view had been lifted, and what Americans saw, with the exception of the few prints depicting Native Americans, were views of the heretofore unknown American midcontinent. Inasmuch as the artists shared the perspectives of their European forebears, whether empiricists or Romantics, these eyewitness scenes looked remarkably like better-known European, Asian, and South American vistas.

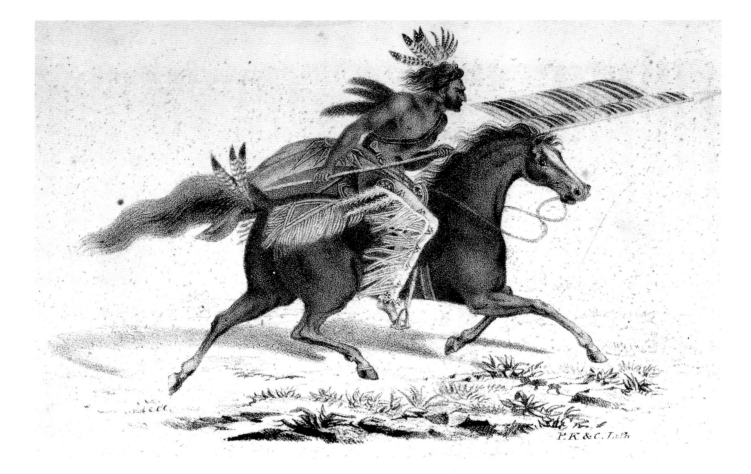

Peter Rindisbacher preceded George Catlin in
documenting the life of the Plains Indians by
several years, but his work was not widely known
among his contemporaries. P.K.&C. after
Rindisbacher, Sioux Warrior Charging
(lithograph, 1829), in American Turf Register
and Sporting Magazine 1 (Oct. 1829),
opp. p. 73.

THE NOBILITY OF NATURE

Had it not been for a small band of artists, naturalists, and historians, there would be little visual record of the Native American, until perhaps photography became popular after the Civil War. In 1809, however, few expected that the Indians would last that long. A writer for the London *Quarterly Review* predicted that "there is . . . no time, we fear, . . . for . . . those benevolent efforts at civilizing the Indians. . . . The natives have nearly completed their own extermination with weapons put into their hands." The belief was widespread that if they did not complete their own destruction, white men stood ready to do it for them with warfare, disease, and liquor. Artist George Catlin reiterated that conviction in 1830 as he committed his life to documenting the aboriginal civilizations. "Black and blue cloth and civilization are destined, not only to veil, but to obliterate the grace and beauty of Nature," he predicted.

Although the growing Indian populations today mock such fears, the expectation of extinction—combined with the scientific and Romantic desire to know more about all the peoples of the world—inspired artists along with others to undertake extensive studies of the Indians. Shortly after Seymour and Peale published a few images of the Plains Indians selected from their Long expedition sketches, a young Swiss became one of the earliest artists to depict the Indians extensively. Peter Rindisbacher, who had come from Switzerland with his family in 1821 to settle in the Red River Colony of Canada and then immigrated to the American Midwest, was perhaps the first to portray the life of the Plains Indians such as the Chippewa, Assiniboin, and Sioux. No one before him had pictured the inside of a tipi—although he did not publish many of his images for others to see—and his pictures of the A-shaped travois, snowshoes, and toboggans were among the earliest genre scenes of Indian life, providing some information on how the Indians dealt with their environment. His first published work, for which he did not receive credit at the time, was the series *Views in Hudson's Bay,* which appeared in London in 1825.

In 1829 Rindisbacher moved to Saint Louis, perhaps hoping to study with an established artist or to have access to a better market for his pictures. It might have been

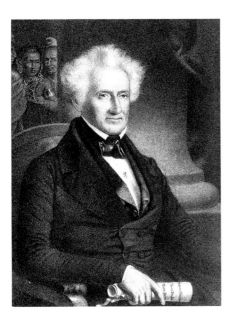

Thomas L. McKenney began to collect Indian objects and information about them in 1817. One of the treasured portraits from his Indian Gallery, begun in 1821, hangs over his shoulder in this portrait. P. S. Duval after Albert Newsam, Thomas L. McKenney *(lithograph, c. 1837), from McKenney,* Memoirs, Official and Personal, *frontispiece.*

through one of the nearby military men that his strong, stylized, and compelling watercolor *Sioux Warrior Charging* was published in the *American Turf Register and Sporting Magazine* to accompany an article entitled "Horsemanship of the North American Indians." An unnamed correspondent wrote the magazine that the original painting was even better than the lithograph. "Taken from nature," the painting "is remarkable for its spirit and the neatness of its execution," the author said. "The artist . . . has lived since early youth in our *western wilds.* He is perfectly acquainted with the subject of his very successful effort; and has . . . in his portfolio, views of many of the finest scenes in that part of the country, whose *untamed wilderness* has never before furnished subjects for the pencil or the burin." It could have been the beginning of a prosperous career. Rindisbacher "has . . . a genius as fruitful, and an imagination as vivid as the scenes amongst which he has dwelt," the unnamed writer asserted. "These will enable him, in cultivating his fine talents, to throw aside the threadbare subjects of the schools, and give to the world themes as fresh as the soil upon which he was bred;—glowing as the newness of nature; and as picturesque as a combination of bold scenery, with bolder man and manners, will afford."

When the *Turf Register* published a second of Rindisbacher's drawings in July, a buffalo being attacked by a band of prairie wolves, yet another writer commended the artist: "The buffalo chase is pronounced true to nature, by all who can estimate its merits. He is very happy in his landscapes; and, when time and opportunities shall permit him to spread the magnificent west before the admirers of the grand and picturesque, his sketches from Hudson's bay to Saint Louis, will, I have no doubt, secure him a lasting reputation." A friend of Rindisbacher's predicted as much in a December 1829 letter to the *Saint Louis Beacon:* "Mr. Rindisbacher has marked out a new track, and almost invented a new style of painting—one, too, of much interest. His sketches of groups or single Indians, are deserving of the highest admiration. . . . Talent, I might almost say genius, like his, deserves encouragement. . . . Those who have not yet examined his fine paintings of Indian dances, lodges, &c. will be well paid for their trouble by calling at his rooms and viewing a style of painting so new and novel." The *Turf Register* published a few of his other drawings before his untimely death in 1834.

While young Rindisbacher was depicting typical, lively, and violent scenes of Western life, a few artists on the East Coast had developed a modest industry of painting portraits of the Indian delegations who visited Washington. Delegations had been visiting capitals and heads of state ever since the late seventeenth century, when the French introduced the practice in their continental rivalry with the British. President Jefferson encouraged Lewis and Clark to arrange for "influential chiefs, within a practicable distance" to visit Washington, and a party of Osage chiefs had accepted the presidential hospitality even before Lewis and Clark returned from their trip. In the capital, meanwhile, Charles de Saint-Mémin drew lifelike profiles of the visitors with the aid of a physiognotrace, a wood-frame device that permitted him to make a quick, precise, and life-size profile of the sitter, which he then filled in.

Thomas L. McKenney, who also feared that the aboriginal races would become extinct and had begun to collect objects and information about them in 1817, brought organization to the process. As superintendent of Indian affairs, McKenney had amassed, by the time of his dismissal in 1830, considerable artifacts and portraits. The heart of his collection, however, was the Indian Gallery, a group of more than a hundred por-

Rindisbacher painted the first pictures of the interior of Plains Indian tipis. J. Yeager after Rindisbacher, Interior of a Sioux Lodge *(aquatint, 1829), in* Casket *(Oct. 1829), opp. p. 433.*

traits that he had commissioned at the hands of artist Charles Bird King and others. His goal, which he probably developed some time after the gallery began to attract public attention, was to produce a great "Indian History."

He began the gallery in 1821, when agent Benjamin O'Fallon brought a distinguished group of Kansas, Missouri, Omaha, Oto, and Pawnee Indians from the upper Missouri to visit Washington. Included in the delegation, among others, were the Pawnee chief Petalesharro, whose dramatic rescue of a captive Comanche woman had caught the public attention, and Eagle of Delight, a handsome and popular young woman. King painted twenty-five portraits of members of the delegation, from which McKenney selected eight for his gallery. Seventeen were given to the Indians.

McKenney asked agents of the bureau to assist him, and in 1824, Michigan governor Lewis Cass sent him a "striking likeness" of the Shawnee Prophet, Tecumseh's brother, by James Otto Lewis, a Philadelphia artist and engraver whom Cass had employed to accompany him to treaty signings. Lewis later provided illustrations for McKenney's *Sketches of a Tour to the Lakes* and ultimately sent forty-five watercolor portraits for the *Indian History,* which McKenney had King copy in oil for the gallery.

Not everyone agreed that McKenney should be collecting the paintings, of course. As America's Indian policy turned increasingly hostile and the Congressional Retrenchment Committee targeted possible budget cuts, Congressman Thomas P. Moore of Kentucky expressed his dismay that McKenney was spending money "for the pictures of these wretches," the only possible purpose of which seemed to be "to gratify the curiosity of strangers" who visited his gallery. The collecting slowed considerably as a result and ceased altogether when Andrew Jackson's Democratic administration fired McKenney in the fall of 1830.

Fortunately, McKenney was too far along on the *Indian History* to be stopped. Jared Sparks, editor and proprietor of the *North American Review* and a potential investor in the history, had suggested in 1829 that he publish these "rare & curious" images, but it was Samuel F. Bradford, a Philadelphia publisher, who provided the means to accom-

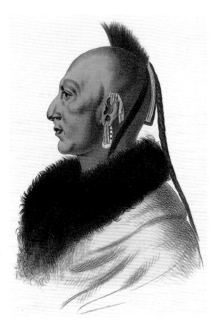

President Thomas Jefferson inaugurated the practice of bringing influential Indian chiefs to Washington, where many of them had their portraits painted. Charles de Saint-Mémin painted this portrait in 1805. Alfred M. Hoffy after Saint-Mémin, Le Soldat du Chene, an Osage Chief *(lithograph by Bowen, 1836), from McKenney and Hall,* History of the Indian Tribes of North America *2, opp. p. 153.*

plish the task when he and McKenney established a partnership later that year. Bradford proposed that the portraits be published the same size as the original paintings, 18 by 14 inches, in twenty sets, or numbers, six to a set, for a total of 120 plates. McKenney was to supply the biographical and anecdotal sketches, and Bradford would bear the expenses of printing and publication. The profits would be divided equally. McKenney also hoped that the work would be published simultaneously in Europe.

Bradford returned to Philadelphia in September 1829 with six of Charles Bird King's portraits, which he turned over to lithographer Cephas G. Childs. Bradford might have been tempted to use Lawson, who had engraved and printed the plates for Alexander Wilson's *American Ornithology,* which Bradford (and Inskeep) had published between 1808 and 1814. By 1829, however, lithography was coming into its own. Childs had just established the first commercially viable shop in Philadelphia, along with John B. Pendleton and Francis Kearney, and the result was equally as good as engraving, so Bradford chose it. In reproducing King's images, the lithographic artists faced a daunting task: to copy the colorful and exotic portraits of men and women of a different race whom they had never seen. Childs employed the skilled Albert Newsam to copy the portraits onto stone.

McKenney was delighted with the results. After viewing one of the early proofs, he wrote in the margin, "I consider the above copy, perfect, a perfect likeness of the man who is known to me—and an exact copy of the original drawing by King, now in the office of Indian affairs." He sent a copy of the portrait of Seminole chief Neamathla to former president John Quincy Adams "to shew you the design, & in some sort the skill that will be employed upon this branch of the work." To Nicholas Biddle, who had edited the Lewis and Clark report and was then serving as president of the Bank of the United States, he wrote, "I confess I am delighted to see the perfection to which the arts have risen in our Country, as exemplified in this work." He soon announced that his "GREAT NATIONAL WORK," which would contain 120 portraits printed on fine, heavy paper, would soon be available at $6 per number, or $120 for the entire set.

McKenney had also begun work on the text that was to accompany the portraits by requesting biographical information on important chiefs from the field agents. His dismissal from the Indian office meant that he would no longer have access to the agency's library, manuscript collection, and franking privilege, and he might have been cut off from the portraits themselves. To earn a living, McKenney moved to Philadelphia to become editor of the *Commercial Herald.* At least he would be in the city where the portraits were being printed and could more easily oversee that work.

Production slowed with the sixth galley, because the printer was working on another large job that required some of his limited supply of type, and by May 1832 it was apparent that the project was in trouble. Bradford had spent $1,250 on the first number, but only 104 subscribers had responded, and he declared bankruptcy. Nor had McKenney managed the project well. Only about a dozen portraits had been lithographed, but he had ordered the full edition of 400 copies of each printed. Audubon, by comparison, began his historic *Birds of America* project cautiously, ordering only fifty copies of the first five prints, then reordering and increasing the number printed as he sold subscriptions. McKenney's historical narrative, intended for the first number, had been printed, but he had not finished a single biography and had, in fact, decided that he needed to make a Western trip to do additional research before he

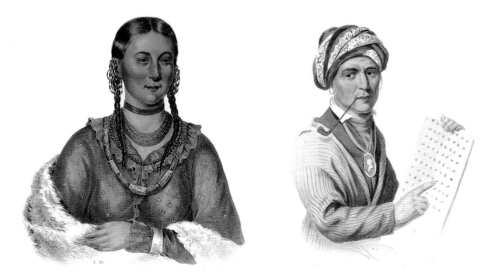

LEFT: *Eagle of Delight was among the first group of Indians that Washington artist Charles Bird King painted. Albert Newsam after King,* Hayne-Hudjihini, the Eagle of Delight *(hand-colored lithograph by Childs and Inman, 1833), from McKenney and Hall,* History of the Indian Tribes of North America *1, opp. p. 79.*

RIGHT: *McKenney soon conceived an Indian history that would contain not only the history but also portraits of all the notable Native Americans that he could gather. This is the only known portrait from life of the great Sequoyah, inventor of the Cherokee syllabary. Childs and Inman after King,* Se-Quo-Yah *(hand-colored lithograph, 1833), from McKenney and Hall,* History of the Indian Tribes of North America *Copied from the collections in The Center for American History, the University of Texas at Austin.*

could write them. Lack of funds and the need to remain in Philadelphia to tend his editorial responsibilities made the trip impossible.

McKenney, however, averted a greater disaster. Although he had been assured that he would be able to use the King portraits for the history, he feared that an unsympathetic President Jackson, whose hostility to the Indians was well known, might withdraw that privilege at any moment. As a result, McKenney arranged for portraitist Henry Inman, Childs's new partner, to copy each portrait in oil when it arrived in Philadelphia. He estimated that thirty to forty portraits had been copied by the spring of 1833 and that Inman would be finished with them all by the fall.

McKenney continued writing as best he could, interviewing Indians who came through Philadelphia, Washington, and other eastern cities and trying to persuade Cherokee leader John Ross to write a sketch of Sequoyah, also known as George Guess, the inventor of the Cherokee syllabary. He was briefly encouraged when Edward C. Biddle and John Key bought Bradford out and agreed to continue the project on the same terms, and Nathan Sargent, publisher of the *Commercial Herald,* offered to make the necessary Western research trip.

Another blow fell in the spring of 1833 when Childs and Inman went bankrupt. Childs took George Lehman, who painted landscape backgrounds for some of Audubon's most famous birds, as partner and struggled along for another year before leaving the firm himself. Lehman then joined P. S. Duval, a skilled craftsman whom Childs had enticed from France, to form Lehman and Duval, but by then McKenney was so discouraged by the delays that he had shelved the project and spent most of 1834 and 1835 working for the Whigs in the hope of a patronage post if they were successful in the next election. When he failed to receive a political appointment, he returned to his Indian history in 1836. His disorganization had caused some delays, but money was the more serious problem. He found that Key had dropped out as publisher and Sargent could no longer help with the research.

James Otto Lewis provided portraits for McKenney, but in 1835 he began his own competitive publication. Lehman and Duval after Lewis, View of the Great Treaty Held at Praire du Chien, September 1825 *(hand-colored lithograph, 1835), from Lewis,* Aboriginal Port-Folio *3, pl. 1.*

In 1835, James Otto Lewis began a competitive venture in Philadelphia. Lewis had contributed paintings to McKenney's effort, but he now embarked on *The Aboriginal Port-Folio; or, A Collection of Portraits of the Most Celebrated Chiefs of the North American Indians,* promising that the ten monthly installments would contain a total of seventy prints. Actually, he finally published seventy-two, including *View of the Great Treaty Held at Prairie Du Chien, September 1825* and *A View of the Butte des Morts Treaty Ground.* He advertised the publication (approximately 18 ½ by 11 ½ inches) as "the *first* attempt of the kind in this country." J. Barincou drew the portraits on the stone, and Lehman and Duval printed them. Some critics might have objected to his rather crude likenesses, but Lewis correctly pointed out that they were the results of direct observation done while attending treaty conferences in the service of the Indian Department, clearly an effort to upstage McKenney's forthcoming project. Even Catlin would have sympathized with his explanation: "The great and constantly recurring disadvantages to which an artist is necessarily subject while travelling through a wilderness, far removed from the abodes of civilization, and in 'pencilling by the way,' with the rude materials he may be enabled to pick up in the course of his progress will secure for him the approbation, not only of the critic, but of the connoisseur." As for the quality of his likenesses, he explained that the "deep-felt anxiety . . . to possess a large collection" necessarily meant that he could not spend too much time on any one picture. Still, he emphasized, only three of his portraits were based on the work of other artists, a concession that he made as he was bringing the work to completion and had exhausted all his suitable material and, again, a claim that he knew McKenney could not match. He also included portraits of twenty-five of the same Indians in McKenney's collection, including eight made from sketches he had provided McKenney. Finally, he priced each number of his portfolio at $2, one third the announced cost of the forthcoming McKenney set.

The critics were kind. The Library of Congress copy of Lewis's *Port-folio* is bound in

its original wrappers, on which are printed favorable reviews of the work from important newspapers. The *New York Mirror* is quoted as calling it a "splendid publication." The *Commercial Herald* suggested that it would be "invaluable" in "preserving the features of an extinct race," and the *Knickerbocker* pronounced the "likenesses . . . excellent," declaring that they show the Indian "as he is." "The work is elegantly and expensively got up," said the reviewer for the *New York Courier and Enquirer*, "and in the coloring, nature has been strictly followed, however grotesque or ridiculous the consequences." The *Philadelphia Journal and Literary Gazette* concluded, "No gentleman's library can be considered complete without a copy of this work."

With praises ringing in his ears, Lewis attempted an English market edition in 1838. What appears to be a salesman's sample copy, now in the Library of Congress collection, was printed in New York by J. H. Bufford. It contains a new preface by Lewis but is about two thirds the size of the original portfolio. As with the American edition, favorable comments from London newspapers appear on the wrappers. Lewis might have expected a tougher audience, offering "the limited time and means accorded him as an excuse for the style in which he has made his sketches: He need not have done so," for the London *Sunday Times* apparently reported that "they bear the impress of fidelity." Lewis announced that this 1838 edition would contain thirty prints, but since no full bibliographic record of it can be found, it is impossible to determine if it was completed. He apparently attempted to bring out editions in 1850, 1853, and 1858 as well. It was left to a twentieth-century critic, Frederick Webb Hodge, to tell the truth about Lewis's effort, that it was crude even by the standards of the day and that "the best that can be said" of many of his paintings "is that they could have been little better than caricatures."

Just as Lewis's publication seemed about to doom the *Indian History*, McKenney found a savior. Judge James Hall of Cincinnati, a former military man, frontier lawyer, and editor of the *Western Monthly Magazine*, agreed to write the history and biographical sketches that McKenney could not and, in return, became joint editor and owner of half of McKenney's interest. With the moribund project revived, Biddle agreed to continue to bear the publication expenses. Working on a biography of Daniel Boone at the time, Hall had much to offer. "My materials . . . are very voluminous, and of the most authentic character," he told George Catlin in an effort to recruit him for the project in 1836.

Catlin would have had much to contribute. He later wrote that it was a visiting band of Indians in Philadelphia that inspired him to give up his promising law career and dedicate his life to documenting America's native cultures. Whether one accepts his account as inspirational or as a later romanticization, many would have agreed with him that "Man, in the simplicity and loftiness of his nature, unrestrained and unfettered by the disguises of art, is surely the most beautiful model for the painter,—and the country from which he hails is unquestionably the best study or school of the arts in the world. . . . The history and customs of such a people, preserved by pictorial illustrations, are themes worthy the life-time of one man." Hall had seen Catlin's Indian Gallery, which now consisted of hundreds of paintings—portraits as well as landscapes and depictions of ceremonies and hunting scenes. By combining Catlin's paintings with works by King, James Otto Lewis, and others, Hall explained, they would achieve a "complete monopoly" and "immense profits."

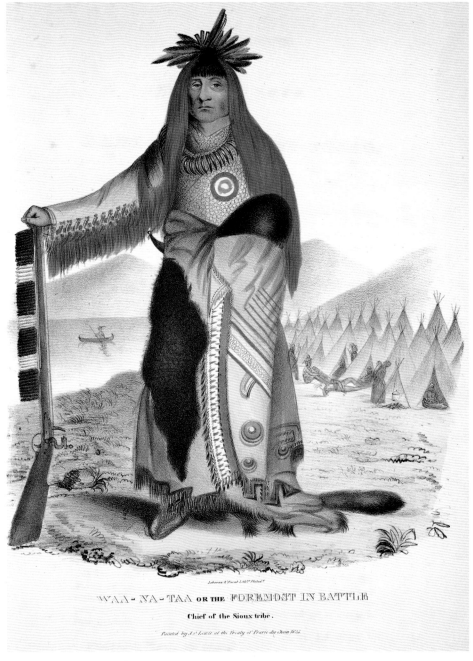

Lehman and Duval after Lewis, Waa-Na-Taa, or the Foremost in Battle, Chief of the Sioux Tribe, Painted at the Treaty of Prairie du Chien 1825 *(hand-colored lithograph, 1835), from Lewis,* Aboriginal Port-Folio *1, pl.1.*

But Catlin had publishing plans of his own and was "astounded" to learn that "a great National Gallery of Indian portraits" was about to go on a national tour and be published in such a lavish format. He was well aware of King's portraits and had tried to get in on the federal patronage himself after returning from his trip up the Missouri in 1832, but when the *New York Evening Star* praised McKenney's gallery in the summer of 1836 as "the most remarkable that has ever been presented to the inspection of the public," Catlin protested:

I have been travelling at great expense and risque of my life, for six years past, and undergoing privations of an extraordinary kind, living and eating with almost every tribe east of the Rocky Mountains, painting my portraits by their own firesides, and studying (for the world) their true manners and customs, . . . supposing that I was going to possess the Gallery Unique, and that I would write a book also; but I find the world becoming so full of books and paintings on my return, histories, traits, portfolios, portraits, &c. &c. of American Indians, that I thought best to . . . enquire of you how such splendid schemes could have been started and accomplished while I have been immersed in the wilderness.

Judge Hall pressed on without Catlin, compiling information and inquiring of and interviewing Indian agents, traders, and soldiers. "The labor was Herculean," he recalled. "Here were a long list of Indian heroes, to be supplied with biographies—of whom we knew nothing but the names. But I was compromised to the work—and I determined to do it—and to make the work what was intended: an authentic National work." "Nothing was compiled from books," he later maintained. Indeed, as Maximilian had found, there were few books that he could have used. "All was collected from original sources—mostly from living and highly respectable individuals, whose testimony was examined carefully, and compared with one another."

The first number of what was now called McKenney and Hall's *History of the Indian Tribes of North America* was published in February 1837. Some of the lithographs bear dates as early as 1833 as a result of Bradford's early efforts. McKenney was delighted. He sent word to Albert Newsam, the lithographic artist, whose "fame, and his name & his honor, are all at stake," that "he is the best fellow in the world to engrave Indians, but would not do to *fight them.*" The reviewers were also impressed: The *Harrisburg Chronicle* said the portraits were "lithographed with great elegance, and coloured in a manner which has never been equalled this side of the Atlantic." The *Boston Daily Advertiser and Patriot* predicted that the publication would be "a source of pleasure" for anyone and "a valuable legacy to his children." The *Saturday Courier* in Philadelphia went even farther, describing the *History* as "one of the largest and most splendid works which the literature and arts of the country have ever produced." Even more gratifying was the public response. After signing up 1,250 subscribers, among them Andrew Jackson, Martin Van Buren, Daniel Webster, the king of England, the Marquis de Lafayette, and Audubon, McKenney anticipated income of about $150,000. The War Department alone subscribed for 50 copies and authorized King to make additional portraits.

The good fortune did not last. When the worldwide depression dealt the fragile U.S. economy another series of blows in 1837, Lehman and Duval resigned the project. McKenney quickly contracted with John T. Bowen, an English immigrant who had developed into one of the best lithographers in the country. He brought another talented lithographic artist, Alfred Hoffy, to the project, replacing Newsam. Then, in November 1838, Biddle withdrew as publisher and was replaced by Frederick W. Greenough of Philadelphia. More serious was the resulting loss of subscribers and the slow method in which the War Department paid for its subscriptions, all of which, in combination, finally brought publication to a standstill. Bowen waited for a couple of years, hoping that the publishers would recover, then printed number 14 on his own in an attempt to recoup some of his expenses. Biddle and Bowen finally transferred their

interests to Daniel Rice and James G. Clark of Philadelphia, who brought the *History* to conclusion in 1844.

Between 1821 and 1842, King painted at least 143 portraits of Indians for the government, receiving $20 for busts and $27 for full figures, a total of more than $3,500. McKenney obtained other paintings from those who appreciated what he was doing and wanted to help, and he was able to have copies made of existing portraits. McKenney incorporated the work of several artists, in addition to Lewis: Peter Rindisbacher, F. Bartoli, George Cooke (a student of King's), Gustavus Hesselius, R. M. Sully (nephew of Thomas Sully), Saint-Mémin, Karl Bodmer, and perhaps Samuel Seymour.

In quality and number, the McKenney and Hall *Indian History* is probably the premier collection of printed Indian portraits in American history. The finished images are colorful and exotic, splendid examples of the noble savage. In several cases, perhaps most notably Sequoyah, this is the only known likeness. The question then arises as to how accurate the lithographs are, an assessment that is more difficult to make than it might have been, because most of the original King portraits were destroyed in the Smithsonian fire of 1865 and are, therefore, not available for comparison. In the rare cases where it is possible to compare an extant King portrait with the Inman copy used for the final lithograph (Hoowaunneka or Jackopa, for example), one can see that Inman made numerous small changes, such as facial colors and various elements of the costumes. More important, however, is the change in the sitter's physiognomy, giving him a more Caucasian look and rendering the likeness inadequate for serious anthropological study. The facial features, perhaps more than any other element, betray the fact that the lithographs ultimately are copies of copies, made by artists who did not know the Indians. In the case of Jackopa, for example, King changed the facial features that Lewis had recorded; the body has been filled out and made more powerful and dignified, and various elements of the costume have been altered. In the cases where King copied a Lewis watercolor, the images are fourth-hand, having gone through Lewis's, King's, Inman's, and Newsam's or Hoffy's hands.

The *Indian History* went through at least six editions, the last one appearing in 1972. Some were full size, but others, beginning in 1855, were reduced to octavo and published by Rice and A. N. Hart. McKenney tried a British edition in 1838, but it failed.

Charles Bird King's portraits were not so fortunate. Secretary of War John Bell moved them from the Indian Office and donated them to the new National Institution, which exhibited them at the Patent Office until 1858, when they were placed, along with John Mix Stanley's paintings, in the new Smithsonian Institution. Fire destroyed most of the collection on January 24, 1865. Fortunately, the Inman copies still survive.

McKenney's and Lewis's efforts might have contributed to Congress's failure to purchase George Catlin's great Indian Gallery. Trained in the scientific and Romantic culture of Philadelphia and Peale's Museum, which called for the rigorous description of every aspect of the savage life, Catlin had in fact "become the historian and limner of the aborigines of the vast continent of North America." In pursuit of his dream of memorializing the soon-to-be extinct Indians so that they might "phoenix-like rise from the 'stain on a painter's palette,'" he had created a gallery of approximately 470 paintings by 1837.

Catlin first went west in 1830 against the wishes of his family. In Saint Louis he met

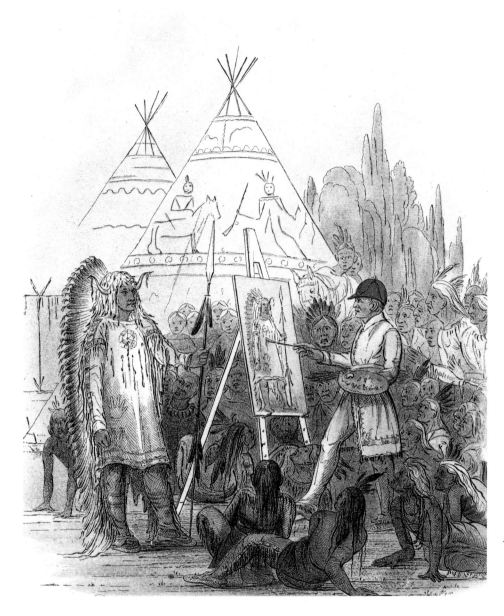

Catlin used the image of Mandan chief Mato-Tope from his self-portrait as the frontispiece to his book (engraving by Myers and Company, 1841). From Catlin, Letters and Notes on the Manners, Customs, and Condition of the North American Indians.

General Clark, then governor of Missouri Territory and superintendent of Indian affairs, who became a friend and mentor. Clark had assembled a considerable number of artifacts in his personal museum, which he proudly showed visitors, and he took Catlin on the artist's first expedition—up the Mississippi to Fort Crawford at Prairie du Chien, where Catlin witnessed several councils and treaty signings. Catlin painted his first Indian portraits on what might have been a detour into northwestern Kansas on his way back to Saint Louis.

In the summer of 1832, Catlin set out on the trip that would be the most important of his career. He took *Yellow Stone,* the first steamboat to go up the Missouri, two

thousand miles upriver to Fort Union near the present-day North Dakota–Montana border, visiting with Indians all along the way. "The desire to study my art, independently of the embarrassments which the ridiculous fashions of civilized society have thrown in its way, has led me to the wilderness for a while, as the true school of the arts," he wrote that summer. At the American Fur Company post at Fort Union, he felt that he beheld the epitome of the savage life. In mid-July, he returned downriver in a canoe, which provided him a bit more freedom to see the sites and tribes that he had missed, principally the Mandan, Hidatsa, and Arikara, whose villages were near Fort Clark. Catlin probably stopped at Fort Leavenworth again and continued painting portraits of visiting Indians even after he arrived at Saint Louis in October. He worked for the remainder of 1832 and much of 1833 finishing the 135 to 170 paintings that he had sketched during his trip and began showing the unfinished collection in Pittsburgh and Cincinnati the following spring. As a firsthand observer of the government's treatment of Indians, Catlin had become convinced that U.S. policy should change, and he included such sentiments in the lectures that he gave at his exhibitions.

Catlin returned to the field in 1834 with the first U.S. military expedition into the Comanche country of the Southwest. Traveling by steamboat from New Orleans up the Mississippi and Arkansas rivers to Fort Gibson, in what is today northeastern Oklahoma, he visited and painted the Cherokee, Choctaw, Creek, and Osage Indians. Then he rode with the dragoons southwestward across Indian Territory toward the Red River, where they encountered the Comanche, whose equestrian skills impressed both Catlin and the military. Here it became clear, if Catlin had not realized it before, the contribution that the horse had made to Plains Indian life. On the return to Fort Gibson, he almost died from the same fever that killed about a third of the regiment, but he survived and returned cross-country to Saint Louis, adding dozens of portraits and landscapes to his gallery.

To gather most of the remainder, Catlin made another trip up the Mississippi to the Falls of Saint Anthony the following summer, extending his travels into what is today southwestern Minnesota so that he could, at last, see the sacred Pipestone Quarry, where the Indians obtained the soft red stone now called catlinite for their pipebowls. Then he turned his attention to finishing the paintings and assembling his notes in preparation for another tour of his gallery.

Catlin was by now a seasoned exhibitor and lecturer, but his powerful message of mistreatment of the Indians was unwelcome in a nation that had removed the southeastern tribes to Indian Territory west of the Mississippi and that was in the process of pushing the Native Americans farther westward on every front. As Maximilian had observed, "It is incredible how much the original American race is hated by its foreign usurpers." With the Indian Gallery to establish his credentials, Catlin set out to educate the American public; he wanted to change government policy toward the Indians. At the same time, he wanted the nation to purchase his gallery. He fine-tuned his presentation in Albany and Troy before booking space in New York and Washington.

Eastern audiences knew little of the far West or of the native inhabitants in 1837, and much of what they might have heard bordered on the fanciful. In his nightly lectures at Clinton Hall in New York, Catlin tried to show that the Indians were neither bloodthirsty savages nor noble warriors but complex individuals and heirs of a legitimate culture. He knew firsthand the corrupting practices of the fur companies

CATLIN'S INDIAN GALLERY:
In the Old Theatre,
On Louisiana Avenue, and near the City Post Office.

MR. CATLIN,

Who has been for seven years traversing the Prairies of the "Far West," and procuring the Portraits of the most distinguished Indians of those uncivilized regions, together with Paintings of their

VILLAGES, BUFFALO HUNTS, DANCES, LANDSCAPES OF THE COUNTRY &c. &c.

Will endeavor to entertain the Citizens of Washington, for a short time with an Exhibition of

THREE HUNDRED & THIRTY PORTRAITS & NUMEROUS OTHER PAINTINGS

Which he has collected from 58 different Tribes, speaking different languages, all of whom he has been among, and Painted his pictures from life.

Portraits of Black Hawk and nine of his Principal Warriors,

Are among the number, painted at Jefferson Barracks, while prisoners of war, in their war dress and war paint.

ALSO, FOUR PAINTINGS REPRESENTING THE

ANNUAL RELIGIOUS CEREMONY OF THE MANDANS,

Doing penance, by inflicting the most cruel tortures upon their own bodies—passing knives and splints through their flesh, and suspending their bodies by their wounds, &c.

A SERIES OF ONE HUNDRED LANDSCAPE VIEWS,

Descriptive of the picturesque *Prairie Scenes* of the Upper Missouri and other parts of the Western regions.

AND A SERIES OF TWELVE BUFFALO HUNTING SCENES,

Together with *SPLENDID SPECIMENS OF COSTUME*, will also be exhibited.

☞The great interest of this collection consists in its being a representation of the *wildest tribes* of Indians in *America*, and entirely in their *Native Habits* and *Costumes:* consisting of *Sioux, Puncahs, Konzas, Shiennes, Crows, Ojibbeways, Assineboins, Mandans, Crees, Blackfeet, Snakes, Mahas, Ottoes, Ioways, Flatheads, Weahs, Peorias, Sacs, Foxes, Winnebagoes, Menomonies, Minatarrees, Rickarees, Osages, Camanches, Wicos, Pawnee-Picts, Kiowas, Seminoles, Euchees,* and others.

☞In order to render the Exhibition more instructive than it could otherwise be, the Paintings will be exhibited one at a time, and such explanations of their Dress, Customs, Traditions, &c. given by Mr. Catlin, as will enable the public to form a just idea of the CUSTOMS, NUMBERS, and CONDITION of the Savages yet in a state of nature in North America.

The EXHIBITION, with EXPLANATIONS, will commence on Monday Evening, the 9th inst. in the old Theatre, and be repeated for several successive evenings, commencing at HALF PAST SEVEN O'CLOCK. Each COURSE will be limited to two evenings, Monday and Tuesday, Wednesday and Thursday, Friday and Saturday; and it his hoped that visiters will be in and seated as near the hour as possible, that they may see the whole collection. The portrait of OSEOLA will be shewn on each evening.

ADMITTANCE 50 CENTS.—CHILDREN HALF PRICE.

☞These Lectures will be continued for *one week only.*

Catlin had this broadside printed to advertise the showing of his Indian Gallery in Washington, D.C., in April 1838.

and told his fellow citizens that their national policy—and rampant land speculation—was destroying the native cultures and forcing a tragic conclusion: the extinction of the Native Americans that had been predicted for so long. He shocked some of his listeners, convinced others, and aroused outright opposition on the part of the fur companies, but the audiences grew, forcing him to find a larger lecture hall. When the last of his Western letters appeared in the *New York Commercial Advertiser* in 1837, he promised to assemble them in book form.

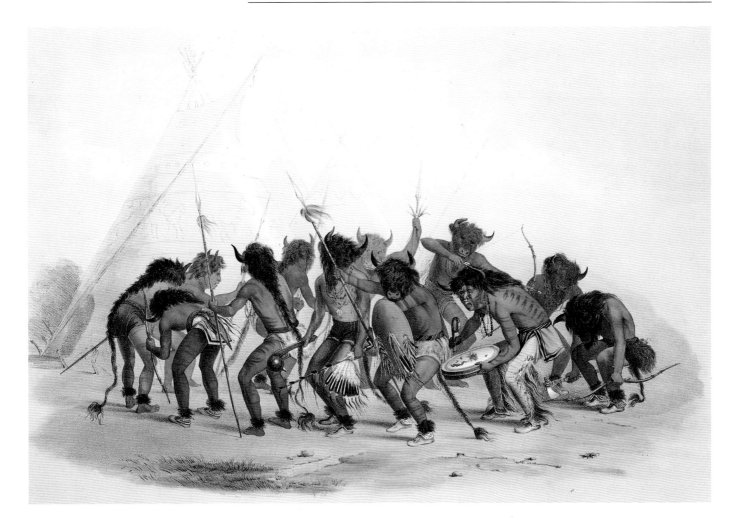

The Mandan performed the buffalo dance day and night until the beasts arrived. Catlin probably composed this picture from his notes and sketches and added the tipis for verisimilitude. Ackerman after Catlin, Buffalo Dance *(hand-colored lithograph, 1845), from* Catlin's North American Indian Portfolio, *pl. 8.*

In the spring of 1838 he took the collection to Washington, where friends such as Daniel Webster had tried to lay the groundwork for its acquisition. His price might have been as high as $150,000 for what he later called "a monument to a dying race, and a monument to myself." When no government offer was forthcoming, Catlin took his case to the public again, sending the collection on tour for the next eighteen months. But the government that Catlin had roundly criticized for its Indian policy declined to purchase the gallery, even after he let it be known that $60,000 might be a more realistic price. In fact, Congress had several reasons, including a lack of appreciation for what Catlin had accomplished, for declining to appropriate money to purchase the gallery. In addition to the always present problem of too few funds, Catlin had serious competition for the available monies in the persons of McKenney and, later, Henry Rowe Schoolcraft.

Spurned by Congress and repulsed by a market that seemed satiated by competitors' works, Catlin took the eight tons of freight that comprised the Indian Gallery to England in 1839, hoping that foreign success would increase the regard his countrymen held for him, as it had for Audubon and other American artists. In early January 1840, he installed the collection in Egyptian Hall, a popular London exhibition gallery, cov-

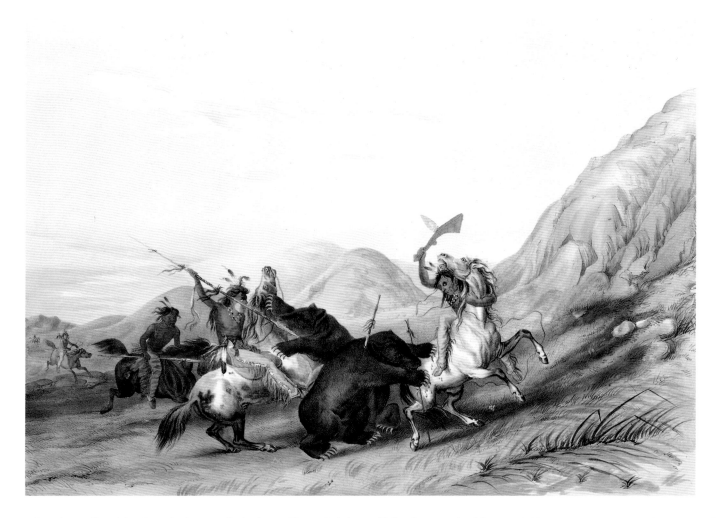

ering the walls with 485 paintings and placing a Crow tipi, beautifully decorated with a series of hunting and battle scenes, in the center of the room. Around it he arranged several hundred costumes, weapons, and utensils of all kinds on screens and tables. Rather than dwell on the shortcomings of U.S. Indian policy, he lectured the English audiences on the manners and customs of the North American Indians, padding his colorful narratives with personal incidents from his travels.

Probably in an attempt to attract the attention of British hunters and sportsmen, Catlin focused on hunting scenes. Ackerman after Catlin, Attack of the Grizzly Bear *(hand-colored lithograph, 1845), from* Catlin's North American Indian Portfolio, *pl. 19.*

After modest success but with the realization that the Indian Gallery probably would do no more than break even in London, Catlin published in 1841 an account of what the *Saturday Courier* of Philadelphia later called "the fullness of the life of the Western Indians." *Letters and Notes on the Manners, Customs, and Condition of the North American Indians* was well received on both sides of the Atlantic. Its chronology is somewhat confusing, and some scholars have valid questions about the accuracy of some of his observations, but the book remains the basis for much Plains Indian ethnology today and, as Catlin biographer William Truettner says, "his literary talents often surpassed his skill with a paint brush." The illustrations in *Letters and Notes* are nothing more than black line copies of many of the paintings in the Indian Gallery, but the book was reprinted perhaps twenty times between 1841 and 1860 (one of the most beautiful ver-

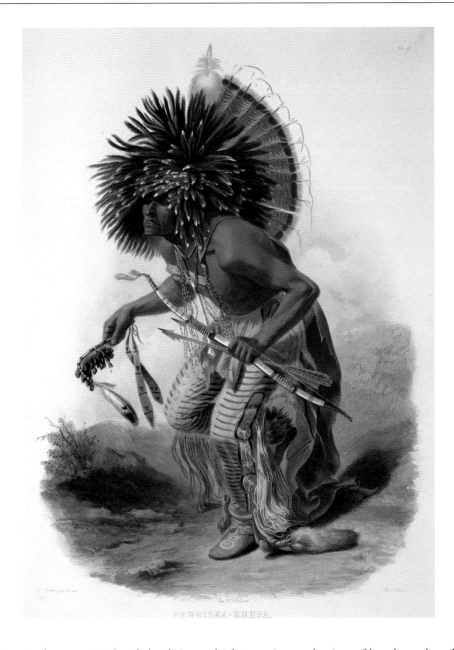

Pehriska-Ruhpa, the principal leader of the Dog Society in his village, is shown wearing a large black cap of magpie tail feathers, tipped with tiny down feathers on the point of each plume, with a wild turkey tail in the middle. René Rollet after Bodmer, Pehriska-Ruhpa, Moennitarri Warrior in the Costume of the Dog Danse *(hand-colored aquatint and etching, printed by Bougeard, 1840), from Wied,* Reise in das innere Nord-America, *atlas, tab. 23.*

sions is the rare 1848 Swedish edition, which contains a selection of handsomely colored lithographs).

The effect of Catlin's work reached beyond his own extensive efforts, as his portraits were widely copied in the *American Turf Register,* James C. Prichard's *Natural History of Man,* and other such publications. Catlin was a "decided hit," but the failure of the gallery to turn a profit gradually lured him away from the rigorous authenticity that had characterized his early work and in the direction of hyperbole, drama, and theatrics. Prince Maximilian (a veteran of the upper Missouri and the author of his own book on the Plains Indians) criticized Catlin for the "exaggerated and poetic descriptions" of the Indians in *Letters and Notes.* After visiting with Catlin in London in 1842, Alfred Jacob

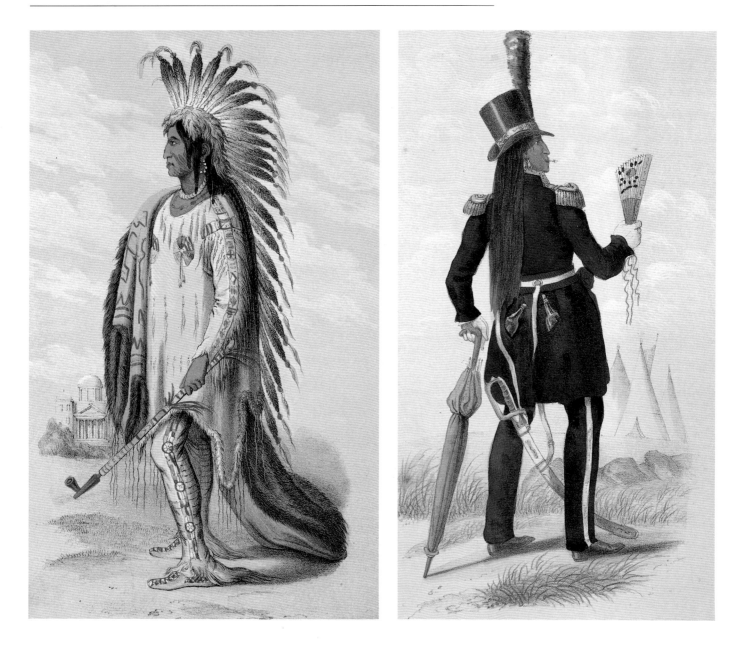

Miller, who in 1837 had become the first artist to go into the heart of the Rocky Mountains, agreed, writing his brother, "There is in truth . . . a great deal of humbug about Mr. George Catlin. He has published a book containing some extraordinary stories and luckily for him there are but few persons who have travelled over the same ground." Audubon, whose bird portraits were often compared to Catlin's Indian works, was even more denunciatory. After following Catlin's route up the Missouri in 1843, he wrote in his journal, "Ah! Mr. Catlin. I am now sorry to see and to read your accounts of the Indians *you* saw—how very different they must have been from any that I have seen!" There was more than a little professional jealousy toward the man who had been called "the Audubon of the Indians" as well as fur-company propaganda in Audubon's remarks.

Catlin told the story of Wi-Jun-Jon (Pigeon's Egg Head, or the Light) to emphasize his message of support for Native Americans. Ackerman after Catlin, Wi-Jun-Jon, an Assiniboin Chief *(hand-colored lithograph, 1845), from Catlin,* Nord-Amerikas Indianer *(1848).*

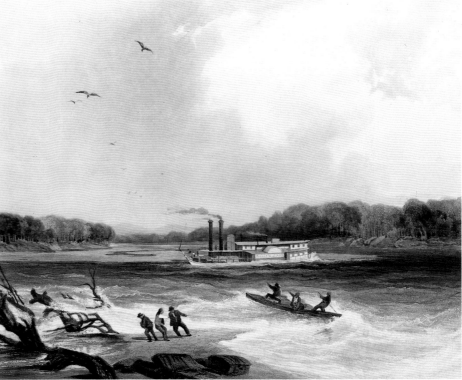

The Yellow Stone *encountered sandbars and dangerous snags as it steamed up the Missouri River. Here Bodmer shows the boat being unloaded so it can get over a sandbar. Lucas Weber after Bodmer,* The Steamer Yellow-Stone on the 19th April 1833 *(hand-colored aquatint and etching, printed by Bougeard, 1840) from Wied,* Reise in das innere Nord-America, *atlas, tab. 4.*

Catlin's desperation showed in other areas as well. At social gatherings, he and his nephew Theodore would sometimes paint their faces with "bold daubs" and dress in costumes from the Indian Gallery. On another occasion, he organized a war dance, chanting and waving clubs and tomahawks in the faces of amused guests. Encouraged by the reception, he added the theatrics to the Indian Gallery, shaving, painting, and dressing twenty white men to look like Plains Indians (until he could get real Indians) for what he called his *Tableaux Vivants,* which ranged from a scalping scene to an Indian wedding. Eugène Delacroix and George Sand saw Catlin's Indian Gallery and performance at the Salle Valentino in Paris in 1845. Delacroix compared "the chief brandishing his lance" to "Ajax defying the Gods," but Sand was completely overcome by the spectacle. "A cold sweat came over me; I believed I was witnessing the real scalping of some vanquished enemy or some still more horrible torture. Of all that was in front of me I saw nothing but the redoubtable actors and my imagination placed them in their true setting, under ancient trees by the light of a fire burning the flesh of the victims, far from all human help: for these were not men that I saw but demons of the desert, more dangerous and implacable than wolves or bears among whom I would gladly have sought refuge." Had Catlin possessed the financial resources, he probably would have gone even farther, as evidenced by the Indian field day that he later staged at Vauxhall Gardens, an event that anticipated Buffalo Bill's Wild West show of the 1880s.

His next publishing venture, *Catlin's North American Indian Portfolio: Hunting Scenes and Amusements of the Rocky Mountains and Prairies of America* (London, 1844), was a

calculated effort to gain the interest of English hunters and sportsmen. Sixteen of the original twenty-five plates depict buffalo, grizzly bear, and antelope hunting scenes or related subjects. Five of the plates are of games and dances, a visual reference to the *Tableaux Vivants.* There is also a double portrait of Pigeon's Egg Head (the Light), the Assiniboin warrior who was unwittingly victimized by his trip to Washington to visit President Jackson. Catlin was present when the Indian, dressed in a military uniform that Jackson himself had given him, returned to his village. The more he talked of his visit to Washington, the more his neighbors grew to dislike and distrust him. Finally, a young man from a nearby tribe murdered him. The message was clear: the gap between savagery and civilization was too great to overcome in one generation. It was an image that Catlin thought would appeal to British and European audiences, who were more likely than Americans to believe that savagery was the reason that Indian civilizations should be preserved.

The prints are approximately 18 ½ by 25 ½ inches in size. Catlin published two versions, tinted for five guineas and hand-colored for eight guineas. Shortly after the original issue, he added six prints: two portraits, two dances, and two more hunting scenes. Bartholomew Close of London issued one or more editions with slightly larger prints. One researcher estimated that there are at least six editions of the *Portfolio* dated 1844 as well as a handsome American edition published by James Ackerman of New York in 1845. A New York sign and banner painter turned lithographer, Ackerman probably copied his twenty-five hand-colored plates from the English edition rather than from Catlin's paintings. Finally, Currier and Ives reprinted some of Catlin's portfolio from the Ackerman stones during the 1850s.

Catlin intended the *Portfolio* as the first in a series, with the later volumes to concentrate on portraits, which made up the bulk of the gallery. He intended to publish three additional volumes of the same size, one each quarter, but sales did not justify the investment. He tried to borrow the 500 pounds needed to publish a second volume, estimating that it would earn between 600 and 800 pounds, but was unsuccessful. His poor financial situation was evident when he sold twenty copies of the *Portfolio* to a bookseller at a substantial discount in March 1845.

It is difficult to estimate the influence of Catlin's work. He was an internationally known personality who gave hundreds of lectures and published dozens of books and articles in conjunction with his Indian Gallery during a career of almost forty years. He had become the historian of the Indians, as he desired. Although the government never purchased his collection, he spent his last years as a guest of Secretary Joseph Henry at the Smithsonian Institution, and his Indian Gallery, by happy but unrelated coincidence, wound up there in 1879, seven years after his death. Today his work is criticized for its unrelenting Romanticism, but it is treasured by historians and anthropologists alike, who value his attention to detail and brave dedication to his task.

If Catlin was the popularizer of the Plains Indians, the most accomplished artist to paint them was Karl Bodmer, who accompanied Prince Maximilian of Wied-Neuwied on his expedition up the Missouri River in 1832–1834. Prince Maximilian was a serious student of natural history and had studied with Johann Friedrich Blumenbach at Göttingen, the same professor who set the brilliant naturalist Alexander von Humboldt on his course. Blumenbach pioneered the study of anthropology, and in one of his most famous books, *On the Natural Variety of Mankind,* he pondered the characteris-

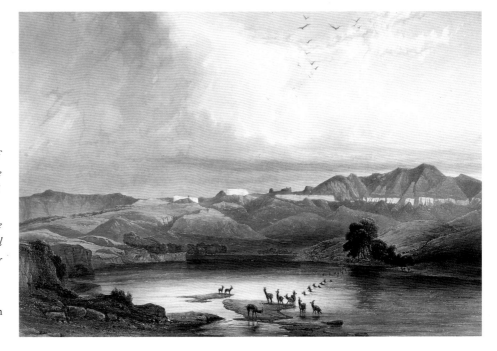

When Maximilian challenged the placement of antelope in this picture, Bodmer recalled that he had seen many herds in the region and claimed them as "an authentic motif" to relieve the monotony of such "sad parts of the country." The title again suggests the similarity of these natural formations to classical architecture. Himely after Bodmer, The White Castels on the Upper Missouri *(hand-colored aquatint and etching, printed by Bougeard, 1840), from Wied,* Reise in das innere Nord-America, *atlas, tab. 37.*

tics of the different races of the world. Like Buffon, the great French naturalist, he believed that all human beings had descended from a single set of parents, whose offspring had populated the globe. But the variety of races discovered by the likes of Captain Cook raised serious questions about his theory. Were the primitive peoples of Africa, the South Seas, and America from the same racial stock? Catlin believed that the Indian civilizations had deteriorated greatly when they came in contact with the Anglo-Americans, which is why he searched so diligently for those cultures that remained pristine—and perhaps why he pictured virtually all his sitters in native splendor, as if they were untainted by civilization. Blumenbach tended to agree that the Indians were degraded but thought that more research was needed. Maximilian arranged his trip to western America to fit that piece of the great scientific puzzle into place.

The fifty-year-old prince, later described by Alexander Culbertson, a company clerk at Fort McKenzie, as "well-preserved . . . of medium-height, rather slender, sans teeth, passionately fond of his pipe, unostentatious, and speaking very broken English," was a veteran of the Napoleonic wars. He had already ventured into the dense Brazilian jungles in 1815–1817 and published a book containing prints made after his own drawings. Although those drawings seem to possess a certain charm today, his artist brother and sister had teased him about them and had redrawn them for publication. Even then, the critics denounced them. For his American trip, he wrote a colleague, "I would want to bring along a draftsman who would not be too much of a burden on my pocketbook, a landscape painter but also able to depict figures correctly and accurately, especially the Indians."

One of the best-known artists in the area was Johann Karl Bodmer, a young Swiss who had learned his trade from his artist-printmaker uncle on his frequent sketching trips throughout Switzerland. He and Maximilian met in January 1832, and the follow-

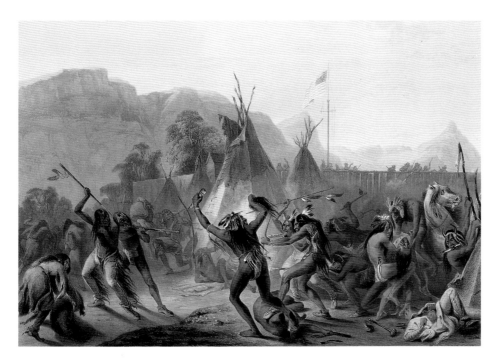

Bodmer became one of the few artists to witness an actual Indian battle when the Assiniboins attacked the Blackfeet at Fort McKenzie, but this picture was composed in the studio after he returned to Paris. Manceau and Hürlimann after Bodmer, Fort McKenzie August 28th 1833 *(hand-colored aquatint and etching, printed by Bougeard, 1840), from Wied,* Reise in das innere Nord-America, *atlas, tab. 42.*

ing month Maximilian offered him a contract to go to America and provide illustrations for his book. The prince would pay the young artist's expenses plus a monthly salary, and all but the most trivial of the paintings and drawings would become Maximilian's property. The prince warned Bodmer not to make any assumptions about their living conditions—"On the ship we will have good food and wine; in America this will often be lacking"—and after some negotiation, they agreed on the particulars and departed on May 17.

Landing in Boston on July 4, Maximilian and Bodmer began a leisurely trip across the eastern United States to Saint Louis, where, in April 1833, they headed up the Missouri on *Yellow Stone,* the same steamer that carried Catlin to Fort Union. Bodmer sketched all the way, and Maximilian searched for specimens and studiously recorded the animal and plant life every time the boat stopped to take on wood, get off a sandbar, or avoid any of the other perils that the Missouri River regularly offered up. They went beyond Fort Union into Blackfoot country in present-day Montana, spending a week at Fort Pierre, ten days at Fort Union, and more than a month among the Blackfeet at Fort McKenzie, the head of navigation. Maximilian had hoped to reach the Rocky Mountains, but an Assiniboin attack on the Blackfeet at the fort convinced him of the dangers that he might face if he pushed farther westward.

On September 14, Maximilian, his servant David Driedoppel, and Bodmer set out in a mackinaw boat stuffed to overflowing with the prince's collections, two live bears in a large cage, a pilot, and an inexperienced crew of three. They reached Fort Clark almost two months later, just as the bitter winter set in. During those months Maximilian studied the small, little-known tribe of Mandan and their near neighbors, the Hidatsa, that had so fascinated Catlin. Because of their facial features, Catlin had speculated that they were descendents of the Welsh prince Madoc, who, English geographer Richard Hakluyt had theorized, had reached America about 1170. Bodmer, meanwhile,

produced dozens of sketches of the villages, ceremonial dances, and the people, a stunning visual record of a people who would be all but wiped out in a smallpox epidemic just a few years later. When the river cleared of ice, the travelers, with Maximilian recovering from scurvy, pushed on to Saint Louis and, on July 16, sailed for Europe.

Maximilian had publicized the results of his Brazilian trip immediately, but work on his American expedition took more time. Maybe he had not fully recovered from his near-fatal bout with scurvy at Fort Clark. He had found the western prairies depressing and monotonous, Americans rude and uncultured, and the climate harsh, all of which might also have dampened his enthusiasm. He was further discouraged when he learned in 1835 that the steamer *Assiniboine* had exploded on a trip down the Missouri and sunk, losing most of his massive natural history and ethnographic collection. Nor could he have been encouraged when he lent Bodmer's paintings for an 1836 exhibition at the Royal Academy in Paris, only to have the reviewer for *L'Artiste* damn them with faint praise: "the *Indian characters* of M. Bodmer have excited our curiosity thanks to the bizarreness of their garb, and we must at least thank the designer for the kind of artlessness with which he has collected the details of this savage attire."

But Maximilian finally realized that in his careful observations and the more than four hundred of Bodmer's fresh and precise watercolors and sketches he possessed a priceless cache of ethnographic and historical information. The publishers would have preferred a travel account illustrated with a few lithographs because of the cost, but Maximilian planned a multivolume scientific work, accompanied by a deluxe atlas containing handsome illustrations. He first organized his field notes and wrote a three-volume journal of the expedition as the basis for his shorter, two-volume *Reise in das innere Nord-America in den Jahren 1832 bis 1834,* which appeared in 1839. Jakob Hölscher of Koblenz printed the German edition and handled the sales, and Maximilian contracted with Bodmer to arrange for publication and sales in France and England. The artist was to receive a monthly stipend plus travel expenses. If the work showed a profit, he would receive two thirds of it.

Bodmer might have chosen lithography as the method of reproduction, but he wanted the finest reproductions that could be achieved, despite the cost, something similar to what London engraver Robert Havell, Jr., had accomplished in Audubon's magnificent *Birds of America.* Probably because he had been trained as an engraver, he chose the same copperplate aquatint engraving method that Havell had used and immediately signed up some twenty engravers and several distinguished craftsmen to produce the atlas. Twenty-four engravers ultimately signed the prints; Bodmer himself signed the plate of the formal portrait of Pehriska-Ruhpa, along with Paul Legrand. Bougeard was the printer.

Maximilian was a demanding patron while on the trip and did not relax his control during the transition from watercolor to print. After the prince approved the sketches, Bodmer turned them over to the wood engraver, if they were to be reproduced in the book, or to the etchers and engravers if for the atlas. The results of aquatint engraving, one of the most difficult of all the printing processes, are impressive. It involves one of the oldest methods of printing, cutting lines into a copperplate, rubbing ink into them, and pressing a sheet of paper against the surface, producing a print. The additional technique of aquatinting seems to have been rediscovered in the second half of the eighteenth century, when it became popular for reproducing landscapes. (The term

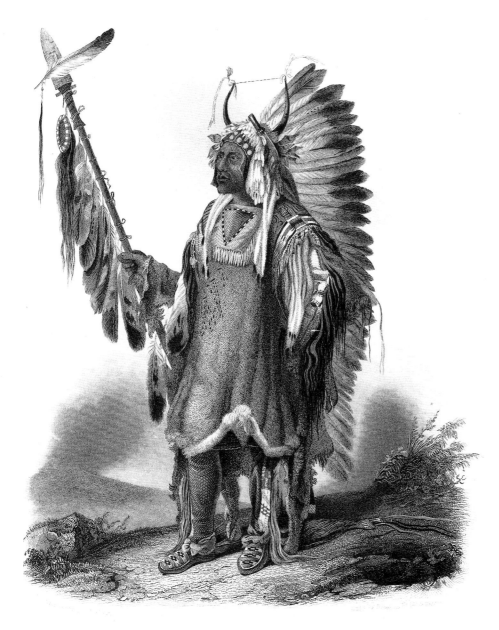

One of Bodmer's portraits of Mato-Tope, the Mandan chief whom Catlin had featured in his self-portrait, was copied widely. Rawdon, Wright, and Hatch after Bodmer, Mandan Chief (Mato-Tope) *(engraving, 1845), from* Graham's American Monthly 26 *(Jan. 1845), p. 45.*

"aquatint" comes from the watercolor effects that can be achieved and has nothing to do with the process itself, which is simply another method of producing tones in a printed work.) The artist dusts powdered rosin on a copperplate. When the plate is warmed, the rosin melts and adheres to the plate. The globules run together, creating a microscopic network of exposed copper, which, when immersed in acid, is etched away. The artist then varnishes over areas of the plate that have been adequately etched and reimmerses the plate, letting the acid bite deeper into the unprotected areas. When the desired result is achieved, the plate is printed. The deeply etched areas hold more ink and print darker than the shallow areas. Conventional engraving may also be used to add line to an aquatint.

Miller made several versions of Hunting the Bear, *including a large one for Stewart. L. N. Rosenthal chromolithographed this version in 1851 for Charles Webber's* Hunter-Naturalist: Romance of Sporting *(opp. p. 359).*

The whole process was complicated, time-consuming, and, therefore, expensive, requiring etching followed by trial proofs (which often had to be sent to Maximilian for approval) followed by additional etching and more proofs. "I have had much misfortune with some of the last copperplates because some had to be made over after I had hoped them ready for printing," Bodmer explained, probably in the spring of 1840. Later that year, he had to reengrave the striking portrait of Pehriska-Ruhpa with the war bonnet. On another occasion, the engraver lost Bodmer's sketch of an Indian he called Watapinat, about whom Maximilian had written in the prospectus and the text. Bodmer suggested that he substitute the portrait of another Indian without changing the name because he did not want to make further changes in the book: "In case there should be one among one thousand people who knows these two Indians personally, one can call it a harmless mixup of the names—the only one in this large opus." He rationalized, "Furthermore, Watapinat, if he is still alive, might have already changed his name, something common among the Indians." Maximilian apparently did not approve the substitution, and the portrait of Wakusásse was used instead. Maximilian apparently continued to add pictures to the work, and Bodmer agreed to do the additional illustrations, suggesting that his "memory and . . . existing sketches" were adequate sources for the new images.

Bodmer often had to defend the content, intent, and quality of his work. After Maximilian apparently questioned the inclusion of antelope in *The White Castles on the Upper Missouri,* for example, Bodmer "vividly recall[ed] the nearly uninterrupted line of antelopes, we saw several times in spring in those areas. . . . I believed I had to use and include such an authentic motif in a picture of these otherwise so sad parts of the country." To the prince's criticism of his sketch for *Dance of the Mandan Women,* Bodmer answered, "Regarding the ugliness of the Indians I can only reply that I stick strictly to the sketches made from real life, as well as of the people's physiognomy, which still is vividly in my mind."

For others, such as *Fort McKenzie August 28th 1833, Bison-Dance of the Mandan*

Indians in Front of Their Medicine Lodge, in Mih-Tutta-Hankush, and *The Travellers Meeting with Minatarre Indians, Near Fort Clark,* there are no watercolor prototypes. Bodmer probably composed them from his sketches and other sources, perhaps models or classical compositions, that he found in Paris. In regard to *Fort McKenzie August 28th 1833,* he explained, "I have designed and composed the print with the highest historical accuracy and completely coinciding with Your Grace's wishes, and it is, for its variety and completeness, very important for the work and certainly appealing to the audience. . . . As the buffalo dance and the bear and buffalo hunt etc., this action is drawn and conceived from nature and contains less conventional aspects than most such objects in other travel accounts." Bodmer's classical training is also apparent, for example, in his handsome portrait *Pehriska-Ruhpa: A Minatarre or Big-Bellied Indian,* which is modeled after the Dresden Zeus, a Roman copy of a Greek sculpture dating from 440–430 B.C. Other historians have suggested that Bodmer might have used Jacques-Louis David's *Leonidas at Thermopylae* as his model for *Bison-Dance of the Mandan Indians in Front of Their Medicine Lodge, in Mih-Tutta-Hankush.*

Soon after he set to work on production of the atlas, Bodmer asked Maximilian for portraits of himself and Driedoppel that he might use in the illustration that became *The Travellers Meeting with Minatarre Indians, Near Fort Clark.* He sent Maximilian a sketch of the plate for his comments, explaining that the scene showed Dechamp, their interpreter, introducing the party to the Minnetarees. "The interpreter points his right hand towards you and makes a sign with his left which connotes 'chief' to the Indians," Bodmer wrote. "The Indian makes the sign for agreement or satisfaction." Bodmer suggested that the chief either had brought the horse as a present for Maximilian or had just dismounted to meet the visitors. "We have not yet included such a strangely painted horse in our whole work," he noted.

Maximilian apparently was not satisfied with the sketch, calling the Indians exaggerated. The criticism must have touched a nerve, for Bodmer responded in some detail:

> I have mainly strived to present the character of the Indians truly and without exaggeration. . . . Indians have always interested me so vividly that I could not neglect exactly to watch and capture their characteristic traits and peculiarities during our stay with the different tribes. The fact that because of a lack of expertise I was forced to copy with unusual eagerness and attention every aspect realistically is also why all my portraits and sketches have been made in an almost ridiculously fussy manner but also with as much authenticity and truth.
>
> In this case, Your Grace should attest as much competence to me as to such critics who have never seen the Indians, or only saw individual demoralized and refined border Indians. For instance someone who saw the portraits made after nature at Your Grace's said that he considered most of it invented! Most likely because it did not coincide with the picture he himself had made of the Indians.
>
> In excuse of the composition I can only say that I vividly recall several such men during our winter stay at Fort Clark, who, on nice days, met with visiting Manitari Indians and who formed similar groups! I also remember very clearly to have seen several of these strangely painted horses; for example, Periska-Ruhpa once arrived on a grey horse painted in that manner, dismounted in Fort Clark, smoked a pipe and rode

away afterwards. Regarding the ugliness of the travelling party, of the Indians and Durand [Dechamp], one cannot possibly use the sent-in sketch which was made to evaluate the composition but not the facial expressions; these mistakes will not surface in the engraving.

Bodmer permitted himself a comment on nature as well. His picture of two grizzly bears, an animal symbolic of the wildness and ferocity of the wilderness to most Americans, tearing apart and devouring the carcass of a bison is a powerful study of the natural cycle. Even as the bears feast on their prey, they are about to fall victim to a greater enemy, man. The buzzards circling overhead complete the cycle, as one species feeds off another in the struggle for survival.

Bodmer was careful to explain various other details of the pictures to Maximilian. He obtained the Oregon snow finch for his illustration *Crow Indians,* for example, from Audubon's plate in *The Birds of America.*

In December 1838, Bodmer reported, "Mato tope with the war bonnet has turned out magnificently." Set against a white background like an eighteenth-century natural history specimen, Mato-Tope is clearly removed from his context. The great Piegan village near Fort McKenzie, on the other hand, is presented in its context—except the context is not complete, for the fort and other trappings of Anglo civilization are not as apparent as they might be. Perhaps Bodmer, held hostage by the prince's instructions and his own Romantic proclivities, was attempting to show the pristine Piegan culture before the influence of Westerners became pervasive.

Printing and coloring the images took several years. Some are virtual copies of the original watercolors; others have been altered, presumably to make a more romantic or pleasing scene, for example, *View of the Missouri, with Blackbird's Grave in the Distance* (watercolor) and *Washinga Sahba's Grave on Blackbird's Hills.*

In November 1839, after production of the atlas was well on its way, Bodmer accepted an invitation to speak to a new ethnological society, the Société Ethnologique, about the North American Indians. He apparently showed the group some of the prints, for he wrote Maximilian after his presentation, "The Société . . . has . . . given me the utmost praise for them by saying that this was the most beautiful and by far the best work which has been published anywhere."

While Bodmer was overseeing completion of the atlas, Hölscher, the publisher of the German edition, began the sales effort by printing and mailing 3,000 copies of the prospectus all over Europe and the eastern United States. He announced that there would be five different editions of the atlas to accompany the two-volume text: (1) printed in black and white on French paper; (2) printed in black and white on India paper; (3) sixty-one plates printed in black and white, twenty hand-colored on French paper; (4) sixty-one plates printed in black and white, twenty hand-colored on India paper; and (5) a deluxe edition, with all the plates printed on imperial vellum and hand-colored. (There might have been other combinations as well, for the Library of Congress atlas, with all eighty-one plates splendidly colored, is not printed on India paper or vellum.) Bodmer contracted with Arthus Bertrand in Paris for 150 copies of the atlas for the French edition and with Rudolph Ackermann in London for 200 copies of the first five numbers of the atlas (relying on sales of those first numbers to determine Ackermann's subsequent orders). Each publisher would undertake the translation and publication

of Maximilian's text. Prices varied according to whether the prints were colored or uncolored and the quality of the paper; one set was advertised for sale in New York for $100. It is difficult to say how many copies of the atlas were printed. Hölscher told Maximilian in June 1838 that he had 244 subscribers; Maximilian listed 278 when his book was published the following year. There could have been as many as 628 atlases printed if Hölscher had 278 subscribers, Bertrand purchased 150 copies, and Ackermann followed through on his order of 200, but there probably were not, for both Hölscher and Ackermann probably lost subscribers over the course of the project. One student has estimated that fewer than 400 copies of the atlas were finally printed.

Although the price was modest compared with the approximately $1,000 that Audubon asked for *Birds of America,* it was still a substantial amount and probably was the greatest deterrent to sales. It also kept Hölscher and the other publishers from sending out review copies, because, as he informed Maximilian, "The reviewers demand free copies, which I cannot give them?" The work, of course, was published at Maximilian's expense, and the question mark at the end of Hölscher's comment probably was intended to provide the prince the opportunity to offer to cover the cost of review copies. Hölscher also hesitated to risk copies by consigning them to booksellers, especially in the United States, because "I have had some losses in New York and Philadelphia."

Those problems aside, the atlas is certainly the most beautiful book to be published on the American West before the Civil War. Philadelphia's *Saturday Courier* called it "magnificent," "the most splendid and costly work on the geography and scenery of North America ever published." Each of the eighty-one "elaborately colored plates, imperial folio" is "beautiful enough to frame as a finished landscape."

With so few copies available and their distribution limited to large institutions or the wealthy, one might wonder what influence Bodmer's handsome images had on America's concept of the West. Just as were the works of Audubon and Catlin, Bodmer's pictures were copied in the popular press, both in Europe and America, permitting them to reach a much larger audience. *Graham's* magazine alone copied at least sixteen of his most beautiful portraits and scenes between July 1844 and December 1847. McKenney and Hall used another one for the frontispiece to their third volume, and Joseph and Hermann J. Meyer copied several in their popular travel series, *Meyer's Universum,* which was originally published in Germany, with portions later reprinted in the United States. Some of Bodmer's work was also used in Heinrich Rudolf Schinz's *Naturgeschichte und Abbildungen des Menschen der verschiedenen Rassen und Stamme nach den neuesten Entdeckungen und vorzuglichsten Originalien.* One of the most unusual uses of his pictures appeared in Johann Georg Heck's *Iconographic Encyclopedia of Science, Literature, and Art* in 1851, where Heck has incorporated into three different composite views of Plains Indian ceremonial and camp life at least six different Bodmer plates, perhaps more.

The third artist to venture into the far West during the 1830s was Alfred Jacob Miller, who accompanied Capt. William Drummond Stewart to the rendezvous of 1837 in the Wind River Mountains in what is today western Wyoming. The second son of a Scottish nobleman, Stewart came to America in 1832 to tour and pass the time in an attempt to forget that he and his older brother, who had inherited all the family titles and land, had quarreled violently. In 1833 he began attending the annual rendez-

Audubon included small landscapes in many of his pictures to indicate the native habitat of each bird or animal. William E. Hitchcock after Audubon, Missouri Meadow Lark *(hand-colored lithograph, 1844), from Audubon,* The Birds of America 7, *pl. 489.*

vous, which fur trader William H. Ashley had begun in 1825 to keep his trappers from having to come into Saint Louis to sell their pelts. By the time Stewart began attending, the annual rendezvous was an extravaganza—a trade fair, a reunion, and saturnalia all rolled into one. Stewart recognized that it was one of the great spectacles that the New World had to offer.

In 1837 Stewart, who had learned that his older brother was quite ill and that he might have to return home to take charge of the family fortunes, prepared for what might be his last rendezvous. He decided to take an artist with him, perhaps because he had met Maximilian and Bodmer as they passed through Saint Louis on their way up the Missouri. He tried to tempt Maximilian into joining him on an excursion into the Southwest. How different Bodmer's pictures would have been if he had visited among the Pueblos and Navajos instead of the Mandans. But the prince declined, preferring the relative comfort and periodic stops of steamboat travel.

The captain met young Miller in New Orleans soon after the artist opened his studio early in 1837. After a brief negotiation, Miller agreed to Stewart's terms, and they joined the caravan of traders that left Saint Louis that April. A significant difference between his contract and Bodmer's was that Miller got to keep his original sketches.

They proceeded along what became known as the Oregon Trail, passing such landmarks as Scotts Bluff, Chimney Peak, the original Fort Laramie, the Continental Divide, and Devil's Gate before reaching the Wind River Mountains. The rendezvous itself was a memorable occasion, with the likes of mountain men Joseph Rutherford Walker and Jim Bridger in attendance, but the naive Miller was more taken by the primitive beauty of the Crow, Shoshone, Snake, Sioux, and other Indians and worked hard to capture the essence of a carefree summer in his charming and vigorous watercolor sketches.

Returning to New Orleans in the fall, Miller promptly began copying his field sketches, both in sepia washes and oil paintings, for Stewart, who had by then learned that his brother had died and was preparing to return home to Murthly Castle on the River Tay, near Perth, Scotland. Miller painted eighty-seven pen, wash, and watercolor sketches and eighteen oils for Stewart before joining him for approximately a year's residence at Murthly in 1840. Like Maximilian, who had just finished his large work on the West, Stewart also thought of publishing a portfolio of prints and raised the subject with Miller, who delayed, asking "your kind indulgence until I reach home before I attempt the lithographs." He never undertook the portfolio.

A few of Miller's pictures were finally printed as the result of author and entrepreneur Charles Wilkins Webber's interest in illustrating two of his books. In 1851, Webber purchased six prints from Miller to use in *The Hunter-Naturalist: Romance of Sporting,* five of them as chromolithographs and one as a steel engraving. The chromos were printed by L. N. Rosenthal of Philadelphia. The only credit that Webber gave Miller was a note in the introduction in which he emphasized that although Miller had exhibited his pictures on at least two occasions, these prints would be his introduction to the public. "I say with perfect confidence that it remains yet for Art in this country to approach the amazing fidelity and spirit of these Drawings," he concluded, "and his glorious Portfolio is but yet just opened!"

Webber's first book went through several printings, leading him to publish *The Hunter-Naturalist: Wild Scenes and Song-Birds* in 1854. Among the illustrations were

Audubon thought the buffalo was the "most important of all our contemporary American quadrupeds," and the buffalo hunt was the highlight of his Western trip. J. T. Bowen after Audubon, American Bison, or Buffalo *(hand-colored lithograph, 1845), from Audubon and Bachman,* Viviparous Quadrupeds of North America, *pl. 57.*

five more Miller watercolors, which were again chromolithographed by the Rosenthal firm; young Max Rosenthal received credit as the lithographic artist. Webber wrote in the introduction that these color prints were the "first experiment in a novel field" and praised them as "unparalleled specimens of the art of Printing in colors upon stone," made possible by the "latest discoveries of Science, and the application of mechanical forces to pictorial illustration, as to cheapen all their cost without any deterioration of artistic value." Still, he noted that they left "much to anticipate" when compared with the original watercolors, and Miller, no doubt, agreed.

Two of the prints also offer a slight insight into Victorian morality. Both *Toilet of the Indian Girls* and *Indian Girl Swinging,* two of Miller's more popular images, judging by the number of copies that he made, show Indian women naked. The prints were altered in later printings of Webber's book to show them fully clothed.

Miller published one separately issued chromolithograph, a large-format print entitled *Lost on the Prairie,* which was a copy of his painting *The Lost Greenhorn.* It depicted the expedition cook, a young Englishman named John, trying to find his way back to camp after a hunting trip. H. Ward of New York published it. The only other print done after Miller's Western work during his lifetime is *Scene in the Rocky Mountains of America,* a black and white lithograph published in a history of the Stewart family that Sir William commissioned in 1868. It shows Stewart standing firm in the face of menacing Indians.

Miller, who settled in Baltimore and spent the rest of his life there, declined an invitation from Sir William to return to the Rockies for one last fling in 1843. His work remained largely unknown, with the exception of Webber's prints, until his original sketches were placed on view in Peale's Museum in Baltimore in the 1930s and published in Ber-

nard De Voto's seminal study of the fur trade, *Across the Wide Missouri,* in 1947.

John James Audubon, perhaps the most popular artist of all those who went west before the Civil War, was also on a cataloging expedition, but one of a different sort. Instead of observing Native Americans, he was documenting the mammals of the continent, a follow-up to his great work, *The Birds of America.* Although he had hoped to make the trip while he was working on *Birds,* Audubon got only as far as Galveston Bay and Houston in 1837, the year before he finished that publication. Then, in 1842, while he was in Washington attempting to persuade the government to sponsor him on a Western expedition, he met Pierre Chouteau, owner of the American Fur Company, who offered him the same steamboat transportation up the Missouri that Catlin and Bodmer had enjoyed a decade earlier. Audubon left in the spring of 1843, as he was finishing one publication, the royal octavo edition of *Birds,* and beginning another, *The Viviparous Quadrupeds of North America.*

The trip almost came too late for both Audubon and the West. "Mr. Audubon is quite an aged man," wrote one of the reporters along the route, "but his active and hardy life has given a vigor and strength to his constitution which renders him far more active than the generality of men of his years." Audubon also found that the West had changed greatly during the intervening decades. Had he been able to go during the 1820s, when he first attempted the trip, he might have seen more of the pristine landscapes and noble savages that he hoped for. As it was, when he saw the Assiniboins, whom he said Catlin had represented as "dressed in magnificent attire, with all sorts of extravagant accoutrements," he found them simply "very dirty." He also believed that Catlin had misrepresented the landscape: "We have seen much remarkably handsome scenery, but nothing at all comparing with Catlin's descriptions; his book must, after all, be altogether a humbug." As a guest of the Chouteau family, Audubon, it must be admitted, saw the West through the fur companies' prejudices, and they had long since denounced Catlin for his pro-Indian views.

He and Sir William, who was preparing for his trip to the last rendezvous, happened to be in Saint Louis at the same time. Stewart invited the fifty-eight-year-old artist-naturalist to accompany him to the Rocky Mountains, tempting him with the offer of five mules and a wagon if he would join the party. But Audubon had his own agenda: he was looking for mammals for his new publication and suspected that Stewart's trip was more of a lark than a scientific expedition. He later concluded that he was glad that he had not gone with the baronet and "his gang." The truth probably was that he, like Maximilian, preferred the relative luxury of the riverboat to the wagons.

Accompanied by longtime friend Edward Harris; Isaac Sprague, a young artist whom Audubon had met in Massachusetts; and taxidermist John G. Bell, Audubon boarded *Omega* on April 25 and steamed up the river. The trip seemed more an adventure than a research expedition, with Audubon being feted all along the way as a celebrity. Fifty days later they disembarked at Fort Union, and Audubon and Harris occupied the same chamber that had housed Prince Maximilian and Bodmer ten years before. Audubon spent the next two months hunting, observing the Indians and traders, and searching for and gathering specimens. Audubon's work was, in many ways, similar to that of Catlin and Bodmer. Just as Audubon had cataloged the birds of the continent and was now working on the quadrupeds, so Catlin and Bodmer had documented the

various tribes of Indians and some of the birds and animals they encountered, each artist contributing documented links to the Great Chain of Being. Finally, on August 16, he and his party began the eight-week float downriver in a mackinaw boat.

The scientific results of the trip were disappointing. He found fourteen new species of birds, which he hastily drew for inclusion in the royal octavo edition of *Birds of America,* but "the variety of Quadrupeds is small in the Country we visited," he explained, and "I fear that I have not more than 3 or 4 New Ones." He returned with some good sketches of flowers, scenery, and heads of antelope, big horn sheep, wolves, and buffalos, but his trip was especially disappointing to his coauthor, the Reverend John Bachman of Charleston. "For the last four nights, I have been reading your journal," Bachman wrote. "I am much interested, though I find less about the quadrupeds than I expected. . . . Your descriptions of Buffalo hunts are first rate," but "the little Marmots, Squirrels and Jumping Mice" had been overlooked.

Audubon did almost half the paintings for *Quadrupeds* before old age and then a stroke forced him to turn the work over to his sons. John completed the paintings of the animals, with Victor supplying the backgrounds. Victor worked with Bachman to finish the text, which is based on Audubon's notes and journals. Audubon contracted with Bowen, the same lithographer who had produced the last volumes of McKenney and Hall's *Indian History* and the octavo edition of *Birds of America,* for the folio *Quadrupeds.* The prints are approximately 28 by 22 inches in size and are hand-colored. Bachman was an admittedly prejudiced critic, but when he saw the first samples, he remarked, "They are most beautiful and perfect specimens of the art. I doubt whether there is anything in the world of Natural History like them. I do not believe that there is any man living that can equal them." They were issued in thirty parts of five prints each and sold for $10 per number or $300 for the complete set. They are usually bound in two volumes.

The 150 prints for *Quadrupeds* were finished in 1848. Audubon died in 1851. Bachman and Audubon's sons completed the three volumes of text in 1852, publishing perhaps as many as 300 complete sets. Between 1849 and 1854, they also published a three-volume octavo edition of *Quadrupeds,* incorporating both the pictures and the text.

McKenney and Hall's *Indian History,* Catlin's *North American Indian Portfolio,* Maximilian's *Reise in das innere Nord-America,* and Audubon's *Quadrupeds* all appeared during the 1840s, revealing much about the West and its occupants. But the national domain was growing at an even more rapid pace during that decade, as Texas, the Southwest and California, and the Pacific Northwest all became part of the Union. It would take another generation of explorers and the active participation of the government to fill in those vacant spaces on the map.

Sarony, Major, and Knapp after Stanley,
Peluse Falls *(tinted lithograph, 1860), from*
Reports of Explorations and Surveys *12, pt. 1,*
"General Report," pl. 41, opp. p. 151.

THE DISCOVERY
OF THE WEST:
GOVERNMENT PATRONAGE

*T*he huge amount of unexplored territory admitted into the Union in the two decades before the Civil War transformed the United States into a continental power with more than just a window on the Pacific. Along with a coastline of almost a thousand miles, the country assumed responsibility for the daunting problems that had plagued Mexico's ownership of the region, stretching resources and the national spirit until, according to Col. John J. Abert, commander of the Topographical Engineers, the "integrity of the Union" was at stake. Abert recognized that the vast distances of the deserts, plains, and mountains constituted formidable obstacles to transportation and communication, but when gold was discovered in California in 1848, a solution had to be found immediately.

Pastoral California, which had been a sparsely settled country of missions and ranchos, boasted a population of more than 100,000 by the following year and was admitted to the Union as a free state in 1850. If it was not linked more closely to the rest of the country, it might well choose an independent course. The government responded with extraordinary effort to insure that it, and the remainder of the West, stayed in the Union. Lt. John Charles Frémont mapped the route that thousands of immigrants came to know as the Oregon Trail, the Great Basin, and the Sierra Nevadas, earning the sobriquet the Great Pathfinder. When the United States went to war with Mexico, teams of engineers and artists accompanied military expeditions into Mexico and the Southwest, and once the national domain had been consolidated by the addition of Oregon Territory and the Southwest, others crisscrossed the region to mark the international boundaries, search for the best route for a transcontinental railroad, identify navigable rivers, and fill in the vacant portions of the Western map.

Expeditionary artists returned from wilderness locales to share their awe of the West with the nation through their evocative pictures. Private expeditions supplemented the government effort as would-be pioneers sought to tell their story or entice others to join them. All their findings were published in large and handsomely illustrated volumes that were issued in editions as few as one hundred but more often in thousands and sometimes in tens of thousands. Icons of the West were identified and revealed to

an eager public for the first time: Mount Shasta and the ancient forests of the North-west, the canyonlands of Utah, Santa Fe and Acoma, the Rockies, the Grand Canyon. The nation spent an estimated one quarter to one third of its annual budget on these expeditions, artists, printmakers, and more than sixty official publications that appeared during two decades, according to historian William H. Goetzmann. Abert and other government officials justified the expenditures by the obvious need to learn about the country's new lands, find routes to link far-flung California and Oregon with the rest of the nation, and disseminate the information.

These publications were but one way in which the federal government sought to hold the country together. Through them the government purposefully created a constituency for expansion into and development of the West and, at the same time, became a major patron of artists and of the fledgling American lithographic industry. Federal policy for expansion may be seen not only in these exploring and scientific expeditions but also in the later support for railroads and the homestead, range, and water laws.

Support for the arts, however, was not by design, for the government had no such coherent policy—indeed, some politicians were vociferous in their denunciations of them. Even though Congress also shares the credit for assisting the artists and printers, for it appropriated the hundreds of thousands of dollars to pay for each of these expeditions and reports, it was hardly a premeditated decision on the part of many. As the scholarly studies from the U.S. Exploring Expedition of 1838–1842 continued to pour from the government printing office, for example, Secretary of War Simon Cameron grew "tired of all this thing called science," and in 1861 Senator John P. Hale of New Hampshire suggested that, "the country" should "know how much we have spent for printing pictures of bugs, reptiles, etc."

This unprecedented government sponsorship was possible because the mechanism existed within the army, the topographical engineers, and the government printing office to bring artists and lithographers into the patronage system. The educated, elite, and well-connected army officer corps considered exploration and dissemination of the information an integral part of a democratic government. By 1836 most of the officers had been educated at West Point, where figure, topographic, and landscape drawing were a part of the required curriculum. Even those officers not educated there would have been more inclined toward the arts and culture than the average citizen, so artists regularly found staff positions with the exploring expeditions and were often included as guests when not a part of the official party. When no artist was present on an expedition, the commander himself was usually capable by virtue of his West Point training of providing the maps and illustrations for his subsequent report. Capt. Randolph Marcy's 1852 search for the headwaters of the Red River may be a case in point, although, in this instance, there was at least one other West Point graduate on the trip, Bvt. Capt. George B. McClellan, Marcy's future son-in-law and Civil War general. The officer corps also wielded considerable political influence in Congress when it came time to appropriate funds to publish the findings of the most recent expedition.

The burst of exploration and publication began in 1838, the year Abert's Topographical Engineers were established, but with the U.S. Naval Exploring Expedition rather than the engineers. It continued during the next decade with Frémont's well-

publicized expeditions into the Rocky Mountains and California and the Southwestern expeditions that followed the 1846–1848 war with Mexico. The Pacific railroad surveys of the mid-1850s, authorized in an attempt to find the best road from the Midwest to the West Coast, resulted in comprehensive surveys and even more impressive publications. The decade closed with Lt. Charles Ives's report on the forbidding Grand Canyon country of the Southwest. Of a different nature, but supported by the government nonetheless, was Henry Rowe Schoolcraft's massive, six-volume *Historical and Statistical Information Respecting the History, Condition, and Prospects of the Indian Tribes of the United States,* published between 1851 and 1857. John Russell Bartlett's *Personal Narrative of Explorations and Incidents in Texas, New Mexico, California, Sonora, and Chihuahua,* which resulted from his service as commissioner of the U.S. Boundary Survey; Andrew B. Gray's *Southern Pacific Railroad;* and Frederick Piercy's *Route from Liverpool to Great Salt Lake Valley,* a handsome handbook for the Mormon immigrant headed for Brigham Young's citadel in Salt Lake City, were three among the dozens of important private publications to appear during these years.

The political strength necessary to launch the U.S. Exploring Expedition was created when New England merchants, who had long been eager to find new sealing and

Wilkes found the timber resources of the Northwest impressive. William E. Tucker after Alfred Agate, Pine Forest *(engraving, 1844), from Wilkes,* Narrative of the United States Exploring Expedition *5. Prints financed by the government before the Civil War tend to be smaller than Catlin's and Bodmer's pictures because they are essentially book illustrations.*

German cartographer Charles Preuss supplied the sketches for Frémont's report. Edward Weber after Preuss, Central Chain of the Wind River Mountains *(tinted lithograph, 1843), from* Frémont, Report of the Exploring Expedition to the Rocky Mountains, *opp. p. 66.*

whaling grounds, joined forces with the eccentric John Cleves Symmes, Jr., who believed that the world was hollow and that entrée to the inner world could be found by sailing to the South Pole. It was not a widely held theory, needless to say, but the Navy welcomed both the scientific and economic opportunities to learn more about a little known region and to show the flag in areas where the American image needed boosting. President John Quincy Adams asked Congress to authorize him to send a ship to the Pacific in 1828, but it was not until a decade later that six ships finally departed from Hampton Roads, Virginia, on America's first around-the-world adventure.

The commander of the expedition was Lt. Charles Wilkes. His team included a large scientific corps, with Titian Ramsay Peale as naturalist, and three artists: Alfred Agate, of New York, a painter of miniatures who had just returned from two years of study in France and Italy; Joseph Drayton, an experienced draftsman from Philadelphia; and landscape painter Raphael Hoyle. Despite Wilkes's dictatorial behavior—he promoted himself to captain as soon as he was at sea, asserting that the additional prestige would help him control the "heterogeneous mass"—the expedition accomplished much. They sailed around South America, charted islands in the South Pacific, and visited Australia, Antarctica, New Zealand, and Hawaii before arriving for the grand finale on the northwest coast of North America. Wilkes began searching the coastline north of the Columbia River for safe harbors in July 1841 and sent extensive surveys inland. It was apparent from the beginning that the Columbia was not the safe harbor they sought when *Peacock,* a sloop-of-war that had been rebuilt as the first American vessel for overseas exploration, ran aground at its mouth and was lost. Neither was there a good harbor between there and San Francisco, nor great rivers leading to the interior. Wilkes's map and Agate's and Drayton's published images were the first

that the American public would see from the Northwest, unless they had access to the rare and expensive volumes of Cook, Vancouver, or Kotzebue; even then, those intrepid captains had not gone inland. Wilkes's data became even more important the following year when Frémont linked them with his findings, enabling the United States to establish a geodetic baseline for the uncharted region between the Mississippi River and the Pacific Ocean.

Wilkes's return in the summer of 1842 was an anticlimax. Some derided the venture as the "Everlasting Expedition," and the first few weeks were taken up with courts-martial, with various charges being brought by and against Wilkes. He was eventually found guilty of only one minor charge, and the expedition's collections and journals were turned over to him for his report. Assisted by Drayton, he produced the five-volume *Narrative of the United States Exploring Expedition* in 1844.

As if to emphasize its lack of interest, Congress authorized the publication of only one hundred copies of the *Narrative,* but Wilkes acquired the rights to the books and reprinted them privately in 1845 (five times), 1849 (three editions), 1850, 1851, 1852, 1856, and 1858. The volumes are well illustrated with steel and wood engravings by G. B. Ellis; Rawdon, Wright, and Hatch; J. W. Steel; and W. E. Tucker, among others. The reviewer for *Graham's American Monthly* noted that one of the 1845 editions was "richly embellished with maps and wood-cuts," which hardly tells the significance of the expedition. In less than four years, Wilkes and his men had surveyed 280 islands and drawn 180 charts, some of which were not superseded until World War II. They mapped the coast of Oregon, were the first to explore much of the Antarctic coast, and collected thousands of natural history specimens, which became the nucleus of the fledgling Smithsonian Institution's holdings. Publication of the expedition's findings continued for thirty years, in fact, with nineteen volumes and atlases ultimately printed at a cost of more than $350,000. Even then, at Wilkes's death in 1877, he was remembered more for his Civil War disgrace in the Trent affair than for his explorations.

Frémont, of the Topographical Engineers, on the other hand, personified Western exploration. Teaming up with Kit Carson and others, he mapped the famous Oregon Trail and penetrated the towering Rocky Mountains, where he climbed what he thought was the highest peak in the Wind River range and unfurled an eagle flag, symbolizing America's "Manifest Destiny" as possessor of the West. His second expedition was a virtual circumnavigation of the region, and his third, made just as the Mexican War began, involved him in the conquest of California. After resigning from the Army, Frémont returned to California, where he served briefly as U.S. senator before running unsuccessfully for president as the "Pathfinder" in 1856.

By the time he left on his first Western expedition, Frémont was a seasoned explorer, having surveyed the Cherokee country in 1836 and 1837, the Pipestone Quarry in southwestern Minnesota in 1838–39, and the Des Moines River in 1841. As the son-in-law of Senator Thomas Hart Benton of Missouri, a firm advocate of American annexation of Oregon, he was able to persuade Congress to allocate funds for the Rocky Mountain expedition in 1842. The ostensible purpose of the mission was a reconnaissance of the territory between the Missouri River and the Rockies, but as he later admitted in his *Memoirs,* the real purpose was to open an immigrant road to Oregon. Upon his return, Congress authorized publication of his *Report on an Exploration of the Country Lying Between the Missouri River and the Rocky Mountains, on the*

Line of the Kansas and Great Platte Rivers. It contained small lithographs printed by Edward Weber and Company of Baltimore, most likely made after cartographer Charles Preuss's sketches of the Wind River Mountains, Chimney Rock, Fort Laramie, Hot Spring Gate, Devil's Gate, and the central chain of the Winds. Weber had established his lithographic shop in Baltimore in 1835 and was well known by the time he won the government contract for Frémont's illustrations.

Preuss was a German-born and -trained mapmaker who accompanied Frémont on three of his five expeditions. He is best known for his precise maps, but when Frémont proved incapable of operating the daguerreotype camera that he had brought along on the first expedition, Preuss's humble sketches were the only pictorial images available for the published report. "That's the way it often is with these Americans," Preuss groused in his journal. "They know everything, they can do everything, and when they are put to a test, they fail miserably." His condescension extended to the scenery that he depicted as well. Of the Wind River Mountains, he wrote, "Whoever has seen Switzerland and expects something similar here is bound for a great disappointment. An American has measured them to be as high as 25,000 feet. I'll be hanged if they are half as high, yea, if they are 8,000 feet high. A little snow on their peaks; that is all, as far as I can see now, that distinguishes them from other high mountains." In fact, Gannett Peak, the highest point in the Winds, reaches 13,804 feet, and Preuss's picture *Central Chain of the Wind River Mountains* is illustrative of Frémont's comment that the "one main striking feature" of the "whole scene . . . was that of terrible convulsion. Parallel to its length, the ridge was split into chasms and fissures; between which rose the thin lofty walls, terminated with slender minarets and columns, which is correctly represented in the view." The expedition had little strategic value, but it made Frémont a hero and led to two more significant expeditions in 1843–44 and 1845.

The secret 1843 expedition was made at the behest of Senator Benton. Frémont began amid a cavalcade of settlers bound for Oregon and California and adventurers like Sir William Drummond Stewart en route to the last rendezvous in the Wind River Mountains, but he soon left them, blazing a new trail via the Kansas River. Beyond the Sweetwater River and South Pass, he turned southward to behold the "still and solitary grandeur" of the Salt Lake Valley, describing it so movingly that Brigham Young would later decide to relocate his long-suffering Mormons from Nauvoo, Illinois, to the Utah desert after reading Frémont's rhapsodical description.

The Pathfinder then turned northwestward to the Columbia and sent a party down the river to Fort Vancouver, thus linking his survey with that of Wilkes, before heading southward in pursuit of the mythical Buenaventura River. Following the Deschutes River, he entered the Great Basin from the north, becoming the first army engineer to see it. He was the first to recognize that this complex of valleys and basins drained toward the interior—that is, no rivers flowed from it to the sea—and named it the Great Basin. In California he reunited with mountain man Joseph Rutherford Walker, who led him through the Mexican territory by a shortcut across the Colorado River plateau to Bent's Fort on the Arkansas and back home again.

Frémont had circled almost the entire West, and Preuss prepared the first relatively accurate map of the region. Congress authorized publication of 10,000 copies of his *Report of the Exploring Expedition to the Rocky Mountains in the Year 1842, and to Oregon and North California in the Years 1843–'44*, which incorporated the narrative of his first

trip as well. To Preuss's pictures from the first report Frémont added the cartographer's depictions of Pikes Peak, Pyramid Lake, and the Sierra Nevadas, among others, as well as several plates of botanical and fossil specimens. Weber again printed the tinted lithographs. It was Frémont's most popular book, and several publishers issued a total of twenty-four subsequent editions, both in this country and in England.

In the spring of 1845, Frémont headed west again, this time to reconnoiter the Mexican border country along the headwaters of the Arkansas and Red rivers. After surveying the upper Arkansas, he sent James W. Abert, his second in command, down the Canadian River with his report and continued to California, where he and his men joined in the war against Mexico.

The son of Colonel Abert, head of the Topographical Engineers, young Abert was a West Point graduate who had studied topographical drawing under Robert W. Weir and his assistant Seth Eastman. He and his classmates were probably among the first to use Eastman's *Treatise on Topographical Drawing.* Eastman had a much more precise form of drawing in mind, but his language sometimes paralleled the Romantic landscapists of the Hudson River School, as when he explained that in drawing rocks, "the best rule that can be given is to imitate nature." Weir believed that his students should be schooled in the principles of freehand drawing and encouraged them to sketch the scenery up and down the Hudson River. Eastman, meanwhile, provided the geometrical explanation for converting a topographical plan into a perspective drawing. "The great utility of a topographical drawing, in a military point of view" he explained, "consists in enabling the officer to ascertain with sufficient accuracy what obstacles will be presented to his ascent, and to what extent the ground will admit of manoeuvres."

Abert was greatly impressed with the scenery of northeast New Mexico, including the Grand Canyon of the Canadian River. Weber after Abert, A Cañoned Creek *(lithograph, 1846), from Abert,* Message from the President, *opp. p. 24. Courtesy the Center for American History, the University of Texas at Austin.*

Charles Parsons' hand-colored lithograph (1848) after Daniel Powers Whiting's drawing Birds-eye View of the Camp of the Army of Occupation, Commanded by Genl. Taylor Near Corpus Christi, Texas, from the North, Oct. 1845 *presented another part of the new country to the public. From Whiting,* Army Portfolio No. 1.

Abert would not see such scenery along the Canadian, but he had no other point of reference. With Thomas Fitzpatrick as guide, he set out to survey the river from its source to its confluence with the Arkansas. The party left Bent's Fort, Colorado, on August 15, 1845. In search of the headwaters of the Canadian, they approached Raton Pass eight days later. "I cannot conclude the day without . . . alluding to the scenery," Abert wrote:

Every moment our eyes were arrested by the imposing grandeur of the precipitous cliffs which walled us in on either side, and the beautiful stream which danced along from rock to rock, whilst continually several small rivulets borne from the cool springs of the mountain side, burst from the dark dells where they seemed to lurk, and joined in the merry dance of the crystal waters. There was not one in our party who did not feel well repaid for the trying hardships he had endured on the sandy wastes of the prairie. I thought that the pleasure afforded us, as with delighted eye we gazed around, seemed not inferior to that experienced whilst looking on the falling waters of Niagara.

Abert and party made numerous sketches that he felt would give "more exact scenographical ideas" of what they saw than any verbal description could. The next day, as they crossed Raton Pass, more rewards awaited. "A splendid view suddenly burst upon us as we reached the point most elevated in the whole route. We had expected to see the valley of the Canadian, but, looking to the south, could discern nothing but a confused mass of rock; whilst on our right the Spanish peaks again welcomed us, asserting their supremacy above the long, many-headed range of the Sierra Blanca, which, gradually dwindling, stretched off to the south as far as the eye could see." As they followed the Canadian southward, the surveyors reached the Grand Canyon of the Canadian, which Abert sketched for inclusion in the published report.

Although trained in topographical drawing, Abert was hardly prepared for the stark and rugged country that he found. "Should a painter, in sketching the landscape, give

The Americans captured San Diego as soon as war broke out between Mexico and the United States. Graham after Stanley, San Diego from the Old Fort *(lithograph, 1848), from Emory,* Notes of a Military Reconnoissance, *pl. 26, opp. p. 128.*

it the true tone of color, he likely would be censured for exaggeration," he later wrote. He did learn to deal with what he found, finally commenting that he was "fully satisfied with the wild scene which I have attempted to portray in the accompanying sketch." Weber once again did the lithographs for the publication.

Frémont, meanwhile, headed to California accompanied by artist Edward M. Kern, among others. Kern was a friend of Joseph Drayton's and a veteran of the Wilkes expedition, and Frémont had found him in Washington working on the illustrations for that publication. Drayton told him how to prepare. Take "a lot of coloured pencils," a camera lucida, and watercolors, he advised. "Make full notes of colours & everything els on the back of the drawings, and interview with Capt Fremont, what sizes you shall addopt for paintings &c., allways finish your drawings on the spot, as much as possible & leave little for notes, be guided by Capt. F. in your department as to how, and what he wishes drawn, and take advantage of every opportunity to produce other drawings your own judgement will dictate for usefullness to the Capt." The camera lucida is a small sketching aid invented in 1806 by Dr. William Hyde Wollaston in England. By looking through an inclined piece of glass, or a prism, at a piece of drawing paper, the artist can see a reflection of the object to be pictured and can copy it. It was particularly popular among travelers and amateur artists in England in the early nineteenth century and became a staple of topographic art equipment.

Simultaneous with Frémont's publications, hundreds of prints and books resulted from the 1846 war with Mexico. Soon after the war began, artists and printmakers on the East Coast began to turn out caricatures and scenes of war to supply the public curiosity for information about Mexico and the war itself. Nathaniel Currier and other lithographers published dozens of prints, some from eyewitness sketches and others copied after European battle prints, but most manufactured from whole cloth—crude and primitive illustrations that did little more than drum up enthusiasm for war or shock with horror. Some artists among the first troops in Mexico rushed back to the United States to publish illustrated books and portfolios of scenes even before the brief

Not being a botanist, Stanley did the best he could with the unusual botanical specimens he encountered as he rode west with Kearny. Graham after Stanley, Vegitation on the Gila *(lithograph, 1848), from Emory,* Notes of a Military Reconnoissance, *pl. 15, opp. p. 77.*

war concluded in 1848. Capt. William Seaton Henry's *Campaign Sketches of the War with Mexico* contained illustrations after Lt. Alfred Sully and Maj. Joseph H. Eaton, while Thomas Bangs Thorpe, a correspondent for the *New Orleans Tropic,* illustrated his own work, *"Our Army" on the Rio Grande.* Much more impressive were the works of Daniel Powers Whiting (*Army Portfolio No. 1* in 1848), Henry Walke (*Naval Portfolio No. 1* in 1848), and George Wilkins Kendall, who provided the commentary to accompany Carl Nebel's careful battle scenes in *The War Between the United States and Mexico, Illustrated* (1851).

Immediately following the war, pictures of the newly annexed territories appeared in dozens of different publications, and the government reports were among the most informative and beautifully printed. One of the first to appear was William H. Emory's *Notes of a Military Reconnoissance, from Fort Leavenworth, in Missouri, to San Diego, in California, Including Part of the Arkansas, Del Norte, and Gila Rivers,* which resulted from Col. Stephen Watts Kearny's invasion of the Southwest. Like Frémont, Emory was a member of the Topographical Corps who could wield considerable influence in governmental circles. He was a member of a tidewater Maryland family who traced their landholdings back to the colonial days. His grandfather had fought in the Revolution, his father in the War of 1812, and like Abert, he was a graduate of West Point. He married Matilda Wilkins Bache of Philadelphia, whose father had a distinguished

career as head of the Coast and Geodetic Survey, and his closest friends were Jefferson Davis, Joseph E. Johnston, and Henry Clay, Jr.

Assigned to Kearny's staff, Emory accompanied the Army of the West to Santa Fe. Finding no resistance there, Kearny dispatched Lieutenants Abert and William G. Peck to survey and map New Mexico Territory, then set out across unknown and difficult terrain for San Diego in September 1846. Artist John Mix Stanley accompanied Kearny down the Rio Grande, then west along the upper Gila River. They encountered complexes of ancient ruins and artifacts, which Emory at first assumed to be Aztec. He finally realized that Casa Grande and the other ruins were the remnants of a native Southwestern culture of which neither he nor any other American knew. Kearny pressed on to San Pascual, clashing there with a desperate group of Mexican soldiers in a battle that the Americans might well have lost had not Kit Carson and others broken through the Mexican lines and recruited reinforcements at San Diego.

Emory's report, published in 1848, contained not only his map of the largely unknown Southwest but also John Mix Stanley's views of militarily significant points, several sentimental portraits of the natives, and pictures of the ancient ruins of Casa Grande as well as examples of the cacti and other plants. Curtis Burr Graham (who had moved his lithographic business from New York to Washington, D.C., in 1842) printed the tinted lithographs for the House version of the report, Weber those for the

Emory was surprised to find evidence of ancient Southwestern civilizations of which he knew nothing. C. B. Graham after Stanley, Hyerogliphics *(lithograph, 1848), from Emory,* Notes of a Military Reconnoissance, *pl. 21, opp. p. 63.*

Abert's panorama of Santa Fe was the first
published picture of the best-known city in the
newly American Southwest. He shows the
American flag flying above Fort Marcy on the
hill. Weber after Abert, Santa Fé *(lithograph,*
1848), from Abert, Report of the Secretary of
War, *opp. p. 419.*

Senate version. Abert and Peck's report on New Mexico, published that same year, contained the first printed image of Santa Fe as well as various landscapes, portraits of the Pueblos, and Acoma, one of the largest pueblos.

Subsequent expeditions by James H. Simpson in 1849 and Lorenzo Sitgreaves in 1851, both accompanied by artist Richard H. Kern, added detailed reports, images, and maps to the growing collection of materials as the Americans took control of more than 1.2 million square miles of new territory in the Southwest. Simpson discovered some of the most important Indian ruins in the country at Jemez, Chaco Canyon, and Canyon de Chelly. Sitgreaves, marching westward from Albuquerque across Arizona to Fort Yuma and finally San Diego, brought back maps and drawings of a forbidding, little known, and stunningly beautiful part of the Southwest. They did not discover a railroad route to the Pacific, but they did obtain valuable information on the natives. P. S. Duval, who had by then established his own firm in Philadelphia, and James Ackerman of New York produced the lithographs.

Colonel Abert, meanwhile, assigned Capt. Howard Stansbury to survey the Great Salt Lake and vicinity. Interest in the area that would become Utah increased significantly after Brigham Young settled the Mormons there in 1847, and Stansbury's task was to seek a better wagon road from Fort Bridger, Wyoming, to Salt Lake City as well as to locate a route for a potential transcontinental railroad. His expedition began in May 1849 amid a raging cholera epidemic on the Missouri frontier, but gold fever proved to be even more debilitating to his expedition as word spread of the California discovery, and his men deserted for the goldfields.

Franklin R. Grist accompanied Stansbury on the first part of his expedition to find a route from Independence, Missouri, to the Great Salt Lake. Ackerman after Grist, Crossing of the Platte Mouth of Deer Creek [Wyoming] *(tinted lithograph, 1852), from Stansbury,* Exploration and Survey of the Valley of the Great Salt Lake, *pl. 3, opp. p. 60.*

Richard Kern had another opportunity to observe the Pueblos as a part of Sitgreaves's expedition in search of the wagon road that Simpson described. Ackerman after Kern, Indian Weaving (Pueblo Zuñi) *(tinted lithograph, 1853), from Sitgreaves,* Report of an Expedition Down the Zuni and Colorado Rivers, *pl. 4, foll. p. 198.*

Richard H. Kern drew this Stonehenge-like picture of Pueblo ruins while on Simpson's punitive raid against the Navajo. P. S. Duval after Kern, North West View of the Ruins of the Pueblo Pintado in the Valley of the Rio Chaco, Aug. 26, No. 1 *(lithograph, 1850), from* Simpson, Journal of a Military Reconnaissance, *pl. 16.*

Stansbury overcame the Mormons' original suspicion that he had been sent to spy on them and gained Brigham Young's confidence, as well as respect and sympathy for his people. He was the first surveyor to march completely around the Great Salt Lake, concluding in his 1852 report, *Exploration and Survey of the Valley of the Great Salt Lake of Utah,* that it was the remnant of a "vast *inland* sea." When the last spike was driven on the transcontinental railroad at Promontory Point, Utah, in May 1869, Stansbury had the satisfaction of knowing that he had explored the site of the event during his circuit of the lake. His well-illustrated report found a wide readership, was reprinted twice by the Philadelphia firm of Lippincott, Grambo, and Company, and was translated into German primarily because of his vivid description of the "Great Basin Kingdom." F. C. Grist served Stansbury as official artist until February 1850, when John Hudson, a young Englishman who had paused en route to California because he contracted cholera, took his place and produced more than half of the drawings for the report. Ackerman printed the lithographs.

At about that same time, the Mormons themselves undertook a major illustrated work intended to recruit immigrants for their community. Church leaders apparently assigned Englishman Frederick Piercy, a recent convert, to make a visual and literary record of his 1853 trip west, which began serial publication the following year in Liverpool as *Route from Liverpool to Great Salt Lake Valley.* Each of the fifteen parts was stitched into printed wrappers and contained two handsome, steel-engraved plates. The work was completed in 1855.

Shortly after Lieutenant Emory published the report on his cross-country trek, he returned to the Southwest, this time as a major and as chief astronomer and surveyor

of the U.S. Boundary Survey team. The treaty of Guadalupe Hidalgo, which ended the war with Mexico, called for a joint Mexican and American commission to mark the new boundary. The commissioners and surveyors were to meet in San Diego in 1849 to designate the point on the Pacific coast that would then be connected to the Rio Grande by survey. At the other end of the survey, the boundary was to begin three marine leagues out in the Gulf of Mexico and proceed up the deepest channel of the Rio Grande until it intersected with the line that had been surveyed from the west. The task became a political disaster, with the United States appointing three commissioners before giving the job to New York bibliophile, would-be adventurer, and Whig hanger-on John Russell Bartlett. Insufficient funds and equipment slowed the work of the Mexican commission even further.

After Bartlett took charge of the American team at El Paso in May 1850, he readily agreed with Mexican commissioner Pedro García Conde that the boundary should be several miles farther up the Rio Grande than the point designated by U.S. astronomer and surveyor Andrew B. Gray. Bartlett's interpretation of the situation probably was in accordance with the treaty, but Gray resigned his post rather than agree to a boundary that he believed would deny the United States the vital southern railroad route that it so badly wanted. Emory replaced Gray but held agreement on that point in abeyance until he had finished the rest of the survey. Meanwhile, the Texas delegation in Congress took up the fight, and when the presidential election of 1852 returned the Democrats to office, Bartlett was dismissed. Emory finished the survey and wrote the report. The boundary dispute was finally resolved when the United States acquired the Gadsden Purchase from Mexico, insuring that it had the best available route for a southern road.

Both Richard and Edward Kern were interested in ethnology and did a number of pictures of the Pueblos they encountered. Christian Schuessele after Kern, You-Pel-Lay, *or the Green Corn Dance of the Jémez Indians, Aug. 19 (1849) (lithograph printed by Duval, 1850), from Simpson,* Journal of a Military Reconnaissance, *pl. 6.*

After reaching the Great Salt Lake, Stansbury's party conducted a thorough survey of the valley. Ackerman after unknown artist, Phrynosoma Platyrhinos, *or the Horned Toad (lithograph, 1852), from Stansbury,* Exploration and Survey of the Valley of the Great Salt Lake, *opp. p. 362.*

Emory's two-volume *Report on the United States and Mexican Boundary Survey* is an expensive and elegantly printed quarto set containing woodcuts, crisp steel engravings, and chromolithographs after illustrations by Arthur C. V. Schott, John E. Weyss, and A. de Vaudricourt. Many of the pictures show cities, towns, points of interest along the border, and portraits of Indians, but most are of landscapes near the boundary, "to perpetuate," as Emory explained, "the evidences of the location of the boundary." William H. Dougal and James D. Smillie supplied the engravings, while Sarony, Major, and Knapp of New York printed the chromolithographs. Emory's accompanying maps were the most detailed of the region yet published. Congress authorized publication of 10,000 copies of the narrative volume and 1,000 copies of the scientific volume (issued in two parts).

The government refused to publish Bartlett's account of his adventures, which he had written with the work of his friend John Lloyd Stephens in mind (*Incidents of Travel in Central America, Chiapas, and Yucatan*), so he made a deal with Appleton and Company of New York: Appleton would publish *Personal Narrative of Explorations and Incidents in Texas, New Mexico, California, Sonora, and Chihuahua* and split the profits with him. Bartlett's lambent text still makes for good reading, and the book is handsome, for he employed Seth Eastman, Harrison Eastman, Henry Brown, and Oscar Bessau to help him with his own lively sketches. Commercial publication deprived him of the government funds that would have made color possible, so the ninety-four woodcuts that appear in *Personal Narrative,* published in 1854, are printed in only one color. Some of the sixteen lithographs contain a tint color as well.

Several more-modest explorations also produced memorable books, such as Randolph B. Marcy's *Exploration of the Red River of Louisiana,* originally printed in 1853 but so popular that it was reprinted twice the following year. Sent to find the headwaters of the Red, Marcy, with Bvt. Capt. George B. McClellan as second in command, turned up Tule Canyon instead but convinced himself that the spring that "bursts out from its cavernous reservoir" there was, in fact, the source of the Red. Ackerman printed twelve scenic views of the area, the most famous of which is *Head of Ke-Che-Ah-Que-Ho-No, or the Main Branch of Red-River,* with "gigantic escarpments of sandstone, rising to the giddy height of eight hundred feet upon each side." But Marcy was mistaken. He should have gone up Palo Duro Canyon, the true source of the Red River. Still, his scenes of the Llano Estacado and its natural history document a little known region. Not until 1876 did the Ruffner-McCauley expedition actually map the elusive source of this river.

But the largest task—both for the artists and the lithographers—remained, for construction of a transcontinental railroad was inevitable. Competition for the route was intense, for it appeared that the road would be so expensive that only one could be constructed, and the promotion of development all along the route would be a financial bonanza for the city that became the eastern terminus. It would control access, as Senator Thomas Hart Benton was wont to say, to "India." After acquisition of the Gadsden Purchase, the Atlantic and Pacific Railroad Company proposed a road west from Vicksburg along the thirty-second parallel. Secretary of War Jefferson Davis favored that route, but with sectional feelings intense, Senator Stephen Douglas of Illinois proposed a northern route from Lake Superior, Chicago, or Cairo, Illinois;

After serving as commissioner of the Mexican Boundary Survey, John Russell Bartlett included several illustrations in his well-written account. Sarony after H. C. Pratt, Fort Yuma, Colorado River *(tinted lithograph, 1854), from Bartlett,* Personal Narrative *1, frontispiece.*

The Mexican village of El Paso (present-day Ciudad Juárez) was near the boundary's intersection with the Rio Grande. Sarony, Major, and Knapp after A. de Vaudricourt, The Plaza and Church of El Paso *(chromolithograph, 1857), from Emory,* Report on the United States and Mexican Boundary Survey *1, opp. p. 92. Courtesy Ron Tyler.*

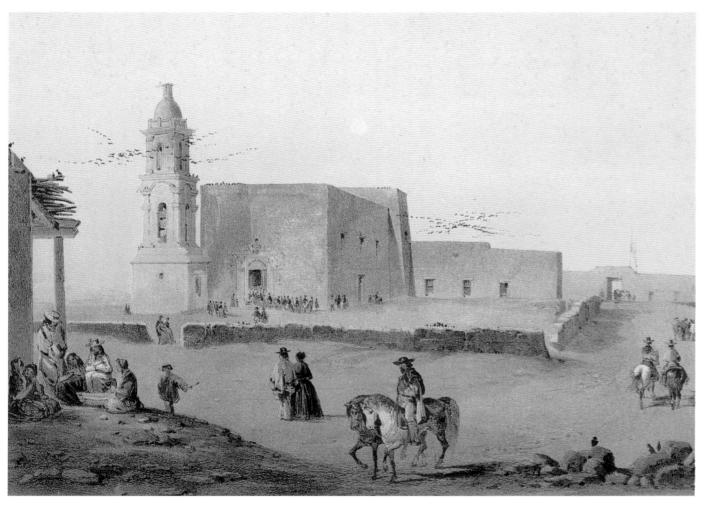

Commissioned by the Mormons to document the Overland Trail from Council Bluffs to Salt Lake City, Englishman Frederick Piercy made his sketches with the aid of a camera lucida. Charles Fenn after Piercy, Great Salt Lake City in 1853, Looking South *(steel engraving, 1855), from Piercy,* Route from Liverpool to Great Salt Lake Valley, *opp. p. 109.*

Missourians suggested a central route with Springfield as the eastern terminus; and others supported a road along the Oregon Trail.

In an attempt to resolve the stalemate, Congress ordered four extensive surveys to find the "most practicable and economical" route for a transcontinental railroad. With the southern route already identified, one survey would follow the thirty-fifth parallel, beginning at Fort Smith, Arkansas, and extending westward through Oklahoma, the Texas Panhandle, New Mexico, and Arizona to Los Angeles. A second was to begin at Westport (present-day Kansas City) and follow a line between the thirty-eighth and thirty-ninth parallels that passed below the Uinta Mountains and south of the Great Salt Lake before continuing westward to California. The third reconnaissance was to cover the territory between the forty-seventh and forty-ninth parallels from Saint Paul through the northern part of the country to Seattle. The fourth party was to search the Tulare and San Joaquin valleys of California for passes to connect the thirty-fifth and thirty-second parallel routes. When attacks by Benton and others raised serious doubt about the feasibility of a southern route—lack of water and timber, danger from Indians—Secretary Davis assigned Lieutenants John Pope and James G. Parke to survey the route from Preston, on the Red River, to California. The engineers were able to take advantage of previous explorations as well, for in a real sense, all the surveyors in the field after the Mexican War had a transcontinental railroad in mind.

Not satisfied with those efforts, at least three private surveys also took the field. Robert J. Walker, former secretary of the treasury under President Polk and a stockholder in the New York-based Atlantic and Pacific Railroad Company, announced his intention to build a railroad from Vicksburg to California via El Paso and the thirty-second parallel. Through his wholly owned Texas Western Railroad, Walker employed Andrew B. Gray, former Boundary Survey chief surveyor, to conduct an independent reconnaissance along the proposed route. It appears that Walker and his influential associates hoped to attract outside investment monies and land grants from the state of Texas to construct the road. Although the plan never had any serious chance of success, Gray completed the survey from San Antonio to California. Both Edward Fitzgerald Beale and Frémont led elaborations on the thirty-eighth-parallel route at the behest of Benton, now a member of the House of Representaives, and several private backers.

Science, unfortunately, was not able to resolve a problem that had sectional strife at its core. Each survey leader insisted that his team had found the best route, political competition deepened, and Congress deadlocked. Lt. Edward G. Beckwith, who completed the survey of the thirty-eighth parallel after John W. Gunnison's death at the hands of Ute Indians, surveyed the route that was finally used, but neither he nor Captain Stansbury, who had discovered a pass near Lodgepole Creek that made the route feasible, was able to promote the route, and their discovery went unnoticed until it was rediscovered by professional railroad men a decade later, leading to completion of the first transcontinental railroad in 1869.

Publication of the *Reports of Explorations and Surveys, to Ascertain the Most Practicable and Economical Route for a Railroad from the Mississippi River to the Pacific Ocean* (1855–1861), on the other hand, was a huge success. The reports (hereafter referred to as the *Pacific Railroad Reports*) filled two octavo volumes and twelve massive, quarto volumes (bound in thirteen), including one full volume of maps, elevations, and views. Among them is the first detailed map of the entire trans-Mississippi West, compiled by twenty-seven-year-old Lt. G. K. Warren, who brought together all the expedition field notes and maps and combined them with the previous work of Preuss and Emory. Also included are the findings of more than one hundred trained scientists who collected and described thousands of specimens, but because they were still dedicated to the nineteenth-century scientist's practice of cataloging and describing, their observations could only be superficial over such a massive region, and they were hampered in forming any overall theses. With an eye toward conditions under which the railroad would be constructed, each survey team made extensive observations about the weather, which, once they were accumulated and evaluated, formed a comprehensive view of trans-Mississippi weather patterns, especially when combined with the monthly meteorological reports from frontier army outposts. By comparison, Native Americans were neglected, with only two expeditioners—Stevens and Lt. Amiel W. Whipple—filing reports. Whipple's was by far the more comprehensive, containing information on the myths, legends, and ceremonies of the various tribes encountered, in the manner of Indian administrator and ethnologist Henry Rowe Schoolcraft. Whipple was justifiably upset when artist Heinrich Balduin Möllhausen, a protégé of the great German naturalist Alexander von Humboldt, pictured Navajos, whom Whipple described as bright-eyed and alert, slumping sleepily over their mounts. The only correct aspect of Möllhausen's pictures, Whipple said, were the ubiquitous Navajo blankets.

Emory succeeded Bartlett as boundary commissioner and continued his study of the Southwest. J. H. Richard (attrib.), Crotalus Atrox, or a Diamondback Rattlesnake *(engraving, 1857), from Emory,* Report on the United States and Mexican Boundary Survey *2, pt. 2, "Reptiles," foll. p. 35, pl. 1.*

Randolph B. Marcy claimed to have discovered the main source of the Red River when in fact he had followed a tributary into Tule Canyon, depicted here. Ackerman after unknown artist, Head of Ke-Che-Ah-Que-Ho-No *(tinted lithograph, 1852), from Marcy,* Exploration of the Red River of Louisiana, *pl. 10.*

The other lithographic illustrations were more successful. Almost a dozen artists contributed more than seven hundred paintings and drawings that were reproduced as engravings and lithographs throughout ten of the twelve volumes. In addition to Möllhausen, they included John Mix Stanley, a seasoned veteran of Emory's march west and of his own roamings; Friedrich W. von Egloffstein, a Prussian-born writer, editor, inventor, artist, and engineer; Gustavus Sohon, a bookbinder and wood carver from Germany via Brooklyn; and Richard H. Kern, a member of Frémont's disastrous 1848 expedition and Simpson's and Sitgreaves's excursions into the Southwest. Kern was among the only casualties of the surveys when Ute Indians killed him, Gunnison, botanist Frederick Creuzefeld, and five others. Other artists included John C. Tidball, Albert H. Campbell, James G. Cooper, John Young, William P. Blake, and Charles Koppel.

Bearing in mind Eastman's admonition that two of the main purposes of topographical drawing are to show the commander what obstacles he will face and what maneuvers the terrain will permit, survey artists produced mostly landscapes depicting the ground over which a proposed railroad might pass. Beckwith, who explored along the central route, explained in his report,

> *The landscape views are presented with no purpose of presenting the beauties of the scenery of the country, but to illustrate its general character, and to exhibit on a small scale the character of its mountains and cañones, and of its plains and valleys, in their respective positions and extents, as seen in nature, together with such passes as it was possible to represent without unduly increasing the number of views. . . . They are taken, as will be seen at once, from elevated positions, and consequently partake somewhat of a panoramic character, and being of great extent, the ordinary inequalities of the surfaces of plains and slopes are not perceptible. But little attention has been paid to the beautiful execution of foregrounds, as it is only the general view of the country which it is desired to present. The smokes seen here and there indicate points at which we encamped.*

As a result, numerous views may appear dull to the modern viewer, but they suggest to the engineer the very real possibility of a roadbed.

Such scenes probably bored the artists as well, and they took every opportunity to depict the more sublime and fantastic views that they encountered. They probably shared the concern of F. B. Meek, who, after taking a steamer up the Missouri in 1853, complained that "these views [of Dakota Territory] are so vast and the objects generally so distant that the drawing has to be made on a very small scale so that it's very difficult to produce that peculiar mingling and contrast of light and shade so pleasing to the eye when we look upon the landscape itself." Still, Kern's *Head of the First Cañon of Grand River, Below the Mouth of Coo-che-to-pa Creek Septbr 7,* Koppel's *Colorado Desert and Signal Mountain,* Blake's *Mammoth Tree "Beauty of the Forest,"* and Stanley's *Grand Coulee* and *Peluse Falls* are examples of artists' rising to the occasion to depict the extremes of a country that they had never seen before, a country that would yield only grudgingly to a railroad construction crew.

Perhaps the best landscapist of all the expeditionary artists was Egloffstein, who accompanied Beckwith on the completion of Gunnison's survey of the thirty-eighth parallel. Four of his landscapes were engraved as folding panoramas that encompass

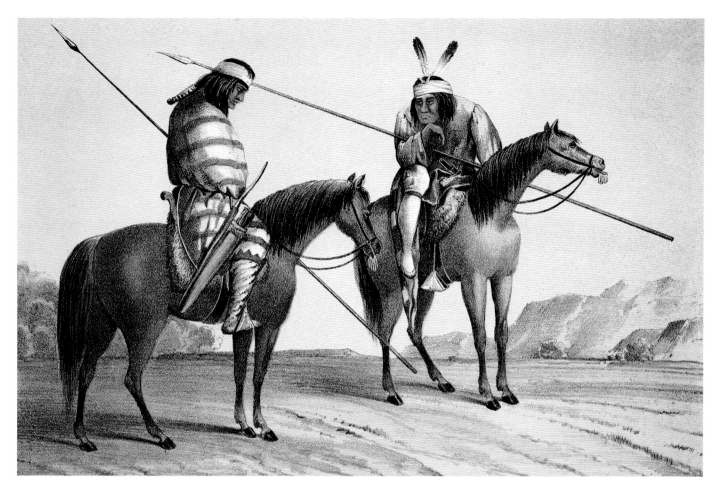

Thomas Sinclair after Möllhausen, Navajos *(chromolithograph, 1855), from* Reports of Explorations and Surveys *3, pl. 22, between pp. 30 and 31.*

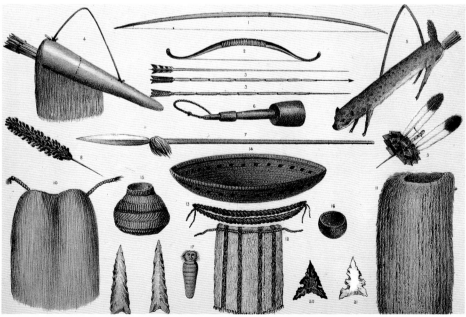

Artist-naturalist Möllhausen, a protégé of the great Humboldt, accompanied Whipple on his survey of the thirty-fifth parallel. Sinclair after Möllhausen, Indian Designs and Manufactures *(chromolithograph, 1855), from* Reports of Explorations and Surveys *3, foll. p. 50.*

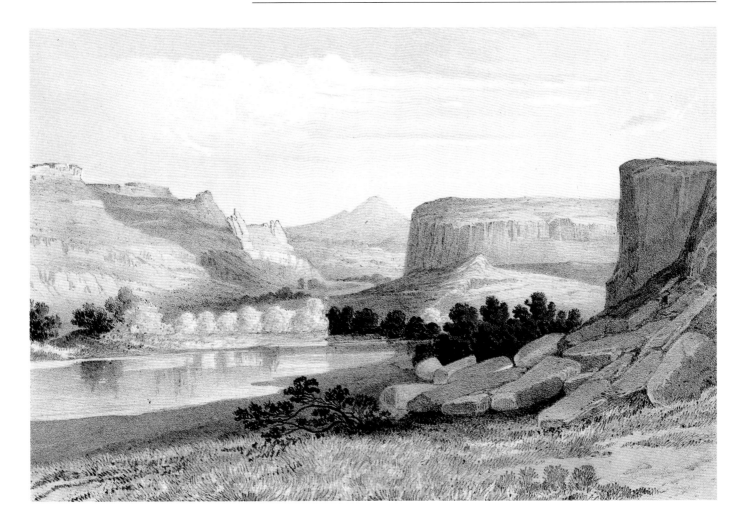

Richard Kern was with Gunnison on his survey
of the thirty-eighth parallel near Sevier Lake
when eight members of the party, including Kern
and Gunnison, were killed by Ute Indians.
Sarony, Major, and Knapp after Richard Kern,
Head of the First Cañon of Grand River,
Below the Mouth of Coo-che-to-pa Creek
Septbr 7 (chromolithograph, 1854), from
Reports of Explorations and Surveys 2,
opp. p. 50.

seventy to one hundred miles of terrain. *Northern Slopes of the Sierra Nevada,* for example, shows Mount Shasta on the horizon fifty miles away. His vista *Franklin Valley* is one of the most Romantic images in the entire work, with the jagged peaks of the Humboldt chain in the foreground and the vast and untouched terrain of the valley below. An Indian reclines on a rock in the left foreground, bow and arrow in hand and dog lying nearby, an unmistakable reference to an allegorical god of nature overseeing his domain. But the expression that the warrior wears is also recognizable: he is either completely lost in a Romantic and introspective daydream, or he is depressed by the change that is overwhelming his country.

The *Pacific Railroad Reports,* finally, include views such as Koppel's *Mission of San Diego, Mission and Plain of San Fernando,* and *Los Angeles* and Stanley's *Dalles, Fort Benton,* and *Fort Vancouver, W.T.,* which suggest some of the idyllic sites that awaited successful completion of the road and, no doubt, helped whet the appetite of an entire generation of Americans for westward expansion.

The most extensively illustrated of the private surveys was Gray's *Southern Pacific Railroad,* which contains thirty-three lithographs by Wrightson and Company of Cincinnati after sketches by San Antonio artist Carl Schuchard, a German immigrant

who had tried his luck in the California goldfields and returned, unsuccessful, to Texas.

Speaking before the Senate on January 6, 1859, Senator James Harlan of Iowa praised the *Pacific Railroad Reports,* pointing out that because "some Senators and members of Congress might not be able to read and comprehend them, they have been illustrated. Every unusual swell of land, every unexpected or unanticipated gorge in the mountains has been displayed in a beautiful picture. Every bird that flies in the air over that immense region, and every beast that travels the plains and the mountains, every fish that swims in its lakes and rivers, every reptile that crawls, every insect that buzzes in the summer breeze, has been displayed in the highest style of art, and in the most brilliant colors."

Any work of such complexity and volume, however, has problems, and the *Pacific Railroad Reports* are no exception. In his report on possible routes along the thirty-fifth and thirty-second parallels, Lt. R. W. Williamson said of Nathaniel Orr's wood engraving of Charles Koppel's sketch *Valley of San Pasqual,* "By a mistake, either of the artist or the engraver, the ocean is too fully represented in the engraving, and appears too near. It is very distant and, according to recollection, is scarcely visible from the hill." Such a comment raises the question of the relationship between the scientific reports

Artist Charles Koppel produced distinctive and soon-to-be characteristic scenes of sthe Southwest while he worked with Williamson's survey. After Koppel, Colorado Desert and Signal Mountain *(chromolithograph, 1853), from* Reports of Explorations and Surveys *5, "Report," foll. p. 40. Courtesy the Center for American History, the University of Texas at Austin.*

(or the scientists) and the artists. Of course, some such mistakes could have been the result of unresolved disagreements among the staff, as might have happened to Major Emory. In his report on the Mexican Boundary Survey, Emory explained, "I . . . do not concur with Mr. Schott in his conclusion on page 96. . . . In the original proof this conclusion was erased, but by some accident was afterwards inserted."

Nor did everyone find the illustrations useful. Congressman John C. Burch of California lamented, "The Government had expended hundreds of thousands of dollars in explorations, and elaborate reports thereof had been made and published in immense volumes, containing beautiful and expensive engravings showing the most picturesque and wonderful scenery in the world . . . yet all this did not demonstrate the practicability of a route, nor show the surveys, elevations, profiles, grades or estimates of the cost of constructing the road over the route finally adopted." Still, the extraordinary compilations of maps, scenic views, scientific illustrations, and data placed before the American public represent the results of one of the greatest reconnaissances of the nineteenth century and had a major influence in constructing the developing image of the West.

Lt. Joseph Christmas Ives added another icon to the list when he published his handsomely illustrated *Report upon the Colorado River of the West,* in 1861. Although Europeans had known of the Grand Canyon of the Colorado ever since Coronado's 1540 expedition into the Southwest, the first pictures of it apparently are Samuel Chamberlain's watercolors, made during the 1850s. Chamberlain was a Mexican War veteran and U.S. Army deserter who had joined John Glanton's gang of scalp hunters in Arizona. While wandering about, probably sometime in 1849, they encountered the "Great Canyon of the Colorado." "Away down, far, far below, we could see a bright silver ribbon, the water of the great river of the West, here imprisoned between walls whose height and vast extent seemed to shut it out forever from the light of day," Chamberlain recalled. "It is the greatest wonder I ever saw."

Chamberlain returned to Boston in about 1855 and was preparing the paintings and recollections of his adventures probably about the time Ives ventured into the canyon

himself. Both Sitgreaves and Whipple had explored portions of the river in 1851 and 1854, but they had not gotten as far as the big canyon. Sent to search for a water route into the Great Basin, Ives and his party arrived at Robinson's Landing at the mouth of the Colorado on November 1, 1857. They unloaded a prefabricated paddlewheel steamer, U.S.S. *Explorer,* assembled it, and, much to the amusement of the nearby Cocopa Indians, steamed up the river.

Because the Mormon War had begun in the meantime, Ives was asked to ascertain quickly the navigability of the Colorado, to see if troops might be sent from Fort Yuma to the Great Salt Lake via the Colorado and Virgin rivers. The war also meant that he was entering potentially hostile territory. He steamed into the southernmost of the Colorado's huge canyons, Black Canyon, on January 8. When *Explorer* struck a submerged rock, he declared that to be the head of navigation and sent half the men back on the steamer. He and two other men surveyed the canyon in a skiff, severely testing his Romantic vocabulary as he saw "Stately facades, august cathedrals, amphitheatres, rotundas, castillated walls, and rows of time-stained ruins, surmounted by every form of tower, minaret, dome, and spire . . . moulded from the cyclopean masses of rock that form the mighty defile. The solitude, the stillness, the subdued light, and the vastness of every surrounding object, produce an expression of awe that ultimately becomes painful." He then led the other half of his force out of the canyon to search for the Mormon Road, which, he noted, was about twenty miles west of the river. His two Hualpai guides took them to the Grand Canyon, which they descended, reaching the floor in April. "Probably nowhere in the world has the action of [water] . . . produced results so surprising both as regards their magnitude and their peculiar character," wrote John Strong Newberry, the expedition's geologist, resulting in "a topographical character more complicated than that of any mountain chain; which has made much of it absolutely impassable to man, or to any animal but the winged bird." Their guides deserted after attempting to leave the canyon by a trail so narrow that many of the men had to crawl along. They finally made their way safely to Fort Defiance.

Egloffstein went west with Frémont in 1853, joining Beckwith's party at Salt Lake City in mid-1854. His panoramic views of the Sierra Nevadas seem particularly characteristic of the country. C. S. Schumann after Egloffstein, Northern Slopes of the Sierra Nevada *(steel engraving by Selmar Siebert, 1861), from* Reports of Explorations and Surveys 11, *fold-out plate. Courtesy the Center for American History, the University of Texas at Austin.*

After Koppel, Mission of San Diego *(chromolithograph, 1853), from* Reports of Explorations and Surveys 5, *"Report," foll. p. 40. Courtesy the Center for American History, the University of Texas at Austin.*

When Charles Koppel's Valley of San Pasqual *(engraving, 1853) was published, Williamson complained that "either . . . the artist or the engraver" had erred because "the ocean is too fully represented . . . and appears too near." From* Reports of Explorations and Surveys 5, *"Report," p. 127. Courtesy the Center for American History, the University of Texas at Austin.*

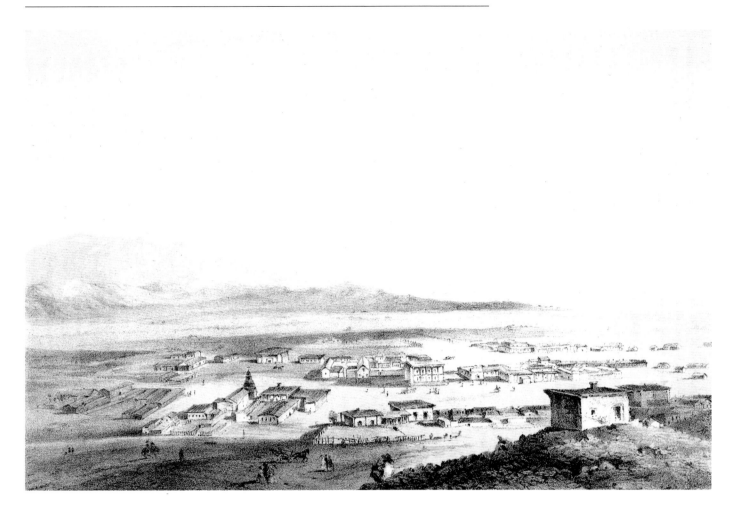

Ives wrote a masterful report, an energetic combination of scientific and Romantic literature. In addition to Egloffstein's new kind of map, which showed physical features in sculptured relief, it contained the dramatic first published pictures of the Colorado and its canyons by John J. Young, after Egloffstein's and Möllhausen's sketches and lithographed by Sarony, Major, and Knapp. One familiar with the fantastic canyon will be surprised by the dark and forbidding character that these German artists ascribed to it. According to historian Wallace Stegner, who likens their image to a "nightmare," Egloffstein's science, as represented in his geological drawings, was either "merely literal or markedly inaccurate." Stegner left the coup de grace to Egloffstein's successor in the canyon, the versatile and talented Capt. Clarence E. Dutton, who reported that "never was a great subject more artistically misrepresented or more charmingly belittled."

Möllhausen was a significant figure in his own right, having initially seen the West as an assistant to Duke Paul of Württemberg. Möllhausen accompanied the duke on two lengthy trips in 1851, one from Saint Louis to the Great Lakes via the Mississippi and Illinois rivers and a second, later that same year, from Saint Louis up the Missouri River and along the Oregon Trail to the Rocky Mountains. Möllhausen almost perished on the Nebraska prairie when their horses gave out and the duke got a ride on a

Koppel produced the first published view of Los Angeles (chromolithograph, 1853). The Catholic church is shown in the middle distance at the left. From Reports of Explorations and Surveys *5, opp. p. 34. Courtesy the Center for American History, the University of Texas at Austin.*

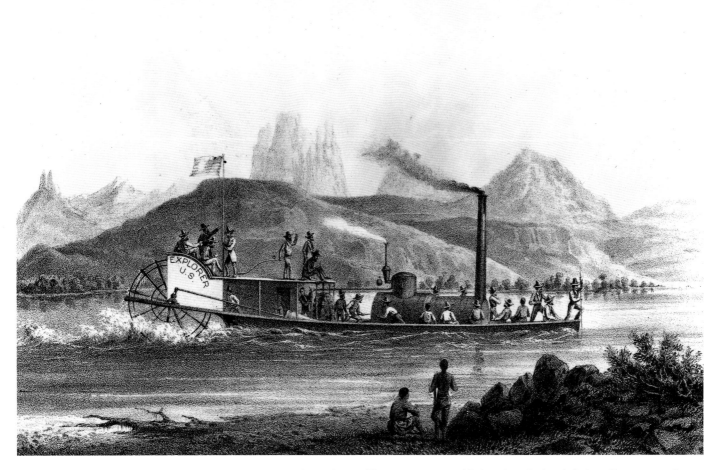

Möllhausen returned to the West in 1857 to accompany Ives on his expedition up the fabled Colorado River of the West. The party started up the river on Explorer *early in 1854. Sarony, Major, and Knapp after J. J. Young after Möllhausen,* Chimney Peak *(lithograph, 1861), from Ives,* Report upon the Colorado River of the West, *frontispiece.*

passing mail coach. Möllhausen remained behind with the duke's collections and gear and was finally rescued by a friendly band of Oto after surviving hungry wolf packs, near-starvation, and an attack by Pawnee.

After a quick trip back to Germany accompanying a shipment of wild animals for the Berlin zoo, during which he met and became engaged to the daughter of Alexander von Humboldt's secretary, Möllhausen returned to the United States in 1853. With Humboldt's recommendation, he got a job as a topographer and draftsman with Whipple's expedition along the thirty-fifth parallel. He returned to Germany as soon as the expedition was over to marry his fiancée and was appointed custodian of the royal residences at Potsdam. He also worked hard on his art and, by late 1855, had rewritten his Whipple expedition diary as a book, which was published in 1858 as *Tagebuch einer Reise vom Mississippi nach den Küsten der Südsee.* It was translated into English that same year and into Dutch the following year.

Möllhausen returned to the United States in 1857 to accompany Ives up the Colorado, then went back to his job in Germany and completed his paintings for the publication there. His account of the Colorado River experience, *Reisen in die Felsengebirge Nord-Amerikas bis zum Hoch-Plateau von Neu-Mexico,* contains several pale chromolitho-

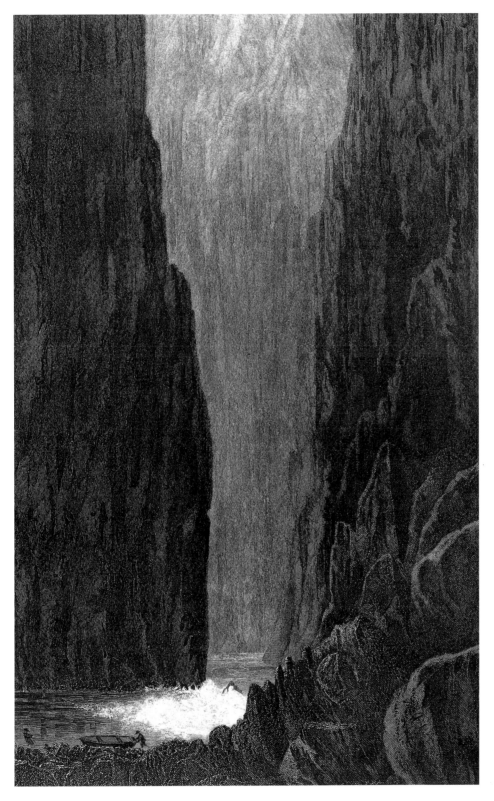

In Black Canyon, the first of the large canyons that the expedition entered, Explorer struck a submerged rock, where Ives declared the head of navigation. Egloffstein after a sketch by Ives, Black Cañon (engraving, 1861), from Ives, Report upon the Colorado River of the West, opp. p. 80.

Möllhausen gives a bird's-eye view of what Ives called "the colossal piles that blocked the end of the vista, and the corresponding depth and gloom of the gaping chasms into which we were plunging" as they approached the Grand Canyon. A. Edelmann after Möllhausen, Schluchten im Hoch-Plateau und Aussicht auf das Colorado-Cañon *(chromolithograph, 1860), from Möllhausen,* Reisen in die Felsengebirge Nord-Amerikas bis zum Hoch-Plateau von Neu-Mexico *2, opp. p. 100.*

graphs of the canyon, one in particular showing various animals in the foreground and a bald eagle perched on a tree with the canyon sprawling in the background (*Schluchten im Hoch-Plateau und Aussicht auf das Colorado-Cañon*). He also provided paintings of Indians that he met along the route, which were reproduced as chromolithographs in both the Ives report and in his own books. Then he undertook a series of novels about the West, which proved to be quite popular. His reputation for walking around Potsdam dressed as a mountain man apparently did not harm the sales of his Indian novels.

While the massive government publications were pouring from the press, an encyclopedic work on the American Indians was under way, also at the expense of the government. Henry Rowe Schoolcraft's work was made possible when he was employed by the Indian Office in 1847. A former Indian agent who first served with Lewis Cass's Exploring Expedition in 1820, Schoolcraft published his *Narrative Journal of Travels through the Northwestern Regions of the United States* in 1821. He assisted Thomas McKenney with gathering biographical information about the Indians whose portraits were included in McKenney's and Hall's *History of the Indian Tribes* before losing his own job when the Whigs took office in 1841. Secretary of War William L. Marcy finally appointed him to a position in the Indian Office in 1847, where his task was to gather materials to illustrate the "history, present condition, & future prospects" of the Indian tribes.

Schoolcraft set out to provide Congress with the "authentic data" it needed about Indians by sending an extensive list of queries, one an ethnological survey 348 questions long, to agents in the field. But he had a much grander plan in mind. His proposed Indian census was simply the first step toward a complete history of North America's native peoples. He received some good advice on the matter from George Gibbs, a thirty-one-year-old Harvard-educated attorney and frustrated adventurer who would later satisfy his wanderlust with an expedition into the Northwest. Gibbs's suggestions are also important because they probably explain the modus operandi for many of the successful authors, artists, and printers who secured funding for the pub-

Some critics thought the untutored Schoolcraft's greatest contribution, aside from the compilation of an enormous amount of material, was the inclusion of pictures of weapons, domestic utensils, and various other kinds of instruments. Ackerman after Eastman, Meda Songs *(chromolithograph, 1851), from Schoolcraft,* Historical and Statistical Information *1, opp. p. 361.*

lication of their works. The "cupidity of the members" of Congress was the "grand secret," Gibbs explained. "The southwestern and western barbarians [in Congress] will not care a d—m for all the results of your labors if they find it only a Shawnee or Sioux dictionary," but they will vote "any amount of public money" to produce an expensive "picture book," which would be theirs for free to possess and give to their valued friends and supporters. Gibbs continued,

> *Make your reports to each Session upon the material & the tangible, and above all things have them full of plates. Congress will print them of course & pay for the engraving without writhing. I should if possible give them a small taste at the commencement of the very next session, just to make their mouths water for more, as you bait round your intended fishing place while you fix your lines. One of the elementary powers at Washington, the government printer, is of course easily propitiated. You need no instruction on the modus.*
>
> *But plates & ground plans take time. Can you not get the regents of the Smithsonian to send with you a good draughtsman. Make an agreement with them to collect objects of curiosity for their museum in consideration for their paying the piper. . . . The West Point men are all good draftsmen & would do it with pleasure to have their names on the plates & receive a copy from the war department. . . .*
>
> *You are to make from this work your real celebrity . . . therefore make it cover as much ground as can be done thoroughly. Your reports to Congress will of course be only the prelude to a larger & more complete work, the Ethnography of America, a work which should be as splendid in its execution as the large works of the Exploring Expedition. . . . These reports to Congress should I think be as full of meat as you can make them, in order that inducement may be given to spin the work out. So long as those devils can count on an illustrated work every session, so long will they make the appropriation. . . . Your great work should be your "final Report"—and for this I should take as much time & demand as many draughtsmen from the office as I could get.*

The 336 full-page illustrations throughout Schoolcraft's six volumes fulfilled George Gibbs's suggestions for expensively illustrated reports. Bowen after Eastman, Cavern in the Pictured Rocks (Lake Superior) *(hand-colored lithograph, 1851), from Schoolcraft,* Historical and Statistical Information *1, opp. p. 170.*

Schoolcraft had always intended for his "Cyclopedia Indianensis" to contain "Plates of ancient ruins, hieroglyphics, portraits &c." and might even have approached George Catlin about using his pictures when the two were both in England in 1842. But Gibbs had outlined in shameless detail a grander vision, and Schoolcraft apparently adopted it as his own.

The person who best fitted Gibbs's description of the West Point man who could draw was Capt. Seth Eastman, an officer and an artist with extensive experience in Indian country. Following his service at West Point, Eastman served at Fort Crawford, near Prairie du Chien, and Fort Snelling and was currently stationed on the Texas frontier. Calculated and persistent lobbying by his wife, Mary, and friends got him furloughed in December 1849 and then assigned to Washington, where he was able to begin work with Schoolcraft on the Indian history. Eastman did not have nearly the repository of materials that Catlin possessed, but he was up to the task. He remained in Washington until 1855, turning out hundreds of drawings and watercolors of tribal ceremonies, landscapes, artifacts, pictographs, tools, costumes, weapons, musical instruments, and maps, often working from memory because he did not have all his sketches and paintings with him.

To insure that his book met the standards needed to guarantee success, Schoolcraft began soliciting bids from government printers in 1850. One suggested that he could obtain 3,000 copies of a one-thousand-page work, 9 ½ by 13 inches, for $6,500, "*much less*" if the contract were awarded immediately. Schoolcraft figured an additional $3,800 for illustrations and binding.

Schoolcraft finally settled on P. S. Duval of Philadelphia and James Ackerman of New York for the relatively new technique of chromolithography. Eastman criticized

Concerned about the increasing numbers of American immigrants, the British government sent Lt. Henry James Warre to Oregon Territory in 1845 to report on the situation. By the time Warre returned, diplomacy had settled the fate of the territory. His picture of Oregon City, The American Village *(hand-colored lithograph, 1848), is included in* Sketches in North America and the Oregon Territory, *but he does not mention the true nature of his trip.*

the chromolithographs throughout production of the first volume, saying that the second volume, issued in the fall of 1851 and containing steel engravings rather than chromolithographs, was superior to the first "in the character of its illustrations." The publisher, Lippincott, Grambo, and Company, was more forthright, telling Schoolcraft that "Capt. Eastman's beautiful drawings suffer" as chromolithographs. While defending his choice of chromolithographs for volume one (without mentioning Gibbs's letter), Schoolcraft suggested that steel or copper engravings be used henceforth because of the lithographer's practice of retaining the stones to be reused. The initial cost of engravings would be more, he explained, but the plates would become the property of the government and subsequently could be reprinted with little additional cost.

Steel engravings had replaced the lithographs by the time volume one was reprinted in 1853, and as usual, some subtle changes are noticeable. The first volume contains a hand-colored lithograph of a spot that Schoolcraft visited on his 1834 trip, *View of Itasca Lake, Source of the Mississippi River,* which Eastman drew after Schoolcraft's sketch. It is a casual scene, with one white man sitting by his tent waiting as the Indian guides, bringing his companions, push their canoes ashore. It appears to be an idyllic and peaceful place; Schoolcraft described it in his text as "wholly sylvan." The reprinted volume, issued in 1853, contains a slightly altered steel engraving of the same scene. The same Anglo is still seated by his tent watching his visitors come ashore, but another white man has been introduced into the scene. He is shown walking purposefully toward the tent, portfolio under his arm, as if he were the commander of the expedition. Perhaps he is intended to be Schoolcraft himself. The hard edge of the engraving may introduce unintended discipline and sharpness into the scene, but when he later reused the print in volume six, the tone of his description also changed. A pleasant

Francis Samuel Marryat, son of the English novelist Capt. Frederick Marryat, visited California on two occasions before suffering an early death in 1855. M. and N. Hanhart after Marryat, San Francisco (1851, hand-colored, tinted lithograph, published by Henry Squire and Company).

excursion into the wilderness was now a "toilsome journey" through a "vast and hostile Indian wilderness."

The works of Eastman appealed on the basis of the strangeness and humanity of the Indians that he pictured, and his wife, a talented writer, took advantage of their popularity to use them in her own books. She wrote *Dahcotah; or, Life and Legends of the Sioux Around Fort Snelling* before they left Minnesota. It included a few of his illustrations, which brought her an invitation to contribute to the *Iris,* a beautifully illustrated annual designed to encourage interest in pictures. Then Lippincott, Grambo, and Company, publisher of *Indian Tribes of the United States,* issued her stories and Eastman's illustrations from the *Iris* in *The Romance of Indian Life, With Other Tales.* Finally, in 1853 and 1854, Lippincott published *The Aboriginal Portfolio* and *Chicora and Other Regions of the Conquerors and the Conquered,* which reprinted plates from *Indian Tribes* for illustrations.

Government support during the years that the lithographic industry was establishing itself in this country was significant. Financial records remain on many of the publications, so it is a relatively easy matter to get an idea of how much the government spent on lithographs and engravings. Duval, for example, charged $1,176.06 to print seventeen views (probably steel engravings, with images of approximately 5 1/2 by

8 ½ inches printed in black) in an edition of 11,530, or $0.006 per print, for Emory's boundary survey report. By comparison, Sarony and Company of New York produced 6,400 copies each of twelve chromolithographs for the same book for a total of $4,608, or $0.06 each. Dougal and Smillie made most of the woodcuts and steel engravings for Emory, which make up the bulk of the 424 illustrations in the report.

It is clear that the price of the prints varied considerably depending on the technical complexity, quality, and number of copies printed. For example, Ackerman produced 3,450 sets of sixty-eight one- and two-color lithographs (image size approximately 4 by 7 inches) for Randolph B. Marcy's *Exploration of the Red River of Louisiana* for $1.30 per set, or an average price of less than $0.02 per lithograph. They included twelve tinted views (printed in two colors) and forty-four natural history plates and two large maps printed in one color. Ackerman reprinted 5,000 sets later that year for $1.25 per set, or $0.018 per lithograph.

The largest illustrated project of the era was the Pacific railroad surveys, which themselves cost about $455,000. The twelve-volume publication (published in thirteen books), however, cost approximately $1,200,000. Historian Robert Taft has estimated that at least 21,000 copies of volumes one through ten, 32,000 copies of volume eleven, and 53,000 copies of volume twelve were published, about 295,000 books in all. A complete set contains approximately 725 separate prints (volumes one and nine are not illustrated) ranging from eyewitness views to portraits of individuals to natural history illustrations of plants, animals, birds, fossils, and fishes, for a total of around 19,560,000 prints, not counting the dozens of maps. Some sample expenditures for the images: Nathaniel Orr received $425 for drawing and engraving fifteen views in wood in 1855 ($28.33 each); in 1857 Thomas Sinclair billed the Senate $1,934.40 for 12,400 chromolithographic copies of six views in 1857 (74,400 prints at $0.026 each); and John

Artist-photographer Solomon Carvalho accompanied Frémont on his 1853 expedition along the thirty-eighth parallel. This photograph, Cheyenne Village on the Big Timber River *(daguerreotype, 1853), is attributed to him.*

Topographic art reached its apex in William H. Holmes, who documented the Grand Canyon for Powell's survey of the Colorado. After Holmes, The Grand Cañon at the Foot of the Toroweap—Looking East *(chromolithograph, 1882), from Dutton,* Tertiary History of the Grand Cañon District. *Courtesy Ron Tyler.*

Cassin was paid $5,320 in 1858 to draw, print, and hand-color 2,000 copies each of thirty-eight plates of birds (76,000 prints at $0.07 each). Isaac Stevens's report on the northern route alone contains seventy views by Stanley, Sohon, and Cooper and more than fifty botany and zoology plates. Even if one estimates the average cost of the prints as low as $0.025 each, the total for illustrations alone would be $489,000, or more than a third of the total cost of the volumes and roughly equivalent to $7,965,810 today. The remaining two thirds would have had to cover maps, typesetting, paper, printing, and binding.

The prints for the first volume of Schoolcraft's *Historical and Statistical Information* cost more on the average because Duval, Ackerman, and Bowen printed only 1,200 copies and, probably, because Schoolcraft's standards were higher for what proved to be a truly handsome book. It contains seventy-six illustrations, including forty-eight chromolithographs, twenty-seven lithographs, and one wood engraving. Extant receipts show that the government paid Bowen $1,896 (for twenty-one lithographs, mostly hand-colored), Ackerman $1,900 (for thirty-one chromos and four black-and-white lithographs), and Duval $1,421 (for seventeen chromos and two lithographs), for a total of $5,217. The price per copy varied from Ackerman's $0.045 to Duval's $0.062 to Bowen's $0.075. The full six volumes contain some 336 full-page illustrations, so many that the publishers ultimately farmed out production of the plates to ten different engravers and two lithographic firms.

Between 1838 (the Wilkes expedition) and 1863 (the John Mullan expedition), the government printing office authorized at least twenty-six separate, illustrated volumes, all, with the exception of the Wilkes expedition, relating solely to the American West and containing more than 1,750 separate images. The government ordered editions ranging from 100 copies (Wilkes) to 53,000 (Stevens), meaning that the American printing industry produced almost 24,500,000 prints of the West for the government in twenty-five years, an unprecedented financial and artistic investment in exploration, expansion, colonization, and incorporation.

Those figures cannot be considered precise, because it is sometimes impossible to know exactly how many copies of a book were actually published. Government publications usually indicate the printing order in the preliminary information at the beginning of each volume; however, in the case of Frémont's second report, for example, the government ordered 10,000 copies, but Baltimore lithographer Edward W. Weber initially delivered only 1,000 sets of lithographs because of some technical problem. Nor do the figures take into account the subsequent publication of government or private editions. The Marcy, Sitgreaves, Cross, and Johnston reports were all reprinted, Emory's 1848 report was reprinted nine times, Wilkes's five-volume narrative was reprinted fifteen times, and Frémont's second report went through twenty-four later editions. Also not counted are other government publications, such as reports on Perry's Japanese trip, Lynch's to the Holy Land, Herndon and Gibbon's to South America, the Naval Observatory reports, the Coast Survey, and a large number of private publications that contained Western illustrations, such as Bartlett's *Personal Narrative,* Piercy's *Route from Liverpool,* and Gray's *Southern Pacific Railroad,* just to mention some of the more outstanding examples.

In addition, the same image was often printed by more than one lithographer or engraver, which meant that two or more different lithographic artists had to draw the illustration on the stone. The pictures for the Senate version of Marcy's *Exploration of the Red River,* for example, are by Ackerman; those in the House version are by Henry Lawrence of New York. Julius Bien of New York printed the lithographs of the Senate version of the Stevens expedition, while Sarony, Major, and Knapp supplied them for the House version. In those and similar instances, at least two different lithographers received a share of the government patronage from one publication.

Although the day of the printmaker by no means ended after the Civil War, it did begin to change, which demonstrated the dramatic and compelling impact of photography. Some explorer-engineers, from the first Frémont expedition onward, had taken camera lucidas or daguerreotype cameras with them. Frémont had been unable to make any daguerreotypes, but William C. Mayhew, on the 1850 Sitgreaves expedition to survey the Creek and Cherokee boundary in Indian Territory, and John Mix Stanley, a member of the Stevens expedition in 1853, were more successful. Mayhew's portraits of the expedition members and of Dr. Samuel Woodhouse survive. Stanley apparently made portraits only of Indians, but they, unfortunately, are not known to exist. One illustration in W. P. Blake's report on the geology of the Great Basin, volume five in *Pacific Railroad Reports,* contains a view of *Placer Mining by the Hydraulic Method, Michigan City* [California] that is acknowledged to have been copied from a daguerreotype. Frémont tried again in 1853 with artist and photographer Solomon N. Carvalho, but the daguerreotypes apparently were destroyed in the fire that later consumed

Frémont's home. One daguerreotype, which may be Carvalho's picture of a Cheyenne village on the Big Timber River, survives in the Mathew Brady Collection in the Library of Congress. Ives had a camera with him on his trip up the Colorado River, and at least one print, *Robinson's Landing, Mouth of Colorado River,* was copied after one of his photographs, but when a wind gust blew the tent and the photographic equipment away, he was not disturbed, noting that it "was of comparatively little importance." He probably would have agreed with Captain Simpson that photographers would not soon replace artists. "A good artist who can sketch readily and accurately, is much to be preferred," Simpson wrote, because "the camera is not adapted to explorations in the field." Alfred E. Mathews, who drew and published many Western prints, reached a similar conclusion:

> The author has frequently been asked why he did not take a Photographic Instrument along, in order to photograph Montana scenery; for it is generally supposed that a photograph of Montana scenery is always perfectly accurate. This, however, is far from being the case. In taking a picture, the lens of the instrument must be adjusted to focus on a certain object or objects; and all others more distant, or nearer, will be more or less indistinct. Another disadvantatge of an instrument is that objects near at hand are magnified, while those farther off are reduced in size. So apparent is this defect in large photographs of persons, that a small picture is now first taken, and afterwards copied and enlarged. Shadows, too, are apt to be deepened and lights intensified. A good artist can, with ordinary care, produce a more accurate and pleasing picture with the pencil or brush.

Subsequent expeditions carried photographers such as William H. Jackson, Timothy O'Sullivan, and John K. Hillers, who were more successful.

A significant exception to this trend was William H. Holmes, a geologist, ethnographer, and artist, who accompanied Ferdinand V. Hayden on his 1872 expedition into the Yellowstone and photographer William H. Jackson into southern Colorado and Mesa Verde in 1875. Holmes joined Maj. John Wesley Powell's staff in 1879 and was with Capt. Clarence Dutton on his 1881 exploration of the Grand Canyon. From an imaginary point above the lip of the canyon, Holmes provided extraordinarily detailed panoramas for Dutton's *Tertiary History of the Grand Cañon District.* Working from an intimate knowledge of geology and a superb aesthetic sense, he produced unique views of the complex terrain that were better than the photographers could make, because his knowledge and pen could depict details that the camera could not see. Julius Bien chromolithographed the illustrations that are, according to historian William H. Goetzmann, "masterpieces of realism and draftsmanship as well as feats of imaginative observation." Wallace Stegner called them "art without falsification," "the highest point to which geological or topographical illustration ever reached in this country."

The influence of the reports and their illustrations is incalculable. Frémont's second report inspired Brigham Young to take the Mormons west and found Salt Lake City. Its popular and detailed map opened up the Oregon Trail. Emory, Abert, Peck, Sitgreaves, Simpson, and others charted the way into the Southwest. The Pacific railroad surveys identified not one but several transcontinental railroad routes, including the first one that was completed in 1869. Northern and southern routes were soon completed along the other main paths that the engineers had charted. And Ives's publication spread

beautiful images of the Colorado River and the Grand Canyon before the public for the first time. These government reports insured that after the bitter and debilitating Civil War, the country had a future to look forward to in the West. The migration began immediately, particularly from the defeated South.

The government publications may be seen as part of the effort not only to document the new territory and its inhabitants but also to establish communications with the distant points, develop a rationale for expansion, and encourage settlement; private endeavors may be viewed as entrepreneurial, scientific, reportorial, or aesthetic, among others. Widespread publication and dissemination of these images had much to do with the acceptance, by the end of the nineteenth century, of the West as an integral part of the country.

The negative aspects of the reports are equally apparent today. The images did not always focus on the scientific or engineering aspects, as was suggested by Gibbs's advice to Schoolcraft. Nor were they representative of the country. "With the exception of the mountain ranges bordering Lake Utah and Salt Lake Valley," photographer Charles R. Savage complained in 1867, "but few objects to interest the photographer can be found thus far. As one progresses westward, the country becomes more and more uninteresting, culminating in the Desert . . . and the tourist in search of landscapes, will find but few combinations that will make good pictures." Taken together, the pictures present an almost completely positive and exciting image of the West—one calculated to encourage adventurers, capitalists, yeomen, and ne'er-do-wells alike, all looking for the main chance. Artists and photographers also neglected many negative aspects of Western expansion. They did call attention to the millions of acres of the West that would be of no agricultural value, but that concern vanished when many of those same areas proved to be rich in minerals. For the most part, however, they ignored the havoc that Western expansion wreaked on Native Americans, Hispanics, and the thousands of immigrants who worked in the mines and on the railroad. That is not to say that artists and photographers were obligated to provide a balanced or objective picture of what existed; it is, rather, an admonition for those who might think that they did. For good or ill, it is now clear that their images played a large and positive role in the development of the West and in America's concept of the West and of itself.

Western exploration also gave a boost to the country's lithographic industry as printers up and down the East Coast received substantial government contracts. European artists and craftsmen were imported to start the industry, and they remained to build its foundation in this country.

David Crockett was a much different person from Daniel Boone, but his popular image, particularly after his death at the Alamo, took on many of Boone's attributes. Artist unknown, Davy Crockett (engraving, 1837), from Davy Crockett's Almanack 1 (no. 3, 1837), cover.

THE DISCOVERY OF WESTERN AMERICANS

*F*or a country like the United States, nurtured on George Washington's Cincinnatus-like character, Jeffersonian democracy seemed the ideal political philosophy and the yeoman the perfect national type. As the nation matured, however, each region of the country developed its own particular character, the best known of which are the New England Yankee and the Southern gentleman. Beginning with the acquisition of Louisiana Territory in 1803, a series of events dramatically thrust the West—and a new type, the Westerner—into the national consciousness.

As Wilkes and Frémont were publishing the findings of their expeditions, complete with small but enticing illustrations of places beyond the imagination of most Easterners, a cadre of artists followed Catlin's and Bodmer's paths westward, eager to produce what one of America's first art historians, Henry Tuckerman, called "correct pictures of what is truly remarkable in our scenery," "tales of frontier and Indian life . . . the hunter and the emigrant." These were the "essentially American" themes that excited interest in the cultural capitals of America and abroad. Charles Deas, George Caleb Bingham, William Ranney, and Alfred F. Tait, among others, quickly propelled the Westerner to the forefront of our national types, ultimately to become what we believed to be the most American of them all.

Through the separately issued engraving, the frontiersman or backwoodsman (best personified in Daniel Boone of Kentucky) made his debut as the forerunner of the Westerner; he reached a new and large audience through illustrations in the increasingly popular newspapers and magazines. Many Americans looked down on the backwoodsman, feeling that he was socially, intellectually, and morally inferior to the nation as a whole. Westerners were often depicted in caricatures of the day as uncouth brutes and uneducated pawns in the game of political power. But as they gained political and economic power, their image improved. James Fenimore Cooper wrote of the heroic Leatherstocking, and the decidedly less genteel exploits of riverman Mike Fink and Tennesseean Davy Crockett came to rival those of Boone. Although the Yankee and the Southern gentleman might decry the Westerner's violence and bad manners,

Ranney pictured Boone as the leader who opened up the frontier to Anglo-Saxon settlement. Alfred Jones after Ranney, Daniel Boone's First View of Kentucky (steel engraving, 1850), American Art-Union Bulletin 38 (May 1850).

they envied him his reputation for independence and competence—the freedom to get up and go and the ability to get the job done.

Charles Deas was the first artist to sense this social and political realignment and personify its ambivalence in a masterful painting of the Western mountain man. Deas's professionally finished work suggests that he was well trained, perhaps in New York. He first went to Wisconsin in 1840. By the time he moved his studio to Saint Louis in 1841, he was also experienced in the ways of the West and the mountain men. He had accompanied several military expeditions, where his humor, flattery, elaborate manners, and continual chatter, in French as well as English, opened all doors to him, even the Indians' tipi, and earned him the nickname "Rocky Mountain."

He completed *Long Jakes (Long Jakes, the Rocky Mountain Man)* in 1844, at about the same time that Frémont's writings made the mountain man and scout Kit Carson a national figure and interest in the West was reaching a peak. Long Jakes is, at first glance, remarkably similar to eyewitness descriptions of Deas himself—"a broad white hat— loose dress, and sundry traps and truck hanging about his saddle." Even though the viewers might have thought of Kit Carson as they looked at the picture, Deas painted no particular mountain man—he personified the Westerner. His attention, and that of his horse, is focused on some event behind him, calling forth the "state of tension" that the

English traveler and author George Ruxton noticed as characteristic of the trapper: "his mind ever present at his call. His eagle eye sweeps round the country, and in an instant detects any foreign appearance." Long Jakes is one of no more than a thousand "venturesome young men" who made their way independently throughout the mountains and became symbolic of the West as civilization beckoned and the sun set on their livelihood. He is a character "from the outer verge of our civilization" observed a critic for the *Broadway Journal*. He is "wild and romantic." Another focused on "the glorious, the free, the untrammeled sense of individual will and independent power" that he saw.

Long Jakes is a brilliant genre painting, which, unlike many other such works, seems to dignify rather than caricature its subject. Deas has captured the character of the trapper in a way that untutored Westerners could appreciate, but he has also elevated him to special status by depicting him as an equestrian, an art historical reference (through the painting's similarity to Jacques-Louis David's well-known *Napoleon Crossing the Alps*) to military heroes and heads of state, who were normally portrayed on horseback. Speaking eloquently of the past, Deas offered the mountain man as the legitimate heir of the Boone-Crockett legacy at a time when the intelligentsia was searching for representative American figures to set the New World apart from the Old.

Deas's portrait of the frontiersman symbolized the Westerner. Jackman after Deas, Long Jakes *(engraving, 1846),* New York Illustrated Magazine of Literature *(1846). Collection of the New-York Historical Society.*

But even a cursory examination raises questions about this quintessential mountain man, his character, significance, place in society, and, of course, Deas's intent in painting him. With further consideration, one notices that Long Jakes also speaks to the future. The mountains at his back suggest that he might be leaving the West and his chosen profession. Settlers were moving in, many of the fur-bearing animals on which his livelihood depended had been trapped out, and fashions in Europe and England had changed. Like Frémont's Carson, he still possesses the "instinct of primitive man" that Ruxton wrote of, but Eastern audiences could detect the remnants of "the advantages of a civilized mind" as well as "traits of former gentleness and refinement in his countenance." Still, Deas does not seem optimistic about his ability to return to civilization and society, as suggested by the looming, symbolic precipice in front of him. The subsequent painting *The Death Struggle* (1845), which shows the trapper, an Indian, and both their horses careening off a cliff into a bottomless abyss, erases any ambiguity as to their fate. As far as Deas was concerned, the day of the trapper and the Indian were past.

The *New York Illustrated Magazine of Literature* promptly engraved both pictures, and almost a decade later Leopold Grozelier issued a larger and handsomer lithograph of the trapper, *Western Life—The Trapper* (1855).

With the trapper established as a genuinely American if disappearing type, other artists took up the theme. Several, such as William M. G. Samuels of San Antonio, copied Deas's painting (probably from one of the prints), but William T. Ranney, Alfred L. Tait, Louis Maurer, and Frances (Fanny) Palmer went farther, each developing a series of paintings and prints based on the trapper's life, real and imagined. Few of their pictures featured the trapper's workaday world, like Alfred Jacob Miller's 1837 watercolors; instead, they focused on dramatic and heroic incidents such as Ranney's *Trapper's Last Shot*, which supposedly represented the well-known trapper Joseph Meek as he turned to fire his last shot at a pursuing Indian. One reviewer called it "a scene in the far West, of peculiar interest." The Western Art-Union of Cincinnati had the painting engraved in 1850. The following year Ranney painted a more peaceful and beautiful scene, but one imbued with the tension that Eastern audiences had come to associate

T. Dwight Booth after Ranney, The Trapper's Last Shot *(steel line engraving, 1850). Published by J. M. Emerson and Company, New York, for distribution by the Western Art-Union in 1850.*

with Western life. *The Scouting Party* shows a group of trappers on a high bluff as they watch the movement of a group of Indians, whose presence on the prairie below is betrayed by the smoke in the distance. The Indians are not yet aware that they are being watched. The American Art-Union purchased the painting and had it engraved for the *Bulletin.*

Although Ranney did not intend his work to be documentary in the sense of Catlin or Miller, he was equipped to give it a patina of realism. As an art student in New York, he had answered the call for volunteers to fight in the Texas Revolution against Mexico in 1836. He had spent almost nine months in the republic's army, serving as paymaster for the First Regiment Volunteers. After the war, according to his widow, he "remained in Texas for some time, making sketches for many of his future pictures. He was so charmed with everything he saw; scenes that he long dreamt of were now before his eyes; the wild enchanting prairies, the splendid horses, nature in all her splendor; his poetic mind was filled with the beautiful." Somewhat surprisingly, the portraits, history paintings, and genre scenes that he submitted to the annual shows for almost a decade upon his return did not show the influence of his Texas trip. Not until the American Art-Union began to exhibit and publish Western paintings by Deas and George Caleb Bingham did he return to his long-forgotten sketches.

Following in the wake of Deas and Ranney, Tait, Maurer, and Palmer moved the trapper even farther into the mythical realm with the assistance of Currier and Ives, one of the most popular and prolific publishing firms of the nineteenth century. Nathaniel Currier had enjoyed considerable success in the lithographic business in New York since 1834, including his publication of the *Lexington* print in 1840 and various prints of the war with Mexico between 1846 and 1848. The name of the firm changed to Currier and Ives when his brother-in-law, James Merritt Ives, joined in

Otto Knirsch after Arthur F. Tait, The Prairie
Hunter: "One Rubbed Out" *(hand-colored
lithograph by Currier, 1852).*

1852. Currier and Ives published more than seven thousand images of life in the United
States during the nineteenth century.

Tait, an Englishman who never went farther west than Chicago, and that on the
occasion of the World's Fair in 1893, painted from research rather than personal obser-
vation. Two of his most popular pictures were *The Prairie Hunter: "One Rubbed Out"*
(1852) and *A Check: "Keep Your Distance"* (1853), both published by Currier and both
probably inspired by Ranney's paintings. The similarity in the dress of the trappers in
Ranney's *Trapper's Last Shot* and Tait's *Prairie Hunter* suggests that Tait might have
modeled his picture after Ranney's, which was exhibited at the American Art-Union
and published in the *Transactions of the Western Art-Union for the Year 1850,* where Tait
would have had easy access to it. A likely source for *A Check* is Ranney's *Retreat,* which
Tait would have seen at the 1851 National Academy of Design spring exhibition. Per-
haps Tait even took the advice of a reviewer who suggested that Ranney's painting
would have profited from "a more spacious view of the Prairie." Tait lowered the hori-
zon line in *A Check,* as he had in *The Prairie Hunter,* and included only one central
figure instead of Ranney's grouping of three figures with their horses. The veteran
Plains traveler Randolph B. Marcy liked *A Check* so much that he reproduced it in *The
Prairie Traveler* and endorsed it as an effective way of dealing with an Indian attack. "If
the Indians follow and press" a man "too closely," Marcy wrote, "he should halt, turn
around, and point his gun at the foremost, which will often have the effect of turning
them back, but he should never draw trigger unless he finds that his life depends upon
the shot; for, as soon as his shot is delivered, his sole dependence, unless he have time
to reload, must be upon the speed of his horse."

Tait continued to play on the theme of trappers in two more Currier prints, *The
Pursuit* (1856) and *The Last War-Whoop* (1856), depicting an important development in

After Wimar, An Emigrant Train Attacked by Hostile Indians on the Prairie, *from* Ballou's Pictorial *Aug. 15, 1857, pp. 104–5.*

frontier conflict, the effective arrival of the pistol. Perhaps he got the ideas for the paintings from Rufus Sage's exciting description in *Scenes in the Rocky Mountains* of a trapper escaping from a band of Blackfeet. In *The Pursuit,* Tait depicted four mounted Indians pursuing a trapper until "they came within shooting distance." The trapper turned and, "with his double-barreled rifle, picked off two of their number." Thinking that he had to reload, the Indians renewed the pursuit. As soon as they were within range of a pistol, the trapper "again halted, and . . . brought the third [Indian] to the ground." As he drew a second pistol from his belt, the last "terrified savage . . . fled with the utmost precipitancy." *The Last War-Whoop* shows a trapper with pistol in hand as he approaches a downed Indian who is giving his last war-whoop. The continuing popularity of the trapper in the West led Louis Maurer, one of Currier and Ives's most talented artists, to design a slightly different version of that print. In *The Last Shot* (1858), the trapper is on the ground, and the Indian approaches him, tomahawk in hand, only to be surprised as the trapper raises his pistol and fires the last shot.

By the time Fanny Palmer produced *The Trappers Camp-Fire: A Friendly Visitor* (1866) for Currier and Ives, the life of the trapper had been thoroughly idealized and viewers no longer demanded the verisimilitude that characterized Deas's and Ranney's

work—or even Tait's. Palmer was a well-schooled Englishwoman who came to the United States with her "gentleman" husband in the 1840s. When she went to work for Currier is not known, but she drew a series of views of New York in 1849 and went on to produce some of Currier and Ives's most popular prints. Like Tait, she never saw the West.

The second major Western type to achieve notoriety, primarily through the work of George Caleb Bingham of Missouri, was the riverman. In *Jolly Flat Boat Men*, Bingham depicted that "singular aquatic race" that Washington Irving had observed during his Western trip, men who "had grown up from the navigation of the rivers" and "possessed habits, manners, and almost a language, peculiarly their own, and strongly technical." These eight young and confident fellows pass the time as they float down the river on the cabin roof of their flatboat. One leans in to play his fiddle, while another keeps time with a skillet, and a third dances a jig. The pyramidal arrangement heightens their sense of community, which is complemented by the confident young man at the right who looks out almost challengingly at the viewer.

Contemporaries could easily spot literary prototypes for *Jolly Flat Boat Men* in the work of writers like Timothy Flint, editor of the *Western Monthly Review*. Flint, a Harvard-educated missionary who traveled up and down the Ohio for years before writing one of the best books about the region, recalled in 1828 how alluring the life of the boatman looked to the farm families along the bank:

> *At this time, there is no visible danger, or call for labor. The boat takes care of itself. . . . One of the hands scrapes a violin, and the others dance. Greetings, or rude defiances, or trials of wit, or proffers of love to the girls on the shore, or saucy messages, are scattered between them and the spectators along the banks. The boat glides on, until it disappears behind the point of wood. At this moment, perhaps, the bugle, with which all the boats are provided, strikes up its note in the distance over the water. These scenes, and these notes, echoing from the bluffs of the beautiful Ohio, have a charm for the imagination, which although heard a thousand times repeated, at all hours and in all positions, present the image of a tempting and charming youthful existence, that naturally inspires a wish to be a boatman.*

Another inspiration for Bingham might have been Mike Fink, the king of the riverboatmen. Born probably near Fort Pitt, Pennsylvania, about 1770, Mike was a hunter and scout before he joined the ranks of adventurers who found the river irresistible; there he became a legend during his own lifetime. He gained fame for his marksmanship and generally rowdy and irrepressible character, but most of all for his prowess on the river. It would have been almost impossible for Bingham not to have known of him.

The central character in *Jolly Flat Boat Men* bears a remarkable resemblance to a contemporary description of Mike by Morgan Neville, who had known him for years. Mike, said Neville,

> *presented a figure that Salvator [Rosa] would have chosen from a million as a model for his wild and gloomy pencil. His stature was upwards of six feet, his proportions perfectly symmetrical, and exhibiting the evidence of Herculean powers. To a stranger, he would have seemed a complete mulatto. Long exposure to the sun and weather on*

the lower Ohio and Mississippi had changed his skin; and, but for the fine European cast of his countenance, he might have passed for the principal warrior of some powerful tribe. Although at least fifty years of age, his hair was as black as the wing of the raven. Next to his skin he wore a red flannel shirt, covered by a blue capot, ornamented with white fringe.

Neville concluded that "the spirit of the Boatmen" died with Mike, but not before they had become, in the words of another firsthand observer, "the representatives of the whole race of pioneers," an identity that Bingham crystallized with his painting.

Like *Long Jakes, Jolly Flat Boat Men* was shown at the American Art-Union, which purchased it in 1846 and contracted with Thomas Doney, an accomplished mezzotint artist, to make two plates from it, a small etching to be published in the Art-Union's *Transactions* along with an announcement of the publication of the larger one, scheduled for 1847 but not finished until February 1848. A mezzotint is similar to an engraving in that it is an intaglio process, but gradations in tone are achieved by pitting the copper plate with an assortment of roulettes or spurlike tools, which, when rolled across the surface of the plate, produce rows of dotted wells and burrs, which can then be inked and printed. By the nineteenth century, printmakers had begun to use steel, a more durable metal, meaning that many more impressions could be made from a single plate. Doney printed an edition of 10,000 of the larger version to accommodate the 9,666 members of the Art-Union.

Bingham had, finally, done for the riverman what Deas did for the trapper—he brought dignity to a downtrodden and typically Western character. Not everyone appreciated his accomplishment, of course. A critic for the New York *Literary World* denounced the Art-Union's acquisition of the painting and its ensuing publication as a "vulgar subject, vulgarly treated," but a writer for the *Daily Missouri Republican* of Saint Louis was more prescient, pointing out that "Mr. Bingham has struck out for himself an entire new field of historic painting, if we may so term it. He has taken our western rivers, our boats and boatmen, and the banks of the streams, for his subjects. The field is as interesting as it is novel." Several years later the Art-Union reiterated its judgment by pointing to Bingham's "thoroughly American" paintings and their "striking nationality of character." Bingham's elevation of the riverman to respect at a time when he, like the trapper, was facing extinction because of competition from the steamboat gives the pictures of rivermen the same resonance that Deas incorporated into *Long Jakes.*

And, like Deas, Bingham soon found his classic composition being copied by other artists, thus spreading the image beyond even the Art-Union's broad distribution. Flint used it with an excerpt from his manuscript that appeared in *Howitt's Journal of Literature and Popular Progress* in 1847. Two years later, the *Pictorial National Library* of Boston also copied it. Several similar compositions subsequently appeared, including Henry Lewis's *Scene near Bayou Sara Louisiana* in *Das illustrirte Mississippithal* and Currier and Ives's *Bound Down the River* (1870, lithograph). The steel plate for *Jolly Flat Boat Men* was finally sold at auction and a new edition pulled from it by a commercial publisher in 1860.

A third major Western type was not new but was presented in a different way as

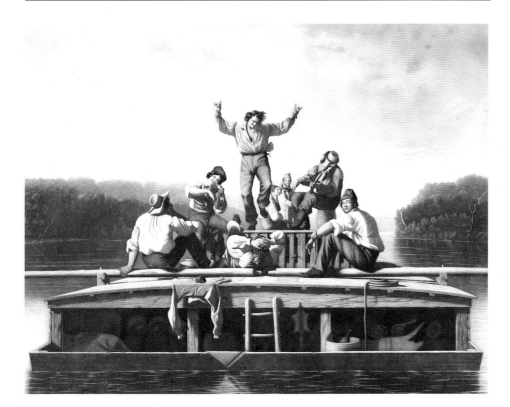

Thomas Doney after Bingham, Jolly Flat Boat Men *(mezzotint, 1846). Published for the American Art-Union.*

Woodcut of Jolly Flat Boat Men *in* Howitt's Journal of Literature and Popular Progress *(London) Sept. 4, 1847, p. 145.*

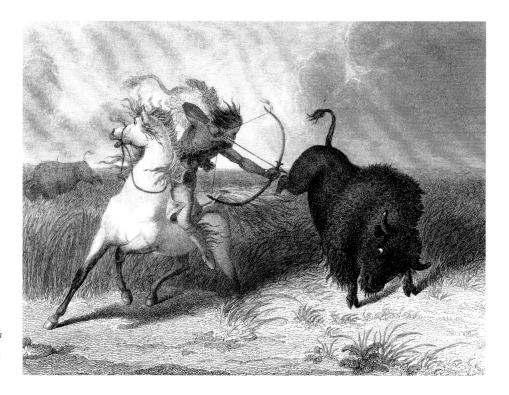

Cushman after Darley, Hunting Buffalo, *from* Graham's American Monthly 25 (Sept. 1844), *opp. p. 97.*

genre painting increased in popularity. Over the decades Indians had been depicted in portraits, imaginary scenes, and formal settings, such as Lewis's picture of the signing of the treaty at Prairie du Chien. Now, as artists such as Catlin, Stanley, Eastman, and Carl Wimar became familiar with the native cultures, they designed genre scenes that at least gave viewers the impression that they were learning more about the Indian. One critic saw an Eastman "home scene," for example, as "quite unlike the vast mass of Indian pictures it has been our bad luck to see—for it is true. There is no attitudiniz-ing—no position of figures in such a group that you can swear the artist's hands, and not their own free will, put them there." Similarly, other artists painted scenes of every-day life in camp, games, hunts, dances and ceremonies, and councils, among others. These same artists also, at times, pictured Indians as hostile to Western expansion and as a doomed race.

Catlin was the first of these artists to become familiar with the Plains Indians and to disseminate his pictures to a large audience. His work might be seen as more documentary in nature than that of those who followed, for he attempted to capture on canvas and in words the history of the tribes that he encountered. Stanley and Eastman attempted something similar, except that they were better artists, and the best of their finished works fall clearly in the realm of genre painting. That is, they deal more with types and common activities than with particular individuals and factual events.

Although Indian hostility was an old theme, Carl Wimar was the first to depict the Indian attack on a covered wagon train. A German immigrant, Wimar grew to man-hood in Saint Louis. From there, he traveled up the Missouri River and experienced a

bit of the West, but he witnessed no such attacks. He returned to Düsseldorf to study art in 1852, and *Attack on an Emigrant Train* (1856) was the last major painting he produced during his four-year sojourn. It is based on a fictional scene that he read in the French author Gabriel Ferry's story of a caravan of gold seekers who are attacked by Indians on the prairie. It could have been patterned after John Russell Bartlett's *Apache Indians Attacking the Train and Party* of the Boundary Survey, which was published in 1854, but there is no indication that Wimar saw that work. Without any realistic props to work from in Düsseldorf, Wimar created an aesthetic construction that contains some problems if one is to take it as anything more. In addition to the lack of documentation for such an attack on civilians, the wagon is more a canvas-covered European cart than the famous Conestoga, the Indians are clothed in brightly colored cloth rather than in buckskin, and the tall grass is uncharacteristic of the prairie.

But the dramatic composition apparently embodied a larger truth to those who saw it—two races on a collision course, representative immigrants confronting "the Indian." The wagon train is shown lumbering across the prairie from left to right. The main body of Indians comes from the right, on a direct collision course with the train, while two other warriors rise up out of the tall prairie grass in an attempt to stop the lead wagon. Wimar published the picture in *Ballou's Pictorial* shortly after he returned to the United States, and it quickly gained notoriety and influenced other artists. Leopold Grozelier lithographed it as *On the Prairie* in 1860; Felix O. C. Darley, one of the most popular illustrators in America, adapted it for his own *Emigrants Attacked by Indians* that same year; and Thomas Hill and Emanuel Leutze painted similar compositions a few years later. The "attack on the Deadwood Stage Coach" was a permanent fixture in William F. "Buffalo Bill" Cody's Wild West show when he inaugurated it in 1883. One can argue that later artists, such as Frederic Remington and Charles M. Russell, and even moviemaker John Ford, owe their famous "attack on the wagon train" pictures to Wimar's imaginary composition. Governor Hamilton R. Gamble of Missouri purchased the painting for his collection soon after Wimar returned to the United States.

The discovery of gold in California in 1848 provided artists with an entirely new Western character—the miner, or the forty-niner. The forty-niner was initially explored more in the printed media than in formal paintings of the sort that Deas and Bingham produced, because of the hurly-burly of the gold rush itself and the consequent mushrooming of communities in California. Hundreds of thousands of immigrants rushed to the goldfields, bringing California into the Union in 1850, and images of the "golden state" soon became familiar across the country. But it would be decades before artists could contemplate what had happened there from the same kind of perspective that Deas and Bingham had enjoyed of the Old West.

Currier was one of the first to enter the market with a series of gold rush caricatures. *The Way They Raise a California Outfit* (1849, lithograph) shows a man in torn and ragged clothes attempting to sell two scrawny, dead chickens to raise enough money for the "Overland Route to Kaleforny." *The Way They Go to California* (1849, lithograph) ridicules the hurry with which many departed, depicting a crowded dock from which men with pickaxes and shovels fall and dive into the water hoping to reach a ship that is sailing out of the harbor. Overhead, a futuristic airship is crowded with

Currier after unknown artist, The Independent Gold Hunter on His Way to California *(hand-colored lithograph, 1850).*

passengers, a man straddles a rocket, and another parachutes from the airship. *The Way They Cross "The Isthmus"* (1849, lithograph) and *The Way They Wait for "The Steamer" at Panama* (1849, lithograph) suggest other hazards of the journey as well as the intemperance of the travelers, while *The Way They Come from California* (1849, lithograph) depicts the hope of ultimate reward, as a long line of men, each holding a sack of gold, lament their inability to board a crowded ship that has just departed. At the same time, they are worried that it will sink under the weight of all the gold that it carries. Several lithographers, Currier included, also caricatured *The Independent Gold Hunter on His Way to California* (c. 1850). Author-artist Frank Marryat joined in the fun with a portrayal of the people of San Francisco, from the miners and merchants to the dandies and their ladies, trying to cross the street in *The Winter of 1849,* when nine inches of rain fell on San Francisco during one November day. The streets, said Marryat, became "unpassable" even for mules and the mud "unfathomable."

A correspondent for the Washington, D.C., *Daily National Intelligencer* foresaw the day when the California gold rush would be treated in a more dignified manner by artists and writers alike. In an article entitled "Independent Way to California," he recommended that the immigrant "should take a blank book with him and keep a journal. This, if well kept, might sell for enough to pay his expenses; at any rate, it would be perused with satisfaction by his children and grandchildren: the future historians and the antiquaries will look for these journals and treasure them up with great care." It was not long before artists such as Augusto Ferran, José Baturone, and Charles Nahl were able to portray the miner in a more compassionate and genteel manner, a genuine if short-lived Western type. He recurred in various guises throughout the West as gold, silver, and other precious metals were discovered in Nevada, Idaho, Montana, Colorado, Dakota Territory, and Arizona.

If the forty-niner was the first type that the overland migration inspired, the pioneer, the settler, and the "heathen chinee" were not far behind, for the newly found Western mineral wealth stimulated the second great continental migration of the pre–Civil War era. Cincinnati artist James Henry Beard, who dealt humorously but seriously with the subject of immigration in his *North Carolina Emigrants* (1845) and *Westward Ho!* (c. 1850), offered an antidote to the largely positive accounts of the westward movement. George Caleb Bingham gave pride, if not dignity, to a family of squatters in Missouri (*The Squatters,* 1850). But the vast overland migration inspired the popular printmakers as well. Currier and Ives published Frances Palmer's *Rocky Mountains—Emigrants Crossing the Plains* (1856, hand-colored lithograph) and *Across the Continent: "Westward the Course of Empire Takes Its Way"* (1868, hand-colored lithograph), which seem to embrace Manifest Destiny completely, albeit in a mythic manner, as Indians recede before the onslaught of civilization as represented by settlers, schools, and the railroad. Following up on the popularity of such images, Currier and Ives also published the hand-colored lithographs *The Great West* (1870), *Through to the Pacific* (1870), and *The Route to California: Truckee River Sierra-Nevada* (1871) by other shop artists.

Life in the new West was the subject of several Currier and Ives prints, such as two hand-colored lithographs by Palmer, *The Pioneer's Home: On the Western Frontier* (1867) and *The Pioneer Cabin of the Yo-semite Valley* (n.d.). Alfred E. Mathews mixed land- and cityscapes in his *Pencil Sketches of Colorado* (1866), *Pencil Sketches of Montana* (1868),

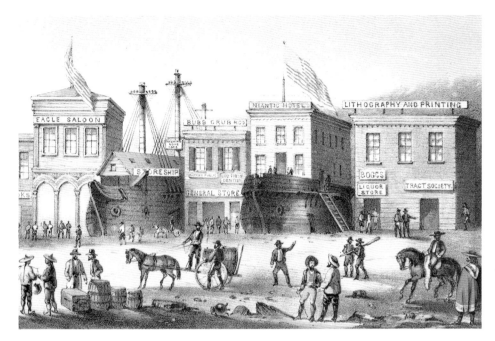

San Francisco expanded at such a rapid pace that some of the old, beached ships, which had been used as storehouses, were cut off from the bay by landfills. J. Brandard after Marryat, High and Dry, *in Marryat,* Mountains and Molehills, *opp. p. 37.*

James Merritt Ives and Frances F. Palmer, Across the Continent: "Westward the Course of Empire Takes Its Way" *(lithograph, 1868). Published by Currier and Ives.*

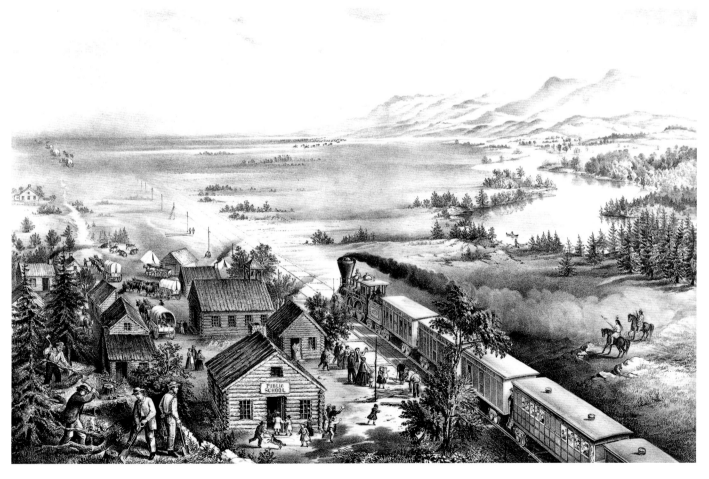

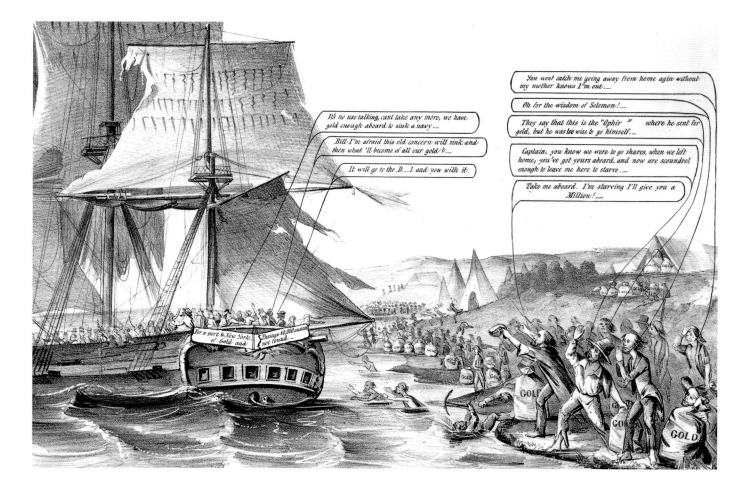

Nathaniel Currier, The Way They Come from California *(lithograph, 1849).*

and *Gems of Rocky Mountain Scenery* (1869), and a generation of artists produced elegant county and state atlases as well as thousands of city views. Chinese immigrants, who came to work on the transcontinental railroad and stayed to establish Chinatowns in cities throughout the West, attracted the attention of reporter-artists such as Joseph H. Becker as well as satirical artists like Frank Marryat and Charles M. Russell.

One aspect of Western life that received special attention was politics. George Caleb Bingham, more than any other artist, treated the workings of American democracy in the 1850s, shortly after the two-party system had matured and as talking about politics had become, in the words of that observant French traveler Alexis de Tocqueville, "the only pleasure" Americans knew. In a series of pictures that are clearly recognizable as Missourian, or Western, in setting but just as clearly intended to be national in meaning and significance, Bingham introduced two more Western types, at least one of which soon became an accepted national type as well: the fiercely independent citizen, or the sovereign, who could sell his vote to the highest bidder or cast it against the moneyed interest with equal freedom, feeling, regardless of the case, that he had acted in his own best interests. The second type is the naive but earnest young politician who appears in several of Bingham's compositions, and although less talked about, he too seems to be an American perennial. Bingham included these characters in a series of

complex prints: *Canvassing for a Vote* (tinted lithograph, 1852–53), *The County Election* (mezzotint engraving, 1854), and *Stump Speaking* (aquatint, mezzotint, engraving, 1856). Of his most famous picture, *The County Election,* Bingham wrote that it should be "as national as possible—applicable alike to every Section of the Union, and illustrative of the manners of a free people and free institutions." The engraver made one minor change to further that goal. In the painting the title of the newspaper that the fellow at the right reads is the *Missouri Republican;* in the engraving it is the Washington, D.C., *National Intelligencer.*

It is apparent in such a cursory survey that many significant segments of the population have been left out in the documentation of Western types: women, African Americans, and Mexican Americans, to mention a few. All of these groups are marginally included in the work of two later artists, Frederic Remington and Charles M. Russell, but both are better known for depicting the Western character that became dominant as the most American of all and one that may be seen as an almost linear descendant of the Daniel Boone image and Deas's trapper—the American cowboy.

Remington and Russell were relative late-comers to the West and, interestingly enough, did not offer the cowboy as a genuine American character until some time after the search for national types had ended. The *Cosmopolitan Art Journal* even suggested in 1860 that "Genre painters, in this country, are an impossibility, if we consider exposition of *stereotyped* local life and manners as necessary material for this class of artists. As a people the Americans have not lived long enough in one spot to gain strongly local as well as national peculiarities. We are made up of everybody from everywhere." But, the vaqueros whom Ranney had seen in Texas in the mid-1830s, and whom the Republic of Texas had featured on its two-dollar bill in 1841, and the Southern cowherder of South Carolina and Florida achieved another identity soon after the

W. A. Rogers redrew Remington's sketch of Wyoming cowboys, and editor Charles Parsons renamed it Arizona Cow-boys: Roused by a Scout *(wood engraving, 1882) for inclusion in* Harper's Weekly *Feb. 25, 1882.*

Remington, Cowboys Coming to Town for Christmas *(wood engraving, 1889),* Harper's Weekly *Dec. 21, 1889.*

Civil War—they became trail hands who herded the millions of head of cattle up the various trails from Texas to Kansas and beyond. They were known by the derogatory name "cowboys," a term that had been applied to Tory guerrillas in New York State during the American Revolution and to a group of "rough men with shaggy hair and wild, staring eyes" in the Texas Army of 1842. Even as late as 1881 President Chester A. Arthur applied the name to a group of "armed desperadoes" in Arizona.

Like the trapper and the riverman, the cowboy of the post–Civil War era was, despite his often bad reputation, an authentic and distinctive member of the working class. Writers for *Harper's Weekly* and *Leslie's Illustrated* characterized him as "a constant source of peril to the settler and tradesman," a man with "no fear," who "respects no law." But with the publicity that tracked the cattle drives to Abilene, Dodge City, and other railheads, his image soon began to change. "This kind of life seems to have an inexpressible charm for the young men," observed a San Antonio author in 1878. "It is an exciting scene to see them in full chase, with their lariats whirling over their heads, their mustangs as much excited by the race as themselves." Theodore Roosevelt, who himself owned a ranch in the Dakota Badlands, told a *New York Tribune* reporter, "I have taken part with them in roundups, have eaten, slept, hunted and herded cattle with them, and have never had any difficulty. . . . Cowboys are a much misrepresented set of people." The cowboy's redemption was complete, the stereotype in place, by 1879 when the *Victoria (Texas) Advocate* noted,

The Gravure Etching Company after Remington, A Dash for the Timber *(photoengraving, 1890).*

There is perhaps no class of civilized beings whose characteristics are more marked than the Texas cow boy. Accustomed to the saddle from infancy, he grows up familiar with his native prairies, and a love for them develops with his manhood, which appears to the stranger an infatuation. What the broad ocean is to the mariner, the broad Texas prairie is to the cow boy. It is the scene of his excitements, his discoveries, and adventures. It is his couch at night, with the star-gemed vault of heaven his covering. In rain or shine, in cold or heat, he is at home among his herds, and laughs at all freaks of the elements. Brave and strong, and true, he is generous, kind and just. Quick to resent a wrong and ever ready to defend his rights, warm in his friendship, but desperate in his chastisement of an enemy.

The Victoria editor may have been able to assess the cowboy's character, but he could not publicize it like two artists who headed west shortly after he wrote those lines: Charles M. Russell arrived in Montana in the summer of 1880, just before his sixteenth birthday, and Frederic Remington followed him west in August 1881, on vacation from his clerking job in Albany, New York.

Although Russell's family had encouraged him as an artist, they probably endorsed the Montana trip in the hope that he would get over this infatuation and return to Saint Louis to complete his education and go into the family business. It was not to be. Russell found what he was looking for in Montana. He took up with an old mountain

After Russell, Bronco Ponies and Their Uses— How They Are Trained and Broken *(line block), from* Leslie's Weekly *May 18, 1889, p. 265.*

After Russell, How the Steer Was Tossed Clear Off the Ground *(line block), from* McClure's Magazine *35 (July 1910), p. 305.*

man and trapper named Jake Hoover, who supplied meat to the local ranches, and imbibed the history and lore of the West from him. Russell soon got a job as a night wrangler and remained in Montana, not only becoming the "Cowboy Artist" but also, as the *Los Angeles Record* later observed, "the real Bohemian."

The nineteen-year-old Remington, like so many other Western visitors, hoped to get rich fast by investing in a ranch or mine. He soon realized he did not have the necessary capital and made a sketch of some cowboys on a piece of wrapping paper, instead, and sent it to *Harper's Weekly.* It was a long shot, for *Harper's,* with a circulation of around 300,000 copies per week, was one of the most influential journals in the country: President U. S. Grant credited it with his election, and Tammany boss William M. Tweed held it responsible for his downfall. Fortunately art director Charles Parsons was intrigued by the Wyoming postmark and the informality of the submission and turned the drawing over to W. A. Rogers, an experienced Western illustrator, to be redrawn for publication as *Arizona Cow-boys: Roused by a Scout,* to accompany an article on cowboys of the Southwest.

With the West now in his every thought, Remington came into his inheritance the following fall and headed to Kansas to try his hand first at sheep ranching and then saloon-keeping. Failures at both, he changed careers again, moving to Brooklyn in 1885 so he could enroll at the Art Students League in New York the following year. He had attended Yale until his father's death and now felt the need for more training if he were to pursue art as a living. The decision paid off. That summer *Harper's* sent him to Arizona to report on the army's search for the Apache chief Geronimo.

Remington fraternized with Generals Nelson Miles and George Forsyth and turned young Lt. Powhatan Clarke into a hero to make more exciting reading for the *Harper's* audience. In the tradition of European military art, he would later characterize the military man as a distinct type in dozens of genre paintings and prints, from the mundane to the heroic, but the public never was as enthusiastic about the army as he was.

In the meantime, he had stumbled onto his true subject with his clumsy sketches of the "Arizona Cow-boys." He followed that in 1887 with a depiction of cowboys at play and accepted the assignment to draw eighty-three illustrations for Theodore Roosevelt's *Ranch Life and the Hunting-Trail.* The following year he wrote and illustrated an article for *Century* on American horses and had four of his illustrations, including *Branding Cattle (An Incident of Ranch Life),* published in John Muir's *Picturesque California* (1888). Other assignments, continuing work with *Century* and *Harper's,* and individually issued prints of cowboys like *Antelope Hunting* (1889) and *A Dash for the Timber* (1890) made it clear that his career had taken off. By the time Remington produced a series of bucking-horse prints in 1894 and 1895, Charles A. Siringo had written his immensely popular *A Texas Cow Boy* (1885), Buffalo Bill Cody had organized his Wild West show, and the cowboy had become a widely accepted American type, a genuine folk hero to be admired and imitated by young boys throughout the world.

Remington was not the only artist portraying the cowboy. At least five artists, including A. R. Waud, William de la Montagne Carey, Paul Frenzeny and Jules Tavernier, W. J. Palmer, and L. W. MacDonald, had published cowboy prints in *Harper's* by the time he submitted his first one. By the 1890s, when it was apparent that Remington had a large following, the young Charles M. Russell of Montana seriously threatened

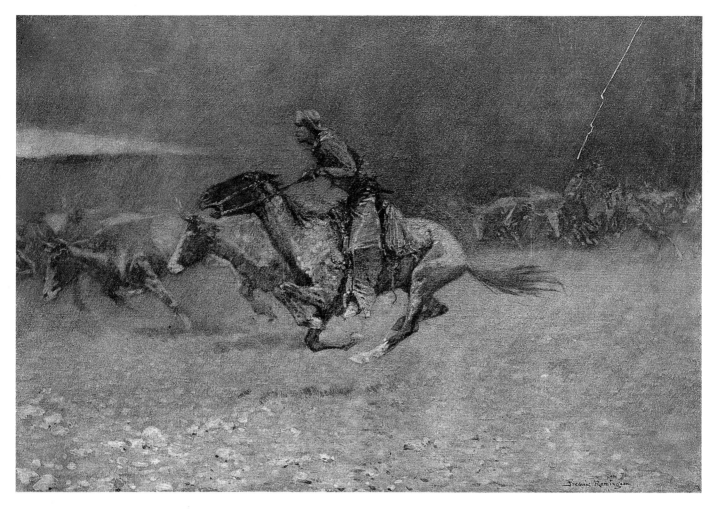

Remington, Stampeded by Lightning
(color lithography), from Collier's Weekly *46
(Feb. 18, 1911), p. 8.*

*By the turn of the century, the cowboy was an
established figure in American folklore. From*
Cowboy Life *(Portland, Maine: Chisholm
Bros., c. 1889).*

Remington, His First Lesson *(color lithography), from* Collier's Weekly *31 (Sept. 26, 1903), pp. 18–19.*

his prominence as the best Western illustrator. Russell published his first illustration, *Caught in the Act,* in *Harper's* in May 1888. It depicted Indians as victims who, because the buffalo herds had been slaughtered, were forced to steal the ranchers' cattle. In May 1889, Russell's *Ranch Life in the North-West* appeared in *Leslie's Weekly.* Like Remington's first work, it was redrawn by a professional artist, J. H. Smith, but it showed energy and a thorough acquaintance with the cowboy and Western life. Russell quickly followed with *Studies of Western Life* (1890). When Russell's new wife, Nancy, took over the management of his business affairs, his fortunes improved. In 1903 he signed a contract with Brown and Bigelow Company in Saint Paul to supply paintings for calendars and for color reproductions; they were so popular that Nancy was able to renegotiate the contract a few years later.

No less an authority than author Emerson Hough clearly preferred Russell's cowboys to Remington's. In an article entitled "Wild West Faking," which appeared in *Collier's,* the same magazine that had been publishing color reproductions of Remington's paintings for five years, Hough charged that the "Brooklyn-style" Western art and literature lacked the authenticity of Russell, "who can draw a cow-puncher swimming naked in a lake, that any Western man can recognize at a glance."

But Remington continued to be the more popular Western illustrator of the day, perhaps because he was closer to the editors and publications than Russell was in far-away Montana, perhaps because his theme was larger than the cowboy. Remington was, in fact, searching for a more inclusive type than the cowboy, and he found it in 1900 with the publication of an anthology of stories. "Men with the bark on" was a phrase that he had used several times over the past few years. "To morrow I start for 'my people,'" he wrote his friend Poultney Bigelow in 1893. "I go to the simple men—men with the bark on—the big mountains—the great deserts & the scrawney ponies." "Bark" was what trappers called hair, so "men with the bark on" were the unscalped ones, the brave ones, the survivors—men he admired.

Just as the cowboy was a character firmly rooted in the Western tradition of Daniel Boone and the trapper, Remington's brave men came from the Old West, which Remington knew no longer existed but which, nevertheless, provided personal inspiration. Like Deas's trapper, the Old West had ended at a pivotal moment in our history when great change was occurring, and Remington had witnessed much of that change himself. "I knew the railroad was coming," he said of his first visit west. "I saw men already swarming into the land. I knew the derby hat, the smoking chimneys, the cord-binder, and the thirty day note were upon us in a restless surge. I knew the wild riders and the vacant land were about to vanish forever." By 1900 it was an accomplished fact. "Shall never come west again," he wrote his wife from Santa Fe that year. "It is all brick buildings—derby hats and blue overhauls—it spoils my early illusions—and they are my capital." The historic characters of the Old West inspired him—Indians, trappers, vaqueros, soldiers—different races all, but brave men who, in his opinion, faced their demise just as bravely as the Old West had. Remington saw it as tragedy: he dedicated his book to "Men with the bark on [who] die like the wild animals, unnaturally—unmourned and even unthought of mostly."

Just as Deas's Long Jakes looked apprehensively toward the future, so do Remington's heroes. Perhaps the clearest presentation of his types is *A Bunch of Buckskins* (1901), which includes individual equestrian portraits of two Indians, two half-breeds, two army men, and a trapper and a cowboy. He followed in 1902 with the portfolio *Western Types,* which includes his famous images of the cowboy, a cavalryman, a scout, and a half-breed. One of his most famous pictures, *His First Lesson* may also be seen as a metaphor for the Old West. Published as a full-color, double-page spread in *Collier's,* which was approaching the one million mark in circulation, and issued as an art print, the picture depicts a pony about to be broken to the saddle. The right rear foot of the horse has been tied up. One cowboy holds the reins, while another tightens the cinch of the Mexican cow saddle. One of them will shortly jump into the saddle. As with many Remington paintings, there are several levels of interpretation. The first question may be, whose first lesson is it? While the terror in the horse's face makes it apparent that it is his, that wildness, coupled with the laughing man on the horse at the right, suggests that the rider may also be in for a lesson. Finally, however, the meaning of the picture becomes apparent as the viewer begins to focus on the terror-stricken horse at the center of the picture, a noble and wild creature, representative of the best the Old West had to offer. Just as this handsome creature will be broken and trained, Remington is saying, so has the Old West been civilized.

There was no place in mid-century Saint Louis for Deas's trapper or Bingham's riverboatman, nor was there a place in twentieth-century America for Remington's "men with the bark on." Remington realized that the cowboy was a popular and thoroughly American character—he painted dozens of pictures of cowboys, many of which were published as color prints—but even he might have been surprised at the puncher's longevity and international renown, or the longevity and renown of his historic West. The image and appeal remain largely the same, even as the inexorable changes continue.

J. M. Lapham provided the first published view of a Sierra big tree. Mammoth Arbor Vitae, Standing on the Head Waters of the Stanislaus and San Antoine Rivers, in Calaveras County, California *was published by lithographers Britton and Rey in San Francisco in 1853. A. K. Kipp and J. H. Daniels of Boston published this identical copy in 1862.*

DRAWN BY A.K.KIPPS.

2 1 6 / 4

J.H.DANIELS LITH. BOSTON.

MAMMOTH ARBOR VITAE.

STANDING ON THE HEAD WATERS OF THE STANISLAUS & SAN ANTOINE RIVERS, IN CALVERAS COUNTY CALIFORNIA. DIAMETER 31 FEET AT THE BASE – CIRCUMFERENCE 96 FT. – HEIGHT 280 FT. 3000 YEARS OLD.

THE LANDSCAPE AS SPECTACULAR

\mathcal{B}y the time Albert Bierstadt made his first trip west in 1859, he was, like Audubon, Catlin, and others before him, as much a businessman and promoter as an artist. He was not the first professional landscape painter to venture into the West, for German immigrant Hermann Lungkwitz brought the Romantic Dresden style to the Texas Hill Country in the early 1850s and, at the same time, other artists followed the gold seekers to California. Among them were New Jersey painter Thomas A. Ayres, who was the first to depict the Yosemite Valley with his handsome lithographs, and William Keith, who arrived in 1859 on assignment from *Harper's Weekly*. But Bierstadt became the most successful of them all and created a vision of the West that still endures.

Bierstadt went west just as genre painting, which had flourished following Thomas Cole's ascendency during the 1830s and 1840s, began to wane. Cole was America's premier landscape artist and the founder of the Hudson River School, but he had only one student, Frederic Church, who went to South America rather than the West. An important and timely topic was, therefore, left to the genre painters to interpret until interest in that style diminished. Rather than "low-taste . . . vulgar and vicious engraving," a correspondent wrote the *Cosmopolitan Art Journal* in 1858, we should focus on "scenes fresh from Nature's great portfolio, embodying the beauty and spirit of her being for our study." Coinciding with this feeling was the growing awareness of spectacular scenery in the West that would compete with any that the world had to offer. Yosemite was rediscovered in 1851, the Sierra Redwoods in 1852, and Yellowstone in 1870. Few Americans would have the chance to see these wonders for themselves, but artists leapt into the breach. Bierstadt was the first important artist to satisfy the renewed interest in landscape painting with original scenes from the West.

Bierstadt was born in Düsseldorf but immigrated with his parents to New Bedford, Massachusetts, in 1832. He returned to Düsseldorf in 1853 to study painting and established a studio in New Bedford upon his return in late 1857. Why Bierstadt chose to go west in 1859 is not certain; perhaps he heard Bayard Taylor, the well-known traveler, lecturer, and author of *Eldorado,* talk about his experiences in the West. Perhaps he was

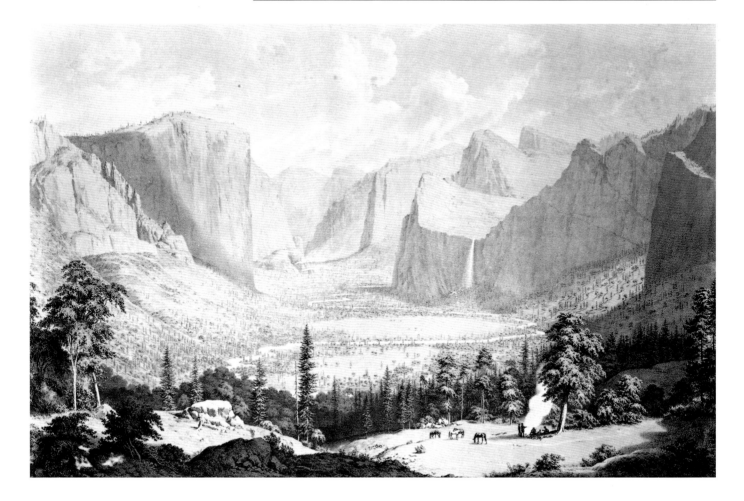

Thomas A. Ayres arrived in California in 1849 and was one of the first artists to go to the Yosemite Valley. The Nahl Brothers of San Francisco printed his General View of the Great Yo-Semite Valley *(hand-colored, tinted lithograph, published by Hutchings and Rosenfield, San Francisco) in 1859.*

simply aware of the huge volume of material being published on this beguiling part of the country. At any rate, in January 1859, the local newspaper announced his imminent departure "for the Rocky Mountains, to study the scenery of that wild region," and that spring he and several other artists joined Col. Frederick West Lander on his expedition to the Rockies.

Lander's prosaic purposes were to improve the "cut-off" from South Pass westward that he had blazed the previous year and to find year-round mail routes. The expedition headed up the Platte River to Fort Laramie, then probably followed the Sweetwater to South Pass, in the southern Wind River range, with Bierstadt taking stereoscopic views and sketching along the way. The artist's anticipation heightened as they approached the mountains; the grandeur of the Swiss Alps had made Americans curious to know if the American continent contained their equal, but the immature compositions exhibited by the young Alfred Jacob Miller twenty years earlier in New York had whetted appetites without resolving the question. Bierstadt was prepared to answer the question definitively. "The mountains are very fine," he wrote enticingly in July. "As seen from the plains, they resemble very much the Bernese Alps. . . . We see many spots in the scenery that remind us of our New Hampshire and Catskill hills, but when we look up and measure the mighty perpendicular cliffs that rise hundreds of feet

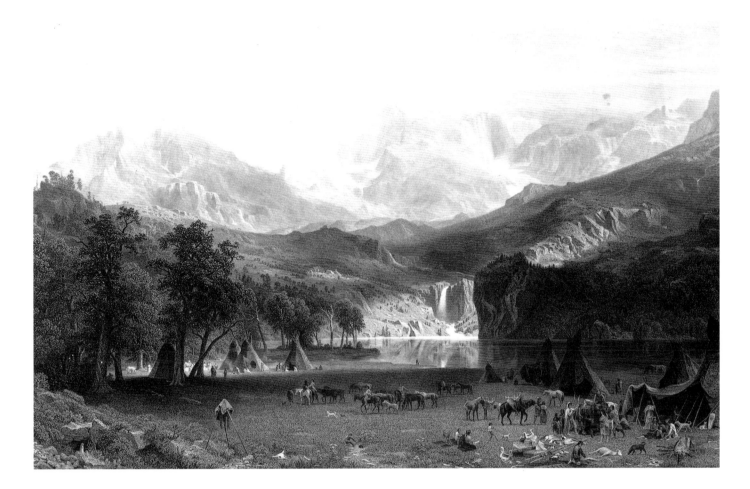

aloft, all capped with snow, we then realize that we are among a different class of mountains." Here Bierstadt turned back, and Lander continued his caretaking march to California.

The summer trip was a seminal experience for Bierstadt. Perhaps because of his experience painting the Swiss Alps, he was one of the few artists of the West who was able to communicate this feeling of awe to the public. Soon after returning east, he moved his studio to New York, and with accumulation of the prolific summer's work before him, began to create his vision of the Rocky Mountains. His sketches (many of which demonstrate that he was a close observer of nature and are often more pleasing to the modern eye than his finished work), his photographs, and a growing collection of Indian clothing and artifacts testified to his firsthand experience of what he painted. He began to publicize the trip by publishing several drawings in *Harper's Weekly*, in August 1859, and explained in detail to a reporter for the *Boston Evening Transcript* how he had undergone "no ordinary privation and fatigue" to make his sketches.

The public and critics alike responded enthusiastically to his first exhibition of Western paintings. A reporter for the New York literary and aesthetic journal, the *Crayon,* recalled that "lovers of landscape" had long been curious about "this section of our territory," but that they were "not satisfied by the vague and contradictory re-

When Bierstadt sent his huge painting of the Rocky Mountains on tour in 1863, it was accompanied by a subscription list so that viewers could sign up for the forthcoming engraving. James Smillie after Bierstadt, The Rocky Mountains, Lander's Peak *(steel engraving, 1866). Published by Edward Bierstadt, New York.*

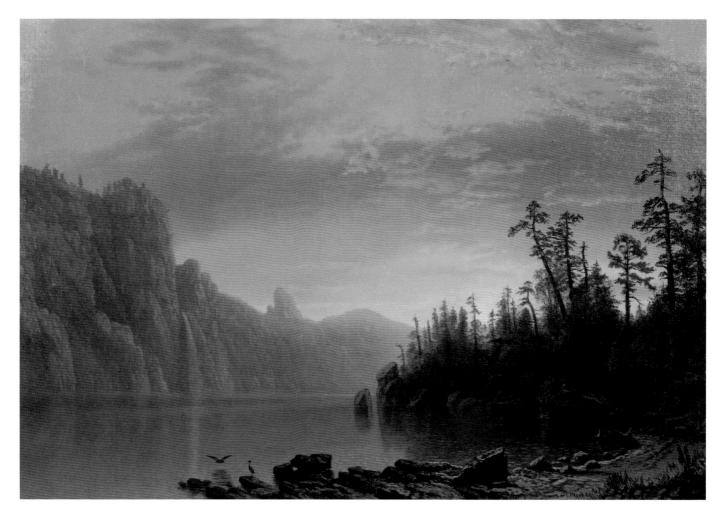

Sunset: California Scenery *was the only one of Bierstadt's pictures to be chromolithographed in America (Prang, 1868). Prang listed it in his 1869 catalogue for $10.*

ports of explorers. . . . Through the better expression of the brush we can now form some idea of it, Mr. Bierstadt's pencil being too true and too powerful to be questioned."

Bierstadt's intention, however, was not to document but to produce "a series of large pictures" within the aesthetic tradition that he valued (and by which the critics would judge him) and, at the same time, to please the public, which demanded "accuracy" and "authenticity" in pictures. His solution was the classic compromise that Deas, Ranney, and others before him had chosen, in which he presented grand pictures that were, on the whole, fictional constructs but also were filled with such specific and correct details—based on his photographs, sketches, and artifacts—that the public accepted them.

The best example of that compromise may well be his most popular picture, *The Rocky Mountains, Lander's Peak* (1863). It is clearly a construct, but with sketches, photographs, and artifacts to back him up, Bierstadt described it as if it were an actual scene. (Frederic Church, by comparison, readily acknowledged that his great *Heart of the Andes* was not an actual scene.) In a brochure that Bierstadt published to advertise the engraving of *The Rocky Mountains,* he commented on his work in detail:

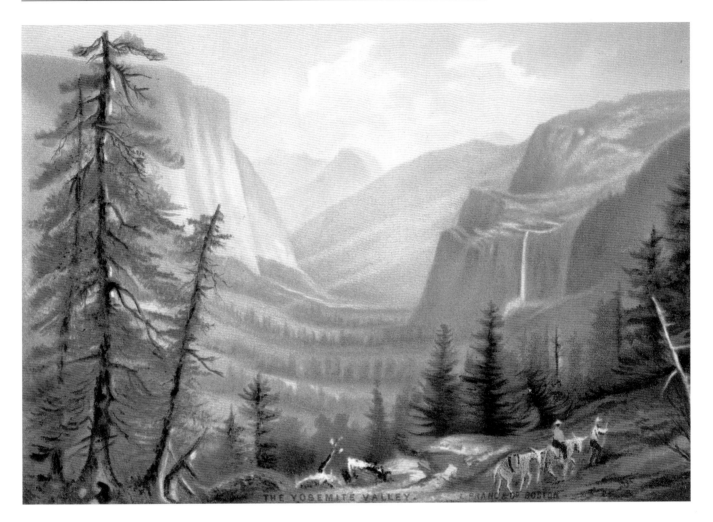

This picture represents the scenery in the Wind River range of mountains, in Nebraska Territory, being a portion of that great chain known as the Rocky Mountains. . . . The particular portion which the Artist has here depicted lies at a distance of about seven hundred miles northeast of San Francisco, and portrays the western slope of the mountains. The streams which are seen leaping down their sides,—are the headwaters of the Rio Colorado. . . . The principal peak of the group is Mt. Lander. Its summit is covered with perpetual snow, and immense glaciers are formed upon its sides. . . . The Indian encampment in the foreground is known as the Shoshone Village, and the various implements of the chase, warfare, and domestic use, scattered about, are those in general employment by this tribe.

After William Harring drew English artist Thomas Hill's painting Yosemite Valley *(chromolithography, 1871) on stone for Prang, the painting was successfully exhibited at the Philadelphia Centennial Exhibition in 1876.*

After exhibiting the painting in New York, Bierstadt then sent it on a tour through New England, accompanied by the brochure and a subscription list for the engraving. As he correctly realized, few viewers would have the experience to object to the lack of "reality" in his characterization, and many among the more sophisticated would appreciate his achievement. The public response was tremendous. Americans accepted the painting as a fact of the West, while a reviewer for London's *Saturday Review* praised

Prang after Moran, Cliffs of the Green River
(c. 1872, wood engraving), from Bryant,
Picturesque America *2, p. 175. Courtesy Amon
Carter Museum, Fort Worth, Texas.*

Bierstadt for being more than "a mere copyist of nature," who had "definite artistic intentions" and carried "them out with care and resolution."

As Bierstadt set out on his second Western trip, he believed that he had sufficient orders and made arrangements with James Smillie, one of the foremost American engravers, to engrave and print *The Rocky Mountains.* Several technical problems delayed it until December 1866, when it was issued in four states: 200 artist's proofs, numbered consecutively and signed by both Bierstadt and Smillie ($50 each); 250 proofs, presumably unnumbered but probably signed ($30 each); 300 proofs with lettering added after the other prints had been made ($20 each); and an unknown number of plain proofs ($10 each). The painting itself was purchased by James McHenry, an American railroad magnate living in London, for the unheard of sum of $25,000. It was later issued as a chromolithograph as well.

Bierstadt might have been inspired to make his second Western journey when he saw Carleton Watkins's photographs of Yosemite at Goupil's Gallery in New York and realized that more spectacular scenery awaited him. Accompanied by Fitz Hugh Ludlow, a *New York Post* writer, Bierstadt set out along the old Oregon Trail. This is the most thoroughly documented of all Bierstadt's trips, because Ludlow published a series of letters in the *Post* and several articles in the *Atlantic Monthly,* later combining them in a book, *The Heart of the Continent.* They followed the southern route, passing through Denver, where Ludlow was almost overcome with emotion at his first glimpse of the Rocky Mountains. They moved on to San Francisco, then up to Yosemite, via the Mariposa Grove of giant sequoias, where they spent seven weeks camping and sketching. In September they left for Oregon, originally intending to extend the trip into Washington Territory and Canada, but returned by way of Panama when Ludlow became ill. They arrived in New York in mid-December.

It was one of Bierstadt's most productive trips. Some of his most famous paintings, such as *Looking Down Yosemite Valley, California* (1865), *Storm in the Rockies, Mt. Rosalie* (1866), *The Domes of Yosemite* (1867), *Sunset in the Yosemite Valley* (1868), and *Among the Sierra Nevada Mountains* (1868), resulted. They were also printed in one form or another for an admiring public. When *Storm in the Rockies* was acquired by McHenry's business associate Thomas William Kennard, Bierstadt arranged to have it and *The Rocky Mountains* exhibited by London print publisher and dealer Thomas McLean to publicize the forthcoming chromolithographic prints, which finally appeared in 1869. The prints received a great deal of publicity, with one account pointing out that twenty stones were required to reproduce one of the pictures, another stating that thirty were used.

As Bierstadt's fame grew, he became a respected member of society. Along with founder Theodore Roosevelt and historian, anthropologist, and zoologist George Bird Grinnell, he joined the Boone and Crockett Club, a small group of "American hunting riflemen" who were also devoted to conserving the Western wilderness and wildlife. His work was reproduced in many magazines and journals. *Chimney Rock, Ogalillah: Sioux Village in the Foreground,* which appeared in *Ladies Repository* in 1866, was the first of his paintings to appear in that format. *Silver Lake, California* (1867) was the first of his California images to be printed. Because *The Domes of Yosemite* (1867) was commissioned for Le Grand Lockwood's Connecticut mansion, Bierstadt could not send it on tour as he had his other great pictures, but he exhibited a smaller version of it at McLean's London gallery, which a Düsseldorf firm used to make the chromo in 1870.

That same year, Ludlow's book appeared with numerous illustrations by Bierstadt, including *Mirror Lake* as the frontispiece. Since Bierstadt had married Ludlow's former wife, Rosalie, in the meantime, it is not surprising that Ludlow refused to give him credit for the images that appear in his book.

One of Bierstadt's most popular prints was *Sunset: California Scenery,* a chromolithograph that Louis Prang of Boston published in 1868. According to reports, Prang's chromo was good enough that when it was exhibited alongside the original painting, visitors often could not distinguish between them. Catharine Beecher and Harriet Beecher Stowe specifically recommended it in their book *American Woman's Home* (1869): "The educating influence of these works of art can hardly be over-estimated," they wrote. "Children are constantly trained to correctness of taste and refinement of thought, and stimulated—sometimes to efforts at artistic imitation, always to the eager and intelligent inquiry about the scenes, the places, the incidents represented."

Prang, like Currier and Ives, proved to be one of the most influential figures in the production of color prints. He, perhaps more than any other of the many chromolithographers, inspired Edwin L. Godkin, editor of the *Nation,* to dub the era after the Civil War the "Chromo-Civilization." It was not intended as a complimentary term, but a closer investigation of Prang's work, from his first Western print after Bierstadt's painting to copies of the pictures of Thomas Hill, John Ross Key, and, finally, Thomas Moran, permits a much kinder interpretation of Godkin's phrase today.

Like so many others in the American printing industry, Prang immigrated following the European revolutions of 1848. He established himself in Boston in 1850 and began business as a lithographer and publisher in 1856. By the 1860s he was printing works of art in color: album and greeting cards, book illustrations, valentines, and,

HARVESTING NEAR SAN JOSE, CALIFORNIA.

PRANG'S
AMERICAN CHROMO
after J. R. Key 72

John Ross Key, the grandson of Francis Scott Key, worked as a draftsman for the U.S. Coast and Geodetic Survey and served in the Confederate army before producing several paintings, fourteen of which Prang published in an album, California Views, *in 1873. Here an unknown artist after Key depicts* Harvesting Near San Jose, California *(chromolithograph). Courtesy Amon Carter Museum, Fort Worth, Texas.*

finally, copies of important paintings. Bierstadt's *Sunset: California Scenery* originally sold for $10 and remained in the Prang inventory for decades.

Prang next reproduced Thomas Hill's *Yosemite Valley* in 1869. Then, in 1873, he undertook a series of paintings by John Ross Key, the grandson of Francis Scott Key, author of "The Star Spangled Banner." According to one authority, Key was "practically self-taught." He worked as a draftsman for the U.S. Coast and Geodetic Survey, then served in the Confederacy during the Civil War. After the war he went to California, where he did a series of landscapes, fourteen of which Prang selected for a portfolio entitled *California Views.* The prints, measuring slightly more than 7 by 14 inches, include images such as *The Golden Gate, Looking West, Harvesting Near San Jose, California,* and *Bridal Veil Fall, Yosemite Valley* and could be purchased individually for $3 or as a part of the portfolio. They all seem to be saturated with bright yellows and golds and an almost garish red. In addition, some are heavily varnished, giving them a rather dull appearance to the modern eye. They are, in fact, fairly good reproductions of Key's work, for he was no match for Thomas Moran, whose portfolio on Yellowstone National Park appeared three years later and proved to be one of the greatest works that Prang ever published.

Thomas Moran was born in Bolton, Lancashire, England, in 1837. He immigrated to America with his family in 1844, settling in Philadelphia, where he apprenticed to a wood engraver for several years. He and his brother, Edward, established a studio in Philadelphia in the mid-1850s but then returned to England in 1861 to study the work of Joseph M. W. Turner and Claude Lorrain. Thomas returned to the United States in 1862 to marry Mary Nimmo, then in 1866–67 they studied Old Master paintings in England, France, and Italy.

Moran's first experience with the West came when he illustrated Nathaniel P. Langford's articles on the Yellowstone region for *Scribner's Monthly*. Langford, of Helena, Montana Territory, based his articles on an 1870 expedition that he and nine Montanans had made into the area. Langford had an agreement with Jay Cooke, the financial agent for the Northern Pacific Railroad, to publicize Yellowstone and ended his articles with, "By means of the Northern Pacific Railroad, which will doubtless be completed within the next three years, the traveler will be able to make the trip to Montana from the Atlantic seaboard in three days, and thousands of tourists will be attracted to both Montana and Wyoming in order to behold with their own eyes the wonders here described." Moran's illustrations, based on drawings provided by two members of the expedition, do him no credit, but he had not been west and had no idea what the extraordinary scenery of the Yellowstone looked like.

Langford's article was not the first suggestion of a national park in Yellowstone. George Catlin had introduced the idea in his effort to persuade Congress to purchase his Indian Gallery, but Langford and then Dr. Ferdinand V. Hayden both mentioned railroads and tourists in promoting the idea, something foreign to Catlin's concept of preservation.

Moran redeemed himself when he finally reached the Yellowstone in 1871 as a guest on Hayden's U.S. Geological Survey of the Territories. William Henry Jackson was Hayden's photographer; Henry W. Elliott was the artist. At the request of the publisher of *Scribner's* and officials of the Northern Pacific Railroad, Moran was allowed to go along, for Hayden realized the importance that tourism might play in the future of the region. The railroad officials explained, "Mr. Moran is an artist (landscape painter) of much genius, who desires to take sketches of the upper Yellowstone regions, from which to paint some fine pictures on his return. That he will surpass Bierstadt's Yosemite we who know him best fully believe. . . . He will be absolutely no trouble nor expense

Moran had not seen the Yellowstone when he engraved The Great Cañon of the Yellowstone, *after a Walter Trumbull sketch. From* Scribner's Monthly *2 (May 1871). p. 8.*

After his trip with Hayden, Moran produced a much more beautiful and convincing picture of the canyon. Prang after Moran, The Grand Cañon of the Yellowstone, YNP, *from Hayden,* Yellowstone National Park.

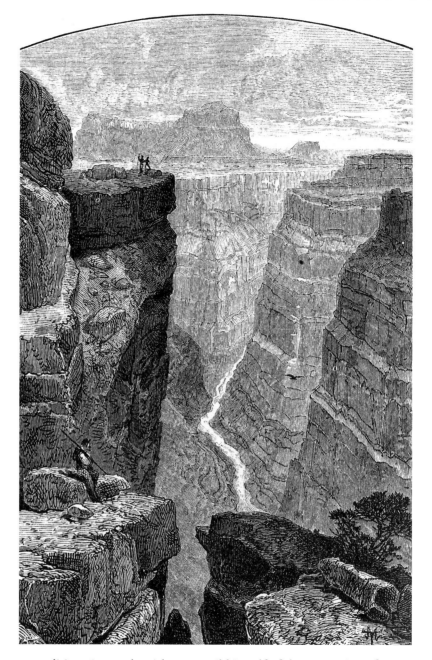

After Moran, Grand Cañon from
To-Ro-Weap, Looking East *(wood engraving,
c. 1874), from* Scribner's Monthly 9
(March 1875), p. 528.

to your expedition, & merely wishes to avail himself of the protection of your escort,
& possibly 50 pounds of transportation in a wagon." Moran was a real greenhorn. He
had never ridden a horse before and, according to William Henry Jackson, looked
"frail, almost cadaverous, [and] seemed incapable of surviving the rigors of camp life &
camp food." But he put a pillow on his saddle, broke into the rigor and routine of
camp life, and soon quelled all doubt that he would survive.

Back home by mid-August, Moran established a new studio in Newark so he could
be near the New York editors and set to work turning his pencil and watercolor field
sketches (and perhaps some Jackson photographs) into a stunning array of paintings.

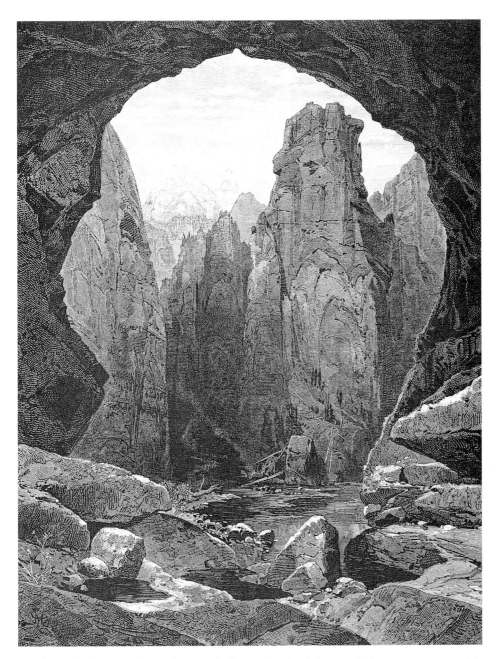

Frederick Juenglingfter after Moran, The Narrows, North Fork of the Rio Virgin, Utah *(1875), from the* Aldine *(April 1875), p. 306.*

Scribner's had expected another article from Langford, but he did not accompany this expedition, so the magazine turned to Hayden, who produced an article accompanied by Moran's watercolors, this time bolstered by his summer's experience. (The article appeared in February 1872.) Moran also made some large drawings for *Harper's Weekly* and accepted a commission to do several for the *Aldine,* all of which helped him repay Jay Cooke the loan that had permitted him to make the trip.

Then he began work on a set of watercolors that British industrialist William Blackmore, who was visiting Washington in November 1871, commissioned for his museum in Salisbury, England. Blackmore might have seen some of Moran's watercol-

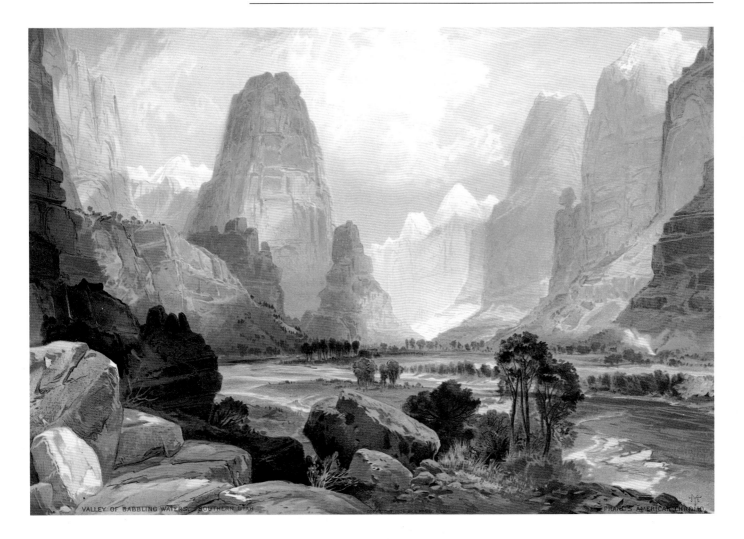

VALLEY OF BABBLING WATERS SOUTHERN UTAH PRANG'S AMERICAN CHROMO

Prang after Moran, Valley of the Babbling Waters, Southern Utah, *from Hayden,* Yellowstone National Park.

ors circulating among congressmen that winter, for Hayden's *Scribner's* article, Moran's paintings, and Jackson's photographs were all a part of the lobbying effort for Yellowstone National Park during the winter of 1871–72. The region was made a national park on March 1, 1872, and just three months later, Congress authorized $10,000 for the purchase of Moran's large *Grand Cañon of the Yellowstone* (1872). When a *Scribner's* critic later saw the Blackmore watercolors on exhibit at Goupil's Gallery in New York, he called them the "most brilliant and poetic pictures that have been done in America thus far." The *Nation* called them "rapid, racy, powerful, romantic specimens of watercolor sketching, showing in each example faculties that any artist ought to glory in."

Editor Godkin must, therefore, have been perplexed when Louis Prang, the most accomplished purveyor of chromolithographs in the country, published a stunning set of Moran's watercolors of Yellowstone National Park in 1875 and 1876. Prang had contacted Moran in 1873, asking him to paint "12 or more watercolor pictures of the Yellowstone country" that Prang could publish. Moran might have been hesitant to work with Prang, who had solicited work from him for a work on American poets, then not published it. He also knew that there were those, in addition to Godkin, who

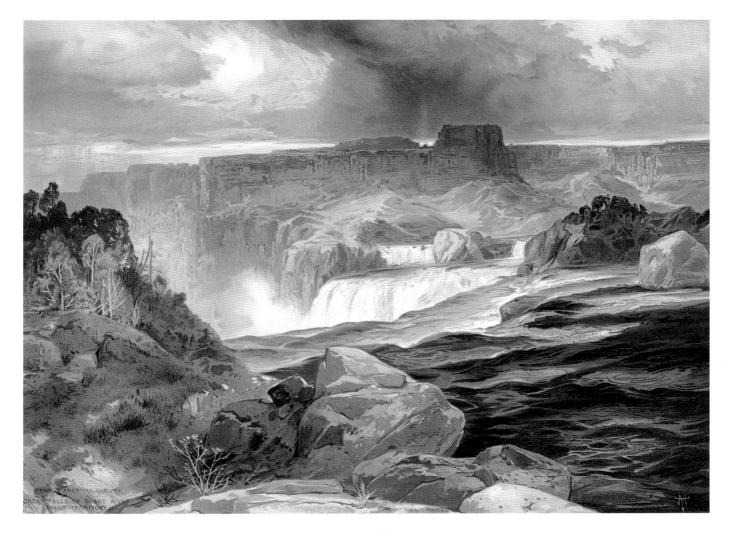

Prang after Moran, Great Falls of the Snake River, *from Hayden,* Yellowstone National Park.

had accused chromo publishers of pandering to the uncultured middle class. But Moran, being a skilled printer himself, having made an estimated forty original lithographs between 1859 and 1869, probably sympathized with Prang's goals and knew that he was a successful publisher. Moran's method of making outline sketches also made it easier for him to convert his sketches to prints, and he later wrote that commercial success was "no hindrance to his art. . . . The real artist will express himself anyway." He might well have agreed with the editor of the *Aldine,* who published much high-quality graphic art. "If chromolithography is not an art," the editor wrote, "it is in one sense better, since it goes where pure art cannot go, into . . . popular aesthetic culture, which the latter could never accomplish."

Moran eventually made twenty-four watercolors, from which Prang chose the fifteen he published. Hayden wrote the text, and Prang published 1,000 copies of *The Yellowstone National Park, and the Mountain Regions of Idaho, Nevada, Colorado, and Utah,* which sold for $60 each. Prang destroyed the stones when the edition was finished.

Prang's Yellowstone chromolithographs are among the most beautiful printed in

145

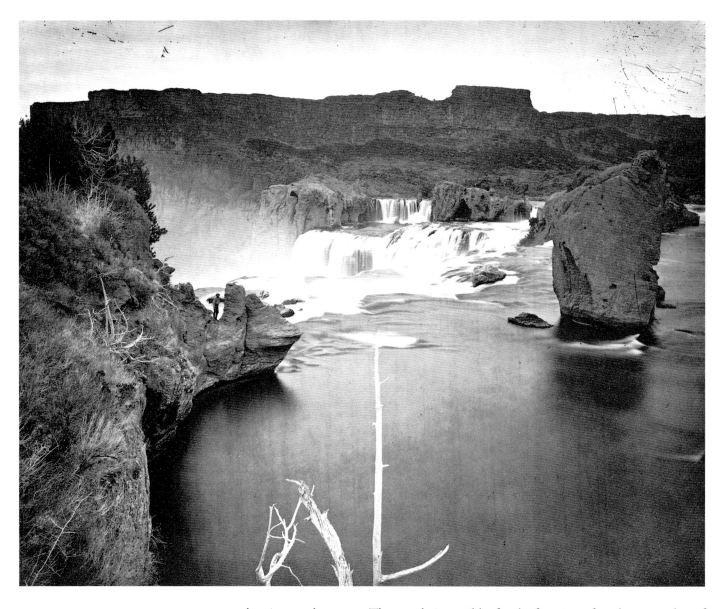

Timothy O'Sullivan, Shoshone Falls, Snake River, Idaho *(photograph, 1868). Courtesy National Archives.*

the nineteenth century. They made it possible, for the first time, for a large number of people to comprehend the otherworldly color of Yellowstone. *Hot Springs of Gardiners River* depicts Mammoth Hot Springs, which photographer Jackson characterized as "those bubbling cauldrons of nature." Hayden described *Great Blue Spring* as "wild, weird beauty, which wafts one at once into the land of enchantment; all the brilliant feats of fairies and genii in the Arabian Nights' Entertainments are forgotten in the actual presence of such marvelous beauty." *Castle Geyser* combines the strangeness of the Yellowstone geyser field with vivid color. *Tower Falls and Sulphur Mountain* and *The Grand Cañon of the Yellowstone* effectively portray the size and grandeur of the new park. Langford had written that in the Grand Canyon of the Yellowstone, "the brain reels as we gaze into this profound and solemn solitude. . . . The stillness is horrible. . . . Even the voice of its waters in their convulsive agony cannot be heard. . . . The

solemn grandeur of the scene surpasses description. It must be seen to be felt. The sense of danger with which it impresses you is harrowing in the extreme. You feel the absence of sound, the oppression of absolute silence." For the first time the public had believable images to go with the fantastic descriptions they had been reading.

In his preface to the book, Hayden pointed out the importance of color in considering these Western splendors. Not having color would be like watching "Hamlet with the part of Hamlet omitted," he wrote. "So strange, indeed, are the freaks of color which nature indulges in habitually in this wonderful country, that it will no doubt require strong faith on the part of the reader in the truthfulness of both artist and writer to enable him unhesitatingly to accept the statements made in the present volume by the pen as well as by the brush. . . . It is a just subject for national pride to see a work of this character, which takes equal rank with anything of the kind ever undertaken in Europe, produced wholly on American soil." Of the prints themselves, he noted, they are "exceedingly correct renderings of their subjects, interesting alike to the man of science, the lover of art, and the admirer of nature."

They set a new standard for fine art printers, introducing patterns and colors as well as the subtleties by which Moran captured the startling range of colors of the Yellowstone. Even the *Nation,* which had denounced chromolithography, commended Prang for being "willing to undertake so costly an enterprise, the copying of such watercolors as

Moran popularized the Grand Canyon with dozens of engravings for Powell's, Exploration of the Colorado of the West *(1875), the* Aldine, Picturesque America, *and* Scribner's Monthly. *After Moran,* The Grand Chasm of the Colorado, *from* Scribner's Monthly *9 (February 1875), p. 408.*

Albert Ruger, Bird's-Eye View of the City of Omaha, Nebraska, 1868 *(tinted and hand-colored lithograph, published by Chicago Lithographing Company).*

these being one of the things that lithography is undeniably fitted to effect. . . . Having seen several of the original aquarelles prepared by Mr. Moran, we are prepared to testify to the remarkable accuracy of the rendering into chromolithographs, an accuracy which we do not think could have been surpassed in any country."

That accuracy was apparent to anyone who knew the photographs of Jackson or Timothy O'Sullivan. That some of Moran's images should be similar to Jackson's photographs should come as no surprise, for they both accompanied Hayden into the Yellowstone in 1871. They became friends and worked well together; Jackson credited Moran for helping him with composition, and Moran realized that any time he spent helping Jackson would be repaid later when he used the photographs as he would sketches for his finished paintings. But Moran had not been to southern Idaho when

he painted *Great Falls of the Snake River,* which bares a striking resemblance to O'Sullivan's 1868 photograph of Shoshone Falls.

Prang could not control the consistency of the color, but the London *Times* concluded that "no finer specimens of chromo-lithographic work have been produced anywhere." Moran and Prang must have known the extent of their success when even John Ruskin, the English critic who had denounced chromolithographs for years, purchased a set of *The Yellowstone National Park.*

Contrary to the title, the portfolio also contained images that were not in Yellowstone, such as *Great Salt Lake of Utah; Valley of the Babbling Waters, Southern Utah; Mountain of the Holy Cross, Colorado;* and *Summit of the Sierras, Nevada.*

Moran made his second trip west in the summer of 1873. Basking in the success of his great painting *Grand Cañon of the Yellowstone,* he joined John Wesley Powell, who had navigated the length of the Grand Canyon of the Colorado River in 1869. Powell had seen how effective Moran's watercolors were in publicizing the Yellowstone in the fall of 1872 and wanted the same kind of recognition for the Arizona canyon. Joining Powell in Salt Lake City in July, Moran accompanied the surveyors south through the valley of the Rio Virgin. With Powell's photographer, John K. Hillers, he finally reached the Grand Canyon. It was "most awfully grand and impressive," he wrote his wife a few

C. J. Dyer, Bird's Eye View of Phoenix, Maricopa Co., Arizona, View Looking North-East, 1890 *(printed by Schmidt Label and Litho Company).*

days later. Powell later showed him the vista from the Kaibab Plateau on the north rim, describing it as a "grand facade of storm-carved rocks." That is the perspective that Moran chose to paint.

Upon returning to his Newark studio, Moran began a series of sketches for *Scribner's;* the *Aldine,* an art journal that strove to illustrate the work of the best American artists with the latest technology; and Appleton and Company's *Picturesque America,* which was edited by William Cullen Bryant. These images did not seem to create the same excitement that those of Yellowstone had, and Prang did not include any of them in his chromolithographic portfolio, but they did reveal the awesomeness of the Grand Canyon to an appreciative and large audience.

Moran continued to make prints throughout his career, especially etchings, but none would surpass *The Yellowstone National Park* in beauty and public appeal.

There is a final aspect of landscape prints that attracted patronage in nineteenth-century America. Taking advantage of the continued interest in the West, as well as Westerners' desire for self-promotion, printmakers published thousands of urban bird's-eye views and illustrated atlases of Western communities. Such views were not limited to the West, notes historian John W. Reps, who has spent years cataloging and studying these views, for they were popular throughout late nineteenth-century America.

Most of the views show the cities from an imaginary viewpoint high in the air, hence the name, bird's-eye view. Reps has counted more than 2,400 American and Canadian cities that are documented in the prints, with more than 150 portraits each of large cities such as New York and San Francisco. Some art historians assert that these images were an American contribution to printmaking, but Reps, while admitting that they did become an important part of nineteenth-century urban boosterism, traces the bird's-eye cityview far back into European history and concludes that their American counterparts are unique only in their ubiquity. The *Liber Cronicarum* [Nuremberg Chronicle] (1493) contained them, as did Sebastian Münster's *Cosmographiae Universalis* (1550) and Georg Braun and Franz Hogenberg's *Civitas Orbis Terrarum* (1575), among others. The California gold rush provided the opportunity for cityview artists to take this established art form west. Henry Firks's view of San Francisco, issued by Thomas Sinclair in Philadelphia in 1849, might have been the first, followed closely by George Cooper's panorama of the Sacramento waterfront and Henry Larkin's two views of Monterey in 1842, all published in 1850. Two German immigrants, Charles Kuchel and Emil Dresel, published a beautiful and important series of views of mining towns through the San Francisco lithographic firm of Britton and Rey.

Although the quality of the views varies, the methodology of making and selling them was remarkably similar in each city for each artist. The editor of the *Rocky Mountain News* in Denver said the process began there in November 1865, when Alfred Mathews walked into the office and "showed us several of his pictures of scenes of interest in and around Nebraska City . . . which . . . bear the marks of an Artist's hand." Camille Drie used the same technique in 1871 in Galveston, Texas, where the editor of the local newspaper explained that the artist would be making "some drawings . . . for a map of Galveston, which will exhibit the buildings on every lot within the city. It is an isometrical projection," he explained. It "promises to be a fine picture of the Island City, and will be invaluable to all property holders."

Artists like Drie began by choosing the perspective from which the city would be

OPPOSITE, TOP: *William Endicott and Company, after George V. Cooper,* Sacramento City, Ca., from the Foot of J. Street, Showing I., J., and K. Sts., with the Sierra Nevada in the Distance *(chromolithograph, 1850; published by Stringer and Townsend).*

OPPOSITE, BOTTOM: *Mathews,* F Street, Denver *(1866), from Mathews,* Pencil Sketches of Colorado.

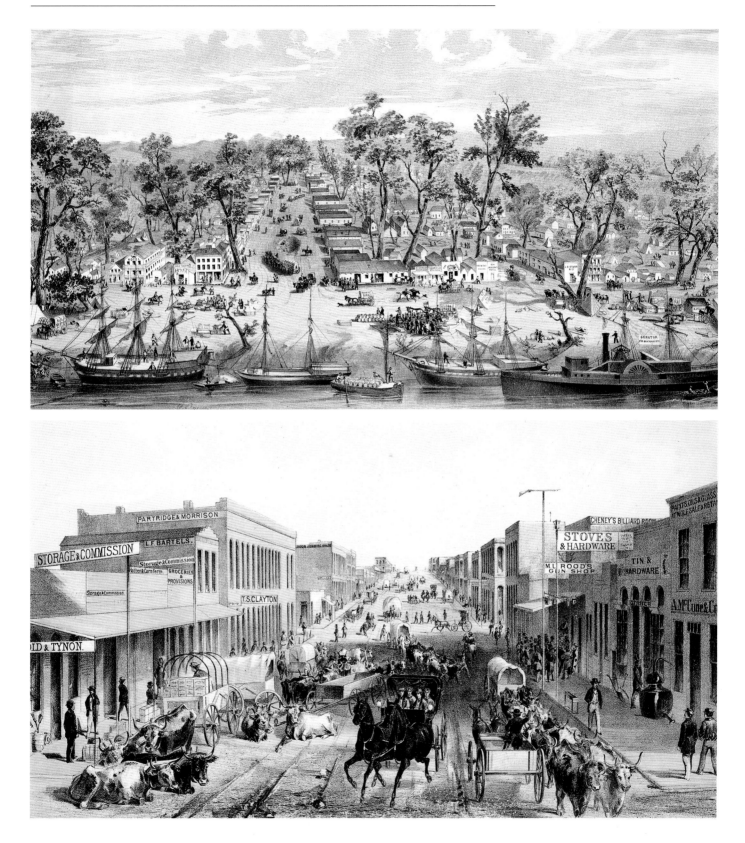

shown, then went around town sketching individual buildings from that direction to achieve the desired aerial effect. Sometimes they would sketch individual buildings; sometimes whole blocks or areas of the town. If a city map was available, they probably used it; if not, they might have made one for their own use. Thaddeus Fowler's unfinished view of Sunset, Texas, illustrates what might be an interim step in the process in which Fowler made a few notes on the drawing, either as an aid to producing the finished drawing or perhaps to guide the lithographer in putting the drawing on the stone.

Four days later the Galveston editor announced that anyone wanting to order one of the views should contact Drie at the post office and called attention to an advertisement in his paper, selling subscriptions to the soon-to-be view for $3 per print. It was but one of the various methods the agents used to finance their prints. Many Western cities were large enough to produce sufficient subscribers, at $2 to $5 each, to justify a print run of several hundred lithographs. Joseph J. Stoner "had no difficulty in filling his subscription list" of 250 in San Antonio without having to resort to that other popular ploy of the bird's-eye view salesman: point out how many copies the citizens of a neighboring community had ordered of their view and threaten that if sufficient subscriptions were not sold, the view could not be printed. When the agent for Herman Brosius's view of Dallas called at the *Herald* in December 1872, he showed a just-completed view of Jefferson, Texas, and offered to have the Dallas drawing lithographed only if "a sufficient number of subscribers" signed up.

Accurate information about the number of copies made of each view is difficult to obtain, for the viewmakers often exaggerated the number to impress prospective clients and customers. H. H. Bailey said that he needed 500 subscribers before he would print his view of Milwaukee, Wisconsin, in 1872, and in 1883 Augustus Koch told the citizens of Hebron, Nebraska, that 25 would suffice. The average run seemed to be about 250, as Henry Wellge requested in Denison, Texas, and Stoner in San Antonio, but there were exceptions. When a local wholesale grocer purchased copies of Wellge's 1886 view of Fort Worth to give to his customers, Wellge was able to print 1,100 copies.

If public response was not sufficient, the next most obvious method of financing was to find a sponsor. In some instances, the local railroad might have assisted, for this was the era of railroad building, and virtually all of the views show at least one train entering or leaving the city. Sometimes it was the local newspaper or, perhaps, a real estate company. Wellge's good fortune in Fort Worth came from wholesale grocer Joseph H. Brown, who used the view to advertise his business; in Laredo it was the Laredo Real Estate and Abstract Company.

Another method of funding the print was to sell "portraits" of schools, churches, city halls, businesses, and even private residences to appear as vignettes in the margins around the main view of the city. Kuchel and Dresel's *Los Angeles* (1857), Grafton T. Brown's *Portland* (c. 1861), Albert Ruger's *Omaha* (1868), and C. J. Dyer's *Phoenix* (1885) are good examples. Mathews might have used a slightly different technique in Nebraska City and Denver. Many of the business signs are blank in his views of those two cities, but others prominently display the store name. Perhaps Mathews required a fee or a certain number of subscriptions before he would identify a place of business.

It is impossible to look at these intriguing prints without wondering how accurate they are. Did San Francisco or San Antonio or Salt Lake City really look like that in the nineteenth century? Do the two Helena views in 1865 and 1890 really reflect changes

that took place in the city during the intervening twenty-five years? Urban archeologists and historic preservationists regularly consult them for their work, but accuracy concerned the artists too, because, to a large extent, their sales depended on the perceived authenticity of their images—even a flattering portrayal had to be close enough to reality so as not to destroy credibility. Nor is it a question that the editors overlooked when the artists came calling. A Dallas editor reported that Brosius's 1872 view of that city "shows every house in the corporation limits, together with every street, so accurately drawn that any one acquainted at all with the city can recognize any building." An Austin reporter vouched for the accuracy of "every individual house" in Koch's 1873 drawing of that city, then exclaimed that the lithograph "far exceeds the sample shown us when these gentlemen were here some months ago taking sketches." In San Antonio salesman Stoner "subjected [Koch's drawing] to the inspection of several gentlemen, [and] they failed to discover wherein a single house had been omitted from the drawing." Morse's 1876 view "shows Fort Worth as it is," according to the local editor, while Wellge's 1886 view apparently exceeded that, being the "most accurate and complete drawing ever made of the city."

Despite all that testimony, it was apparent from the start that these views stroked the egos of the local residents and sometimes advertised the cities in shameless ways. It is easy to see that the artist sometimes wrenched the terrain around a bit to fit a particularly significant topographical element into the view. Thus Galveston Bay can be seen in A. L. Westyard's 1891 picture of Houston (perhaps suggesting the city's nearness to the sea), and the Rio Grande seems to make a ninety-degree turn in Wellge's 1892 print of Laredo, perhaps emphasizing the two modern bridges that cross the river and the city's proximity to Mexico. But few were prepared for such deliberate distortions as the 1857 view of Sumner, Kansas, prepared by an unnamed artist and publisher during the Kansas land boom. The handsome view, which depicted a prosperous community with churches, a college, and a hotel, among other impressive structures, was printed by Middletown, Strobridge, and Company in Cincinnati. Copies of the print were distributed throughout New England, and at least one young man was lured west as a result. Much to his disappointment, he found no college or churches. Instead, the main street was "gullied with rains" and "interspersed with rocks and the stumps of trees," and the industrial building shown in the print turned out to be "a rickety old blacksmith's shop." The print, he wrote his father, was a "chromatic triumph of lithographed mendacity."

The bird's-eye views, nevertheless, provided a good representation of the West during the latter half of the nineteenth century, the urban counterpart to Bierstadt's and Moran's colorful images of the Rocky Mountains, Yellowstone, and the Grand Canyon. They also compare well with D. A. Sanborn's famous fire insurance maps, which came into general use in this country at about mid-century, after a disastrous 1835 fire in New York City demonstrated the need for both larger insurance companies and a dependable record of properties. Sanborn first compiled an atlas of Boston, then in 1866 made maps of several Tennessee cities for the Aetna Insurance Company. He went into business for himself the following year and soon expanded his mapping activities to include towns and cities throughout the country.

Just as with the bird's-eye views, Sanborn's maps were block-by-block, street-by-street, structure-by-structure representations of each community, but he used map-

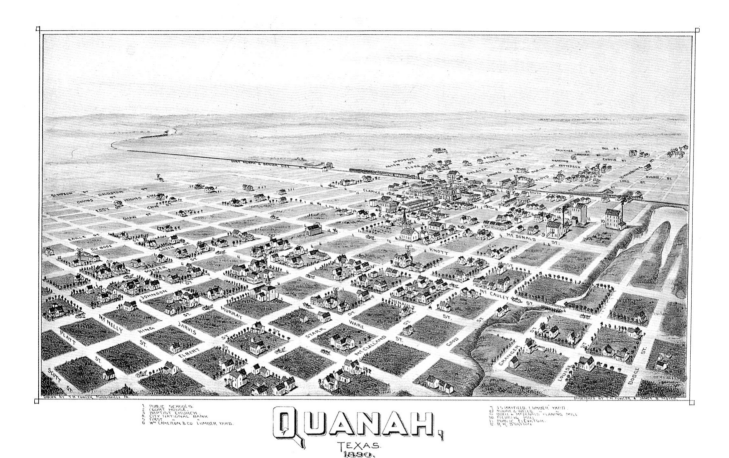

QUANAH,
TEXAS.
1890.

Thaddeus M. Fowler, Quanah, Texas, 1890
(tinted lithograph, published by T. M. Fowler
and James B. Moyer).

ping techniques rather than sketches, portraying the cities at ninety-degree angles rather than the approximately forty-five degrees that most of the bird's-eye view artists used. Thaddeus Fowler's 1890 bird's-eye view of Quanah, Texas, for example, shows the small business section of the city laid out along Johnson and Mercer streets, from the Fort Worth and Denver City Railway Office and Depot to the vacant courthouse square and beyond, a reality that is confirmed on the Sanborn-Perris 1892 map of Quanah, even to the point that sheds and other small, backyard structures are included. The primary business district of the city was originally planned to be Mercer Street, but because speculators purchased all the land and raised the prices, merchants moved over to Johnson Street to establish their businesses. Fowler shows remnants of that process, including the rather elegant Quanah Hotel (at the corner of Clarke and Mercer streets) and the temporary courthouse on the corner of Mercer and McDonald streets.

The business district stretched the two blocks along Johnson Street from the railroad to McDonald Street. Most of the brick and stone buildings shown on the Sanborn-Perris map are accurately depicted on Fowler's view, but there are some differences, which may be attributed to a devastating fire that occurred on August 28, 1891, between Fowler's visit and Sanborn's, that destroyed many of the structures on Johnson Street. Some of the temporary frame structures were replaced with stone and brick

Sanborn-Perris Map Company, Quanah, Hardeman Co., Texas, *1892.*

buildings after the fire, so a frame building on Fowler's view, which is shown as a brick or stone structure on Sanborn's map, might be correct in both instances. The view is more accurate than the map in at least one aspect: Sanborn incorrectly designates the lumber yard at the corner of McDonald and King streets as the Campbell lumber yard, but Fowler correctly shows it as Wm. Cameron and Company. Since the yard is listed as item 6 in the key at the bottom of the print, it is possible that Cameron paid Fowler a fee for the designation, all the more reason for Fowler to get it right.

By the time the bird's-eye views began to fade from popularity, small, attractive souvenir albums full of lithographed illustrations of scenery, cities, and characters appeared throughout the United States and Canada. The West was no exception, as the albums were almost as widespread as the bird's-eye views; in fact, they must have competed with the ubiquitous views for sponsors and customers. They were all manufactured in Germany by what became known as the Glaser-Frey lithographic process.

Most of these pocket-sized books have hard covers, sometimes with decorative or attractive bindings. Made after photographs, the illustrations appear to be photographs. Close investigation of the images and the printing technique, however, reveals otherwise. The lithographers have usually made alterations, such as additions of details or figures, that once spotted suggest that the picture was produced by some kind of print-

ing process. In fact, Louis Glaser of Leipzig and Charles Frey of Frankfurt am Main used a multistone lithographic process to achieve a monochromatic, almost photographic effect that seems to have been rare if not unknown among American lithographers. Using five or more stones, they laid down a series of separate shades ranging from white to light sepia-gray to the darkest sepia-gray or black. The finished lithograph has a varnished surface that creates a greater illusion of depth than a simple lithograph or toned lithograph. Use of five or more stones in the lithographic process was common in American chromolithography, but the printing of oil-based inks to produce a whole series of shades of the same color seems to be unique to Glaser and Frey. Most of the albums were printed in monotones, but Frey and Glaser did produce some multicolored albums of some American cities.

The four major American publishers of these albums—Wittemann Brothers and Adolph Wittemann of New York; Chisholm Brothers of Portland, Maine; and Ward Brothers of Columbus, Ohio—probably purchased the photographs in various parts of the country. Some of the pictures in Charles Frey's *Souvenir of Brownsville, Texas, Ft. Brown, and Matamoros* (c. 1890), for example, apparently were copied after W. H. Chatfield's photographs, for they also appear in Chatfield's *Twin Cities of the Border and the Country of the Lower Rio Grande.* Judging from imprints in the albums themselves, the publishers usually found local businessmen who would assume or share the production costs. J. D. A. Harris sponsored the Dallas album, Victor Phillips and Mason the one of Galveston, N. Tengg and Paul Wagner the ones of San Antonio.

The albums constitute one of the more important visual records of the West during the late nineteenth century. The images are often sharper and more attractive than the extant photographs, and one may find panoramic or bird's-eye views to compare with the larger prints. In addition, there are pictures of courthouses, banks, offices, stores and shops, hotels, warehouses, waterworks, railroad depots, military establishments, bridges, churches, schools, and certain residences (chosen, perhaps, because of the renown of the owner or the architectural interest of the house, or both). The publication of images from one of the pre-1900 Galveston books in Clarence Ousley's *Galveston in 1900* alongside pictures made after the hurricane had devastated the city suggests the historical importance that contemporaries placed on the albums. Nor can one fail to be impressed with the interesting detail contained in the books, such as the bird's-eye view of Galveston with the first battleship *Texas* in the bay, Sacred Heart Church, Ball High School, the Beach Hotel, and the old Clark and Courts building.

By the turn of the century, the West was firmly rooted in the American psyche. More than half a century of literature, science, and art had done its job. After the Civil War, dime novels, melodramas, and Buffalo Bill's Wild West found even larger audiences. Frederic Remington was not the only artist who found his "capital" in the historic West.

Bierstadt's and Moran's famous landscapes emphasize pristine and unspoiled beauty. Unlike William Henry Jackson, who worked side by side with Moran on the Hayden survey and frequently shows a train, a construction site, or a community in his photographs, the painters do not include the hand of man in their landscapes. Charlie Russell appreciated Moran's work for that reason: "When you look at his pictures," he wrote, "the old hills are right there."

Russell probably rejected progress more than any of his colleagues, despising the farmer, refusing to own an automobile, and fearing the effect of the railroad on his beloved West. His philosophy has often been likened to the clock in his favorite saloon, the Mint Bar in Great Falls, Montana. It ran backward, and one had to look in the mirror behind the bar to read it correctly. To Russell it was a metaphor for the relevance of history, a message that he worked into painting after painting. As Nancy Russell, his wife and business manager, told the Great Falls Women's Club in 1914, "Mr. Russell lives in the past as you all know." To a prospective client, she further explained that he identified with the "romance of the West of yesterday and knows its people as well as its animals, their lives and the magic that held them here."

Many people shared his point of view. Wealthy collectors could relive (or imagine) their past through such work, and those who ran railroads, hotels, factories, and other businesses realized its popularity and turned to it to promote their products. They hung giant, new paintings in their homes, offices, hotel lobbies, and railroad stations. They also chromolithographed the paintings by the thousands for art reproductions, calendars, and various other kinds of advertisements so that everyone could share in this vision of the past.

EPILOGUE

*T*he total number of Western prints produced, particularly considering the labor-intensive methods of production, is staggering. The pre–Civil War government prints have already been calculated, at least for the first editions, but there is no way to estimate the number of private publications, for sufficient printing records apparently have not survived. Insofar as the individual prints are concerned, the American Art-Union did ten thousand copies of Bingham's *Jolly Flat Boat Men.* Bierstadt might have printed as many of *The Rocky Mountains* engraving, since it is by far the most common of his important prints, but the final number is not known. By the turn of the century, the ads and magazines that carried Western illustrations were produced in editions of tens and hundreds of thousands.

It is clear that the huge audience for Western prints, whether scientist or congressional committee, would-be immigrant or a curious public simply wanting to know more about the vast domain, valued one characteristic above all others—accuracy. Some would say that this accuracy was nothing more than an aesthetic reaffirmation of the nineteenth-century Romantic view of expansionism, a positive vision of America as a land of freedom and the West as democracy's incubator. But practically all the artists claimed accuracy for their work, from George Catlin and Karl Bodmer to topographic artists to the great landscapists, and they meant something more than an interpretation of history. The critics confirmed it, and James P. Newcomb, editor of the *Tri-Weekly Alamo Express* in San Antonio, revealed the level of confidence that he and other members of the public had invested in pictures when confronted by an illustration of the familiar west side of San Antonio's Main Plaza in *Harper's Weekly* in 1861. The picture is a "miserable cheat," he charged, because the artist (or engraver) had erred in depicting the Plaza House as a "*frame*" building instead of brick. "If all of *Harper's* pictures are of this stripe what a gulled set of folks *Harper's* subscribers are," he concluded.

The artist, of course, was not completely responsible for the print, having to depend on draftsmen, lithographers or engravers, printers, and publishers for the final product. Louis Choris drew some of his pictures on the stone, and Bodmer insured the quality of his work by supervising the printmakers, but others were less fortunate.

Various members of the Topographical Engineers complained about the images that appeared in their works and offered suggestions, which the printers were under no obligation to follow. Sometimes the printmakers made heavy-handed stylistic alterations that might render the image lifeless to the artist but clear and bold to the publisher. At other times, the changes could be devastating to accuracy, as in the case of some of Henry Inman's Indian portraits drawn after Charles Bird King's originals and published in the McKenney and Hall *History of the Indian Tribes.* Like many other beginning illustrators, Remington regularly complained of his treatment at the hands of the wood engravers, but there was nothing he could do about it until his reputation grew to the point that they had to listen to him.

The simple fact is that some prints are excellent copies of the original paintings, and others are not. Historian David J. Weber concludes, for example, that the lithographers of Richard H. Kern's paintings faithfully reproduced scientific works but made improvements on some of the other images, particularly Christian Schuessele's copy of a Navajo man in costume. Discrepancies between Seymour's and Eastman's original paintings and the prints in Long's report and Schoolcraft's Indian history may be seen as minor from one perspective but significant from another. Sometimes the differences were simply mistakes, as is apparently the case in Nathaniel Orr's engraving of Charles Koppel's *Valley of San Pasqual* for the *Pacific Railroad Reports.* But in other instances, the lithographers or engravers might have had political or scientific agendas. Charles Fenderich, a German immigrant, might have wanted to lend a more military air to Daniel P. Whiting's *Monterrey as Seen from a House Top in the Main Plaza* when he added a Napoleonic-looking soldier to the composition. Philadelphia ornithologist John Cassin first became aware of the influence that he could have over illustrations and, as a result, science itself while working on his *Illustrations of the Birds of California.* With hundreds of specimens coming in from the Pacific railroad surveys, he wrote Spencer F. Baird, assistant secretary of the Smithsonian Institution, in February 1855: "When it comes to the picture part of that business I have some idea of offering to contract for them myself—that is in connection with [J. T.] Bowen,—I find that both Bowen and [W. E.] Hitchcock have to be directed and supervised and I think I might as well if I can get into a position of some authority with them, especially Bowen,—I don't see that I can make any money out of it as the proposals have to be at about Bowen's minimum ideas, but I get first rate work done,—as good as my *Birds of California* at least, and looking better on a larger scale." Cassin was probably thinking of exerting political influence rather than changing the nature of the illustrations, but with his assistance, Bowen successfully bid on several contracts for the *Pacific Railroad Reports.* The bird pictures produced under Cassin's oversight might not be as aesthetically pleasing as John James Audubon's, but neither are they as anthropomorphic or romantic. In 1858 Cassin joined Bowen's widow as half-owner and president of the company, solidifying his dominant position in the field of American ornithology and giving him considerable influence in other fields, because the Bowen Company was one of the leading natural history printers in the country.

Needless to say, some pictures are more accurate than others, but in the final analysis, it is equally apparent, even in the case of those pictures that are considered reliable, that truth, like beauty, is in the eye of the beholder, whether artist or viewer. George Catlin and Karl Bodmer earnestly desired to document the Indians and their culture

for posterity and repeatedly claimed success for their efforts, with Catlin even soliciting letters from eyewitnesses who vouched for the authenticity of his images. Historians and anthropologists have considered them valuable sources for decades. Following the lead of anthropologists David Ives Bushnell, Jr., and Clark Wissler, John C. Ewers (ethnologist emeritus at the National Museum of Natural History) has been using eyewitness pictures as documentary evidence on a par with literary records and objects for years. Frequently citing pictures in his classic *The Horse in Blackfoot Indian Culture* (originally published in 1955), Ewers referenced images by artists Paul Kane, Frederich Kurz, Rindisbacher, Catlin, Bodmer, and Wimar in discussing the distribution of the pad saddle.

There are problems associated with pictures, as this discussion of prints suggests, but the deeper concerns deal with interpretation rather than accuracy. As fur trader Henry A. Boller later commented,

> *I would "paint" you, were it not for the constant interruptions . . . two pictures:*
> *The One would represent the bright side of Indian Life, with its feathers, lances, gayly dressed & mounted "banneries", fights, buffalo hunting &c.*
> *The other, the dark side, showing the filth, vermin, poverty, nakedness, suffering, starvation, superstition, &c.* Both would be equally true—neither exaggerated, or distorted; both totally disimillar!

Many artists knowingly chose "the bright side" and in so doing helped create the myth that William H. and William N. Goetzmann have called "the fundamental myth of the American experience, . . . the tale of the American tribe."

Recent scholars have added other interpretative possibilities. Some see more evidence of white attitudes than Indians and their cultures in the pictures, even suggesting that Catlin's and Bodmer's most diligent efforts have been "invalidated by the attitudes with which whites regarded Indians during the nineteenth century." Rather than seriously examining the images to determine what value they might possess, some scholars have dismissed them or treated them only as examples of cultural imperialism, not because they espoused one interpretation or the other but because the artists were white. They no longer see the paintings as part of the serious discussion of Indian cultures.

Some of these authors allow that the portraits might be accurate gauges of white attitudes toward the Indians, but such careful and sensitive creations undoubtedly tell us something about the sitters and their cultures as well. Ewers, for example, also tells of showing Bodmer's stunning portraits to Weasel Tail, an aged Blood Indian, on the Blackfoot Reservation in Montana more than half a century ago. When Ewers turned to the portrait of Stomíck-Sosáck (Bull's Back Fat), Weasel Tail unhesitatingly identified him. Through an interpreter Ewers asked why he thought it was Stomíck-Sosáck, since the portrait had been painted fully two decades before Weasel Tail was born. "I knew his son," Weasel Tail said. "He looked just like that picture."

Regardless of the point of view, however, the fact remains that prints were one of the most important methods of informing the public about the huge Western domain that was acquired in less than half a century of rapid expansion, and only by looking anew at them can we understand much of the motivation that animated our nineteenth-century forebears.

Notes

One: Introduction

Bibliographic information on many of the books discussed in this work may be found in Wagner and Camp, *Plains and the Rockies,* and Bennett, *Practical Guide,* which lists 371 books with color plates.

1 "Graceful and unrestrained": Cooper, *Last of the Mohicans* 1: 70–71.

"Good representations": Wied, *Travels in the Interior of North America* 22: 70. Maximilian went on in this well-known passage to conclude, "It is incredible how much the original American race is hated by its foreign usurpers," but prejudice was not the only reason he found few pictures. Before the widespread use of lithography, relatively few pictures were produced in early America, and even as he wrote, at least four artists and publishers—James Otto Lewis, McKenney and Hall, and George Catlin—had large publication projects under way.

For pictures of Indians, see Parry, *Image of the Indian,* 29, and William C. Sturtevant, "The First Visual Images of Native America," in Chiapelli, *First Images of America,* 417–54; for the impact of lithography on map-making, see Ristow, *American Maps,* 281–301.

2 On early lithography in America, see Peters, *America on Stone,* 22, 88–90, 157–58, 273–75, 312–23, 376–77, 397; Pierce and Slauterback, *Boston Lithography;* Wainwright, *Philadelphia in the Romantic Age of Lithography,* 10; Twyman, *Lithography.* The *Daily National Intelligencer* (Washington, D.C.) Nov. 20, 1822: 2, col. 5, announces the establishment of Henry Stone's lithographic press on "F street opposite the dwelling house of Tench Ringgold."

3 For the story of chromolithography, see Marzio, *Chromolithography.*

"Cheapness of lithographic prints": *Graham's American Monthly,* from Marzio, "American Lithographic Technology Before the Civil War," in Morse, *Prints in and of America,* 215; see also 221, 227. For the growth of lithography, see Peters, *America on Stone,* 312–20; Reilly, *Currier and Ives.*

4 For material on the penny press and the information revolution, see Sandweiss et al., *Eyewitness to War;* Exman, *House of Harper,* 80–93; Jussim, *Visual Communication.*

For the *Lexington* prints, see Brust and Shadwell, "Many Versions and States of the Awful Conflagration," and "Many Versions and States of the Awful Conflagration . . . Update"; Peters, *Currier and Ives,* 1–2.

5 "Literature and art of fact": Fletcher, *Literature of Fact,* as quoted in Stafford, *Voyage into Substance,* xx.

For the many U.S. expeditions, see Goetzmann, *New Lands,* 298–300, 332–33, 338–40, 344–56.

6 For the context of the "art of fact," see Stafford, *Voyage into Substance,* 449. For Bodmer's pictures, see John C. Ewers, "An Appreciation of Karl Bodmer's Pictures of Indians," in Ewers et al., *Views of a Vanishing Frontier.*

6 For points of view on pictures of Indians, see Parry, *Image of the Indian;* Julie Schimmel, "Inventing the 'Indian,'" in Truettner, *West as America,* 149–89; Berkhofer, *White Man's Indian,* 71–111; Dippie, *Vanishing American.*

8 For Boone, see Sweeney, *Columbus of the Woods,* esp. 69. Richard Slotkin in *Regeneration Through Violence* discusses the Boone myth along with several others.

"If the Imagination is shackled": Novak, *American Painting,* 67.

"I place no value": Clark, *Thomas Moran,* 30.

9 "Are so carefully drawn": Wilkins, *Thomas Moran,* 69–70.

"Often . . . found a portrait superior": Tyler, "Approaches to Using Museum Collections," 210.

"Devastating as hidden persuaders": Truettner, *West as America,* 50–51.

TWO: THE GREAT WEST

11 On the fascination with the early West, see Jones, *O Strange New World,* ch. 1.

"Ever held it certain": Hodge, "Narrative of Cabeza de Vaca," 105.

"Few people even know": Catlin, *Letters and Notes* 1: 62.

13 "To obtain new information": Goetzmann, *New Lands,* 1; see also Allen, *Lewis and Clark,* 9; Smith, *European Vision,* 108–32.

15 On early Indian pictures, see Sturtevant, "First Visual Images of Native America," in Chiappelli, *First Images of America,* 417–54, esp. 433; Honour, *European Vision,* entry 59; Harriot, *Briefe and True Report.*

Many of White's watercolors, from which the Bry plates were made, are now in the British Museum. They are apparently copies that White made from his original sketches after he returned to England. On White, see Hulton, *America 1585.* For Jacques Le Moyne de Morgues, see Hulton, *Work of Jacques Le Moyne de Morgues.*

Vancouver quotations under illustration *A Remarkable Mountain:* Vancouver, *A Voyage of Discovery to the North Pacific Ocean,* 334–35.

17 On Cook, see Goetzmann, *New Lands,* 25–51; see also Goetzmann and Williams, *Atlas of North American Exploration,* 42–43, 130–31; Wheat, *Mapping the Trans-Mississippi West* 1: 141; Brosse, *Great Voyages of Discovery,* 71–72.

"Backside of America": Goetzmann, *New Lands,* 47.

"Explore the most unknown parts": Goetzmann and Williams, *Atlas of North American Exploration,* 86. On Carver and the search for a northwest passage, see Goetzmann, *New Lands,* 99–100; Parker, *Journals of Jonathan Carver,* 15–16, 31–33, 43–44; Allen, *Lewis and Clark,* 23–24; Hubach, *Early Midwestern Travel Narratives,* 24.

19 "Shining mountains": Goetzmann and Williams, *Atlas of North American Exploration,* 87.

21 "Natural masterpieces": Stafford, *Voyage into Substance,* 345.

THREE: EARLY ARTISTS IN THE WEST

23 "The Eastern nations sink": an 1807 letter, from Fussell, *Frontier,* 5–6.

On Jefferson, see Donald Jackson, *Thomas Jefferson,* 74–78, 92–94; Goetzmann, *New Lands,* 110–11.

For background of the Lewis and Clark expedition, see Donald Jackson, *Thomas Jefferson,* 98–129, 139–44; Goetzmann, *New Lands,* 112–13; Goetzmann and Williams, *Atlas of North American Exploration,* 136–37.

24 "There are six degrees": *Quarterly Review* 1 (May 1809): 304.

26 For Gass, see Cutright, *History of the Lewis and Clark Journals,* 10–21, 27, 29; Haltman, "Figures in a Western Landscape," 3–17.

Quotations and information on Lewis and Clark: Cutright, *History of the Lewis and Clark Journals,* 28 ["Keeping close," *Eclectic Review* (London) 5, pt. 1 (Feb. 1809): 106–7]; 304 ["Our hopes were somewhat checked," *Quarterly Review* 1 (1809): 294]; 31–32 ("Remarkably unconventional illustrations"); 17–18, 40, 42, 44–46, 49–51 (Lewis's activities and death); 53–57, 59–60 (Clark's activities); 62, 64 (publication of Lewis and Clark's book). On Lewis's papers, see Donald Jackson, *Thomas Jefferson,*

268–80. On Clark's activities, also see Richardson et al., *Charles Willson Peale*, 158–65.

28 On the French colony of Champs d'Asile, see Murat, *Napoleon and the American Dream*, 101–50; Warren, *Sword Was Their Passport*, 189–232; Gardien, "Take Pity on Our Glory," 241–68.

29 Seymour quotations under illustration *View of the Castle Rock:* James, *Account of an Expedition*, Lamar ed., 340–41.

30 Information on the Long expedition: James, *Account of an Expedition*, Lamar ed., xix; Benson, *From Pittsburgh to the Rocky Mountains;* Wood, *Stephen Harriman Long;* Fuller and Hafen, *Journal of Captain John R. Bell.*

31 "Portion of our country": James, *Account of an Expedition*, xix.
"Immense": ibid., 340–41.
James quotation under illustration *Moveable Skin Lodges:* ibid., 393.

32 Story on Long expedition in *Daily National Intelligencer* (Washington, D.C.) Nov. 23, 1820: 3, cols. 2–3.
"Great American Desert": Long's map "Country Drained by the Mississippi Western Section," published in James, *Account of an Expedition.* Long has been credited with originating the idea of the desert, although Zebulon M. Pike clearly described it. See Pike, *Expeditions of Zebulon Montgomery Pike* 2: 525. See also Donald Jackson, *Journals of Zebulon Montgomery Pike* 2: 27n.

33 "Almost wholly unfit for cultivation": James, *Account of an Expedition*, xxv–xxvi, xxix–xxx; see also Goetzmann and Williams, *Atlas of North American Exploration*, 144.

34 "Be of great value": *Daily National Intelligencer* Jan. 8, 1823: 3, col. 4.
"Elegantly executed": *Niles Weekly Register* 23 (Feb. 8, 1823), 353–54; for other reviews see Everett, "Long's Expedition," 267 ("well executed"); *Monthly Review* (London) 102 (Sept. 1823): 71 ("style is plain").

35 Information on Doughty: Trenton and Hassrick, *Rocky Mountains*, 24–28. See also Martha A. Sandweiss, "The Public Life of Western Art," in Prown, *Discovered Lands*, 117–33.

FOUR: THE NOBILITY OF NATURE

37 "There is . . . no time": *Quarterly Review* 1 (1809): 293.
"Black and blue cloth": Catlin, *Letters and Notes* 1: 2.

38 Information on Rindisbacher and quotations: Josephy, *Artist Was a Young Man*, 41, 43, 65–67, 73.
Information on Indian delegations to Washington: Viola, *Diplomats in Buckskins*, 13–21; Turner, *Red Men.*
Information on Saint-Mémin: Ewers, *Artists of the Old West*, 12–15.
Information on McKenney: Viola, *Diplomats in Buckskins*, 238–46; Viola, *Indian Legacy* and *Thomas L. McKenney.*

39 "Striking likeness": Viola, *Thomas L. McKenney*, 247.
"For the pictures of these wretches": ibid., 248–50.
"Rare & curious": ibid., 251.

40 Information on early lithography in Philadelphia: Wainwright, *Philadelphia in the Romantic Age of Lithography.*
"I consider the above copy" and letters to Adams and Biddle: Viola, *Thomas L. McKenney*, 255.

42 "The first attempt": J. O. Lewis, *Aboriginal Port-Folio*, as quoted in McKenney and Hall, *Indian Tribes of North America* 1: xxxvii–xxxviii; see also Dippie, *Catlin and His Contemporaries*, 86–88.

43 *The National Union Catalogue* lists a London edition of the Lewis portfolio in 1838 and a New York edition in 1853, which contains the preface from the London edition. OCLC lists an 1850 edition.
"Best that can be said": Hodge's preface to a 1933 edition of McKenney and Hall, *Indian Tribes of North America* 1: xxxvi.
"My materials . . . are very voluminous": Viola, *Thomas L. McKenney*, 267.
"Man, in the simplicity ": Catlin, *Letters and Notes* 1: 2.
For Hall's plans, see Viola, *Thomas L. McKenney*, 267–68, 277; Dippie, *Catlin and His Contemporaries*, 84–86; Horan, *McKenney-Hall Portrait Gallery*, 108.

43-44 "Complete monopoly" and "astounded": Dippie, *Catlin and His Contemporaries*, 85–86; see also Truettner, *Natural Man Observed*, 26.

45 Hall and McKenney quotations and *History* reviews: Viola, *Thomas L. McKenney*, 267–68, 270, 277–78.

45 For public response to McKenney, see ibid., 268–71; Dippie, *Catlin and His Contemporaries,* 91.
For McKenney's difficulties, see Viola, *Thomas L. McKenney,* 272–74.
For various artists who contributed to McKenney and Hall, see Horan, *McKenney-Hall Portrait Gallery,* 118, 152, 166, 320, 322, 324, 326, 332, 336.

46 For accuracy of McKenney and Hall prints, see Viola, *Indian Legacy,* 82–83; Marzio, *Chromolithography,* 8, 12–15.
For Smithsonian fire, see Viola, *Thomas L. McKenney,* 278.
On Inman copies, see ibid., 278–80; Stewart, *American West,* 22–25; *Native North Americans.* Other Inman paintings are in various private collections.
"Become the historian": Truettner, *Natural Man Observed,* 12. Catlin information, ibid., 26, 131.
"Phoenix-like": Catlin, *Letters and Notes* 1: 16.

48 "The desire": Truettner, *Natural Man Observed,* 23.
For Catlin's career, see Truettner, *Natural Man Observed;* Dippie, *Catlin and His Contemporaries;* McCracken, *George Catlin.*
For Clark's museum, see Ewers, "William Clark's Indian Museum in Saint Louis, 1816–1838," in Bell et al., *Cabinet of Curiosities,* 49–72.
"It is incredible": Wied, *Travels in the Interior of North America* 22: 70.

50 "Monument to a dying race": Roehm, *Letters of George Catlin,* 442.

51 "Fullness of the life": Dippie, *Catlin and His Contemporaries,* 3.
"Literary talents": Truettner, *Natural Man Observed,* 43.
For a bibliography of Catlin's publications, see McCracken, *George Catlin,* 212–13. Ackerman was defensive of the reputation of American lithographers. When he reprinted Catlin's *Portfolio,* he reminded the public in his introduction that "This venture, receiving no impulse from the powerful arm of an overflowing government treasury, starts on an 'Exploring Expedition' of its own, into the waters of criticism."

52 On the Swedish edition, see also Piercy, *Route from Liverpool,* xxiii.
For the use of Catlin's work, see John Porter Bloom, "*American Turf Register and Sporting Magazine,* 1829–44," in McDermott, *Travelers on the Western Frontier,* 201. Frontispiece for the May 1842 issue was *A Patrician of the New World,* copied from Catlin's *Letters and Notes.*
"Decided hit": Roehm, *Letters of George Catlin,* 156–57.
Maximilian review, "Einige Bermerkungen über Geo. Catlins Werk: *Letters and notes on the manners, customs, and condition of the North-American Indians,*" *Isis* (1842): 726–27, cited in Orr and Porter, "A Journey Through the Nebraska Region in 1833 and 1834," 329.

53 Miller letter: Warner, *Fort Laramie,* 191–92.
"Ah! Mr. Catlin": Maria A. Audubon, *Audubon and His Journals* 1: 497.

54 "Bold daubs": Truettner, "For Foreign Audiences: George Catlin's North American Indian Portfolio," in Tyler, *Prints of the American West,* 29.
"The chief brandishing his lance": Honour, *European Vision,* entry 298.

55 *Catlin's North American Indian Portfolio* is fully discussed in Truettner, "For Foreign Audiences," 25–45.
On the prints, see Bernard Reilly, Jr., "Prints of Life in the West, 1840–1860," in Tyler, *American Frontier Life,* 173.

56 Quotation about Maximilian: Thomas and Ronnefeldt, *People of the First Man,* 16; see also Hunt and Gallagher, *Karl Bodmer's America,* illustrated with all the Bodmer watercolors in the Joslyn Art Museum collection.
"I would want to bring along a draftsman": William J. Orr, "Karl Bodmer: The Artist's Life," in Hunt and Gallagher, *Karl Bodmer's America,* 352.

57 "On the ship": ibid.
Catlin's view of the racial origin of the Indians: Catlin, *Letters and Notes* 1: 206–7.

58 For Bodmer's Paris exhibition, see Orr, "Karl Bodmer," in Hunt and Gallagher, *Karl Bodmer's America,* 360, quoting "Salon de 1836," in *L'Artiste* 9 (1836): 170.
The engravers who signed the plates are: Allais, Aubert père, Beyer, Bishop, Chollet, N. Desmadryl, Doherty, Du Casse, A. Fournier, Ch. Geoffroy, Himely, I. Hurlimann, Laderer, Paul Legrand, Alex Manceau, Martens, John Outhwaite, Rene Rollet, Slathé, Talbot, Tavernier, Ch. Vogel, Lucas Weber, and A. Zschokke. For background on engravers, see Christine E. Jackson, *Bird Etchings.*

60 Michael Harrison of Fair Oaks, California, graciously permitted me to use the copies of the Bodmer and Maximilian correspondence (along with the translations) in the Harrison Library in Fair Oaks. The Bodmer-Maximilian and Hölscher-Maximilian correspondence cited here is from that collection. Bodmer to Maximilian, Paris, n.d. but filed between 14iv and 4vi 1840 ("I have had much misfortune"); Feb. 22, 1840 ("in case there should be one"); April 9, 1838 ("memory and . . . existing sketches"); Jan. 22, 1839 ("vividly recall" and "Regarding the ugliness"); Feb. 5, 1840 ("I have designed"); n.d. but filed between 14iv and 4vi 1840 ("the interpreter points"); July 18, 1840 ("I have mainly strived").

On the Bodmer prints, see George P. Tomko, "The Western Prints of Karl Bodmer," in Tyler, *Prints of the American West,* 50–52.

62 Dawn Glanz, in *How the West Was Drawn,* 87, offers information about Bodmer's depiction of animals. The snow finch is plate 398 in Audubon's *Birds of America.*

Bodmer to Maximilian, Paris, Nov. 1, 1839 ("The Societe"); Dec. 28, 1838 ("Mato tope").

For discussions of Bodmer's compositions, see Orr and Porter, "Journey Through the Nebraska Region," 334, 389; Tomko, "Western Prints of Karl Bodmer," in Tyler, *Prints of the American West,* 50, quoting Johnson, "Carl Bodmer Paints the Indian Frontier."

The number of prospectuses and books printed is discussed in the Hölscher-Maximilian correspondence in the Harrison Library. Hölscher was the publisher of the book.

63 "The reviewers demand": Hölscher to Maximilian, Jan. 29, 1840.

An advertisement for the book appeared in the *Saturday Courier* (Philadelphia) Dec. 2, 1843. Maximilian lists the subscribers in *Reise in das innere Nord-America* 1: front. Peter Herbert Hammell also estimates the number printed in his thesis "Images of the American Indian," 28.

"Magnificent," "the most splendid": *Saturday Courier* Dec. 2, 1843: 2, col. 6.

On the rendezvous, see Morgan and Harris, *Rocky Mountain Journals,* 18–26; De Voto, *Across the Wide Missouri;* Wishart, *Fur Trade;* Clokey, *William H. Ashley.*

64 "Your kind indulgence": ibid., 44.

65 On Miller's trip, see Tyler, *Alfred Jacob Miller,* 36–41.

Audubon quotation under illustration *American Bison:* Ford, *Audubon's Animals,* 197.

"I say with perfect confidence": Warder H. Cadbury, "Alfred Jacob Miller's Chromolithographs," in ibid., 447.

The catalogue raisonné of Miller's paintings in Tyler, *Alfred Jacob Miller,* lists all the paintings that were known at the time the book was published.

66 "Mr. Audubon is quite an aged man": Ford, *John James Audubon,* 401.

"Dressed in magnificent attire": Maria A. Audubon, *Audubon and His Journals* 2: 27.

"His gang": Audubon to "Dearest Friends," April 17, 1843, in McDermott, *Audubon in the West,* 57.

67 "The variety": Bannon and Clark, *Handbook of Audubon Prints,* 65.

"For the last four nights" and "they are the most beautiful": Ford, *Audubon's Animals,* 59.

Bibliographic information on all Audubon's publications: Bannon and Clark, *Handbook of Audubon Prints.*

FIVE: THE DISCOVERY OF THE WEST

Much information for this chapter comes from Goetzmann, *Army Exploration,* and Mattes, *Great Platte River Road.*

69 "Integrity of the Union": Abert to Stephen Markoe, Washington, May 18, 1849, in Letters Sent by the Topographical Bureau.

Information on the surveys may be found in Goetzmann, *New Lands,* esp. 178.

70 "Tired of all this": Haskell, *United States Exploring Expedition,* 23.

Background information on patronage of American arists: Miller, *Patrons and Patriotism.* Information on the army officer corps: Kindred, "Army Officer Corps and the Arts." Eastman's *Treatise* gives some idea of the instruction that the cadets received at West Point.

72 Information on the Wilkes expedition: Viola and Margolis, *Magnificent Voyages,* 9–10.

"Heterogeneous mass": Stanton, *Great United States Exploring Expedition,* 115.

73 "Everlasting Expedition": Haskell, *United States Exploring Expedition,* 9.

73 "Richly embellished": *Graham's American Monthly* 27 (Aug. 1845): 96.

The various printings of Wilkes's *Narrative* are thoroughly discussed in Haskell, *United States Exploring Expedition,* 31–45.

Information on the Frémont expedition: Trenton and Hassrick, *Rocky Mountains,* 39; Goetzmann, *Army Exploration;* Goetzmann and Williams, *Atlas of North American Exploration,* 158–59; Preuss, *Exploring with Frémont;* Nevins, *Frémont.* See also Frémont's own writings in *Report on an Exploration* and *Report of the Exploring Expedition.*

74 "That's the way it often is": Preuss, *Exploring with Frémont,* 32–33.

"One main striking feature": Trenton and Hassrick, *Rocky Mountains,* 40.

"Still and solitary grandeur": Goetzmann, *Army Exploration,* 91.

75 "The best rule": Eastman, *Treatise,* 30. See Novak, *Nature and Culture,* 38, for sentiments of members of the Hudson River School. Chapter 8 deals with drawing a perspective view.

"The great utility": Eastman, *Treatise,* 22.

76 "I cannot conclude": Abert, *Message from the President,* 17. The best edition of Abert's journal is Carroll, *Guadal P'a.* Abert's journal and watercolors from the expedition have also been published in Galvin's *Through the Country of the Comanche Indians* and *Western America in 1846–1847.*

"Should a painter": Trenton and Hassrick, *Rocky Mountains,* 45.

77 "A lot of coloured pencils": ibid., 49.

For the camera lucida and its uses, see Hammond and Austin, *Camera Lucida.*

On the prints of the Mexican War, see Tyler, *Mexican War,* and Sandweiss et al., *Eyewitness to War.*

78 For the Kearny expedition, see Goetzmann, *Army Exploration;* Clarke, *Stephen Watts Kearny;* Emory, *Notes of a Military Reconnoissance.*

79 For John Mix Stanley, see Schimmel, "John Mix Stanley."

For the Abert survey, see Abert, *Report of the Secretary of War.*

80 For the Stansbury expedition, see Madsen, *Forty-Niner in Utah* and *Exploring the Great Salt Lake.*

82 "Vast *inland* sea": Stansbury, *Exploration of the Valley of the Great Salt Lake,* xii.

On Hudson, see Madsen, *Forty-Niner in Utah,* 80.

On Piercy, see Jonathan Fairbanks, "The Great Platte River Trail in 1853: The Drawings and Sketches of Frederick Piercy," in Tyler, *Prints of the American West;* Piercy, *Route from Liverpool.*

83 For the treaty of Guadalupe Hidalgo, see Richard Griswold del Castillo, *The Treaty of Guadalupe Hidalgo: A Legacy of Conflict.* Article V, which dealt with the boundary, is on pp. 187–88.

For the work of the Mexican commission, see Hewitt, "Mexican Commission," and "Mexican Boundary Survey Team"; Werne, "Major Emory and Captain Jimenez," and "Surveying the Rio Grande."

For the Bartlett survey, see Goetzmann, "United States–Mexican Boundary Survey."

84 "To perpetuate": Emory, "Personal Account": Emory, *Report on the United States and Mexican Boundary Survey* 1: 96.

Information about Bartlett also from Hine, *Bartlett's West.*

"Bursts out from its cavernous reservoir": Marcy, *Exploration of the Red River,* 59. Further information on Marcy: Flores, *Caprock Canyons,* 105–7.

For the Ruffner-McCauley expedition, see Baker, "Survey of the Headwaters."

For the Pacific railroad surveys, see Goetzmann and Williams, *Atlas of North American Exploration;* Goetzmann, *Army Exploration;* Taft, *Artists and Illustrators.*

86 "Most practical and economical": Goetzmann, *Exploration and Empire,* 281.

87 For the Gray survey, see Bailey, *Survey of a Route on the 32nd Parallel.*

For the Pacific Railroad Survey, see Goetzmann, *Army Exploration,* esp. ch. 8.

88 Among the many printers and artists involved in producing the reproductions were engraver Edwin Bellman of New York and Brooklyn, chromolithographer Julius Bien of New York, engraver William H. Dougal of Washington, engraver Robert Hinshelwood of New York, lithographer August Hoen of Baltimore, engraver Samuel V. Hunt of Brooklyn, engravers Benson J. Lossing & William Barritt of New York, engravers John W. & Nathaniel Orr of New York, engraver Samuel J. Pinkney of New York, engravers James H. Richardson & Thomas J. Cox, Jr., of New York, engraver William Roberts of New York or Philadelphia, chromolithographers Sarony, Major & Knapp of New York, engraver Selmar Siebert of Washington, lithographer Thomas Sinclair of Philadelphia, engraver James D. Smillie of New York, and wood engravers Elias J. Whitney & Albert H. Jocelyn of New York.

88 On Kern and the other artists, see Taft, *Artists and Illustrators;* Weber, *Richard H. Kern,* 236–37.
"The landscape views": John W. Gunnison and Edward G. Beckwith, "Report," in *Reports of Explorations and Surveys* 2: 126.
"These views [of Dakota Territory] are so vast": Goetzmann, *Army Exploration,* 334.

90 On Schuchard, see Peter R. Brady, "The Reminiscences of Peter R. Brady of the A. B. Gray Railroad Survey, 1853–1854": Bailey, *Survey of a Route on the 32nd Parallel,* 172, 183. Many of Schuchard's other drawings were destroyed in the 1865 fire in the Smithsonian Institution, and according to Brady, Gray kept several. See also Taft, *Artists and Illustrators.* The thirty-three plates are listed in Wagner and Camp, *Plains and the Rockies,* 522–24.

91 "Some Senators": Taft, *Artists and Illustrators,* 7.
"By a mistake": "Report," in *Reports of Explorations and Surveys* 5: 127.

92 "I . . . do not concur with Mr. Schott": Emory, *Report on the United States and Mexican Boundary Survey* 1: viii.
Martha A. Sandweiss makes some interesting observations about prints in "The Public Life of Western Art" in Prown, *Discovered Lands;* also see Karpenstein, "Illustrations of the West."
"The Government had expended": Sandweiss, "Public Life of Western Art," in Prown, *Discovered Lands,* 128.
"Great Canyon": Chamberlain, *My Confession,* 284. The Chamberlain manuscript, which contains both the journal and the unpublished paintings of the Grand Canyon, is in the collection of the West Point Museum. See also Goetzmann, *Sam Chamberlain's Mexican War,* 14.

93 "Stately facades": Goetzmann, *Army Exploration,* 387.
"Probably nowhere in the world": Goetzmann and Williams, *Atlas of North American Exploration,* 64.

95 On Möllhausen, see Goetzmann, *Army Exploration;* Taft, *Artists and Illustrators;* Stegner, *Beyond the Hundredth Meridian,* 51, 186, 189; Huseman, "Romanticism and the Scientific Aesthetic." The original Möllhausen watercolors are in the collection of the Amon Carter Museum, Fort Worth.
Stegner quotations: Stegner, *Beyond the Hundredth Meridian,* 51 ("nightmare"); 186 ("merely literal"); 189 ("never was a great subject").

98 Schoolcraft and Gibbs quotations: Dippie, *Catlin and His Contemporaries,* 173 ("history, present condition"); 173–74 ("authentic data"); 176–77 ("cupidity of the members"); 92 ("Cyclopedia Indianensis"); 200–201 ("much less").

100 On Eastman, see McDermott, *Seth Eastman.*

101 "In the character of": McDermott, *Seth Eastman,* 81.
"Capt. Eastman's beautiful drawings": Marzio, *Chromolithography,* 30. Marzio, 30–31, also analyzes the prints in Schoolcraft's book.
"Wholly sylvan," and "toilsome journey": Sandweiss, "Public Life of Western Art," in Prown, *Discovered Lands,* 123, 126.

102 Information on the price of the prints supplied to the government: Records of the Accounting Offices, Misc. Treas. Acc. 127113, 1532 (Duval's payment) and 127338, 817 (Sarony & Company's payment); 115908, 295 (Marcy's first edition) and 117369, 881 (second edition).

103 Taft, *Artists and Illustrators,* 5, estimates the amount of money spent on the Pacific Railroad surveys.
Prices of the prints: Records of the Accounting Offices, Misc. Treas. Acc. 123661, 333 (Orr); 132891, 663 (Sinclair); 132891, 665 (Cassin).

104 Total cost of $489,000 converted to today's dollars by multiplying by 16.29 for inflation. See McCusker, "How Much Is That in Real Money?" pt. 2, 328, 332.

105 B. B. French, *Frémont's Report,* tells of Weber's delay in delivering prints for the Frémont publication.
Information on the photographers: Naef and Wood, *Era of Exploration;* Woodhouse, *Naturalist in Indian Territory;* Rudisill, *Mirror Image.*

106 "Was of comparatively little importance": Rudisill, *Mirror Image,* 34.
"A good artist": Simpson, *Journal of a Military Reconnaissance,* 8.
"The author has frequently been asked": Mathews, *Pencil Sketches of Montana,* introduction.
"Masterpieces of realism": Goetzmann, *Exploration and Empire,* 513.
"Art without falsification": Stegner, *Beyond the Hundredth Meridian,* 189, 191.

107 "With the exception": Savage, "Photographic Tour," 288.

SIX: THE DISCOVERY OF
WESTERN AMERICANS

109 Background information on genre painting and national types: Johns, *American Genre Painting.*

"Correct pictures": Tuckerman as quoted in Peter H. Hassrick's introduction to Tyler, *American Frontier Life,* 9.

110 Information on Deas: Carol Clark, "Charles Deas," in Tyler, *American Frontier Life,* 51–77; Glanz, *How the West Was Drawn.*

Background information on the trapper: Goetzmann, *Mountain Men,* 9.

Deas's *Long Jakes* (1844) is in the Manoogian Collection, Detroit.

"A broad white hat": Carleton as quoted in Clark, "Charles Deas," in Tyler, *American Frontier Life,* 59.

"State of tension": Ruxton as quoted in Glanz, *How the West Was Drawn,* 45.

111 "Venturesome young men": *Broadway Journal* as quoted in Clark, "Charles Deas," in Tyler, *American Frontier Life,* 61–62.

"Instinct of primitive man": Ruxton as quoted in Glanz, *How the West Was Drawn,* 45.

Deas's *Death Struggle* (1845) is now at the Shelburne Museum in Vermont.

Samuels's painting is in the Witte Museum, San Antonio.

"A scene in the far West": *Transactions of the Western Art-Union for the Year 1850,* 15. For additional information on Ranney, see Gruber, *William Ranney;* Linda Ayres, "William Ranney," in Tyler, *American Frontier Life.*

112 "Remained in Texas": Ayres, "William Ranney," in Tyler, *American Frontier Life,* 80.

113 On Tait's prints, see Warder H. Cadbury, "Arthur F. Tait," in Tyler, *American Frontier Life;* Cadbury, *Arthur Fitzwilliam Tait.*

"A more spacious view": *New York Daily Tribune,* June 21, 1851, as quoted in Ayres, "William Ranney," in Tyler, *American Frontier Life,* 97.

"If the Indians follow" and "they came within shooting distance": Cadbury, "Arthur F. Tait," in Tyler, *American Frontier Life,* 119, 122.

115 "Singular aquatic race": Irving, *Astoria* 1: 141.

On Bingham, see Shapiro et al., *George Caleb Bingham;* Bloch, *George Caleb Bingham;* McDermott, *George Caleb Bingham.*

"At this time": Flint, *History and Geography of the Mississippi Valley,* 157.

"Presented a figure": Blair and Meine, *Half Horse,* 47–48.

116 "Whole race of pioneers": Morgan Neville, "The Last of the Boatmen," in Blair and Meine, *Half Horse,* 260.

On the mezzotinting process, see Wax, *Mezzotint.*

"Vulgar subject": *Literary World* 1 (April 3, 1847): 209 and (Oct. 23, 1847): 277.

"Mr. Bingham has struck out": *Daily Missouri Republican* April 21, 1847: 2

"Thoroughly American": Johns, *American Genre Painting,* 88.

For the copies, see McDermott, "Jolly Flatboatmen."

118 Information on Indians: Herman J. Viola, "The American Indian Genre Paintings of Catlin, Stanley, Wimar, Eastman, and Miller," and Bernard Reilly, Jr., "The Prints of Life in the West, 1840–60," both in Tyler, *American Frontier Life,* 131–65, 167–92; Rick Stewart et al., *Carl Wimar.*

"Home scene": *Missouri Republican* in 1848, as quoted in Julie Schimmel, "Inventing the 'Indian,'" in Truettner, *West as America,* 149.

119 For background on Wimar's painting *Attack on an Emigrant Train,* see John C. Ewers, "Fact and Fiction in the Documentary Art of the American West," in McDermott, *Frontier Re-examined,* 85; Stewart et al., *Carl Wimar,* 67.

For Bartlett's picture, see Bartlett, *Personal Narrative* 2: 412.

On Darley, see Ewers, "Not Quite Redmen," 88–98; Sue W. Reed, "F.O.C. Darley's Outline Illustrations," in Ward, *American Illustrated Book,* 113–35.

For the attack on the Deadwood Stage Coach and Buffalo Bill's Wild West show, see Russell, *Wild West,* esp. pp. 12 and 53.

120 "Unpassable": Marryat, *Mountains and Molehills,* 161.

"Independent Way to California": *Daily National Intelligencer* Jan. 1, 1849: 5, col. 3.

On the gold rush, see Watkins, *Gold and Silver.*

120 "Heathen Chinee": Bret Harte, *Plain Language from Truthful James* (1870), stanza 1. See Harte, *Heathen Chinee*. "Heathen Chinee" was a popular phrase, and several publishers used it to title their prints, for example, *The Heathen Chinee* (c. 1870, 19.78/1-10) in the collection of the Amon Carter Museum, Fort Worth, Texas.

Beard's *Westward Ho!* (c. 1850) is at DePauw University, Greencastle, Indiana.

Bingham's *Squatters* (1850) is currently on the art market.

122 "The only pleasure": Tocqueville as quoted in Rash, *Paintings and Politics,* 120.

123 "As national as possible": Rash, *Paintings and Politics,* 130.

"Genre painters": Johns, *American Genre Painting,* 198.

124 For additional information on the cowboy, see Taylor and Maar, *American Cowboy.*

"Rough men with shaggy hair" and "armed desperadoes": Tyler, *Cowboy,* 12. See also Westermeier, *Trailing the Cowboy,* 140–43.

"A constant source of peril": Tyler, *Cowboy,* 12.

"This kind of life": *Victoria Advocate* Jan. 5, 1878.

"I have taken part with them": Roosevelt as quoted in Tyler, *Cowboy,* 12–13.

125 "There is perhaps no class of civilized beings": *Victoria Advocate* April 12, 1879.

127 "Cowboy Artist": Yost and Renner, *Bibliography,* facing 111. On Russell, see McCracken, *Charles M. Russell Book;* Hassrick, *Charles M. Russell,* 81–106.

On Remington, see Samuels and Samuels, *Frederic Remington,* 35–36. Exman, *House of Harper,* 114–15, provides information on *Harper's.*

Antelope Hunting appeared as a chromolithograph in A. C. Gould's *Sport; or, Shooting and Fishing.*

129 "Brooklyn-style": Hough, "Wild West Faking."

130 "To morrow I start for 'my people'": Remington as quoted in Samuels and Samuels, *Remington,* 296–97.

"I knew the railroad was coming": Remington, "Few Words," 16.

"Shall never come west again": Splete and Splete, *Frederic Remington,* 318.

On Remington prints, see Samuels and Samuels, *Remington.* Hassrick, *Frederic Remington,* 146, is illustrated with *His First Lesson.*

On Remington, see Ballinger, *Frederic Remington's Southwest* and *Frederic Remington;* Hassrick, *Frederic Remington, the Late Years;* Shapiro and Hassrick, *Frederic Remington;* Vorpahl, *Frederic Remington and the West* and *My Dear Wister.*

SEVEN: THE LANDSCAPE AS SPECTACULAR

133 Nostrand provides much information on California artists in *First Hundred Years.*

"Low-taste . . . vulgar": Johns, *American Genre Painting,* 198.

134 "For the Rocky Mountains": Trenton and Hassrick, *Rocky Mountains,* 120.

"The mountains are very fine": Anderson and Ferber, *Albert Bierstadt,* 145. For the Lander Cut-Off, see W. Turrentine Jackson, *Wagon Roads West,* 212–14.

135 "No ordinary privation": Anderson and Ferber, *Albert Bierstadt,* 73. See also Nancy K. Anderson, " 'Curious Historical Artistic Data': Art History and Western American Art," in Prown, *Discovered Lands,* 8; Trenton and Hassrick, *Rocky Mountains,* 122.

"Lovers of landscape": Anderson and Ferber, *Albert Bierstadt,* 74.

136 Bierstadt quotations and review: Anderson, "Curious Historical Artistic Data," in Prown, *Discovered Lands,* 8 ("a series of large pictures"); 10 ("this picture represents"); 11 ("a mere copyist of nature").

Church's *Heart of the Andes* (1859) is in the Metropolitan Museum of Art, New York.

On Bierstadt's prints, see Helena E. Wright, "Bierstadt and the Business of Printmaking," in Anderson and Ferber, *Albert Bierstadt,* 272–73.

139 "American hunting riflemen": Lamar, *Reader's Encyclopedia of the American West,* 113.

139 "The educating influence": Wright, "Bierstadt and the Business of Printmaking," in Anderson and Ferber, *Albert Bierstadt,* 268.

"Chromo-Civilization": *Nation* Sept. 24, 1874, as quoted in Marzio, *Chromolithography,* 1. Marzio provides information on Prang's prints after Moran, as does Kinsey, *Thomas Moran.* On Moran and his

career, see Clark, *Thomas Moran;* Wilkins, *Thomas Moran;* Ayres, *Thomas Moran's Watercolors;* Morand et al., *Splendors of the American West,* among others.

140 "Practically self-taught": Marzio, *Chromolithography,* 112.

141 "By means of": Clark, *Thomas Moran,* 11. For Hayden's article, see Hayden, "Wonders of the West," 390–91.

"Mr. Moran": Ayres, *Thomas Moran's Watercolors,* 8.

142 "Frail, almost cadaverous": Ayres, *Thomas Moran's Watercolors,* 8–9. See also William Henry Jackson, *Time Exposure,* 200.

Moran owned several Jackson photographs. Some illustrate Morand et al., *Splendors of the American West,* 63–65. Also see Hales, *William Henry Jackson,* 103–4, and Bossen, "Tall Tale Retold."

144 "Most brilliant and poetic pictures": Wilkins, *Thomas Moran,* 71.

"Rapid, racy, powerful": Ayres, *Thomas Moran's Watercolors,* 25.

"12 or more watercolor pictures": Marzio, *Chromolithography,* 108.

145 "No hindrance": Kinsey, *Thomas Moran,* 79. See also T. Victoria Hansen, "Thomas Moran and Nineteenth-century Printmaking," in Morand and Friese, *Prints of Thomas Moran,* 16; Wilkins, *Thomas Moran,* 152.

"If chromolithography is not an art": Hansen, "Thomas Moran and Nineteenth-century Printmaking," in Morand and Friese, *Prints of Thomas Moran,* 16.

146 "Those bubbling cauldrons of nature": W. H. Jackson, *Time Exposure,* 198.

"Wild, weird beauty": Goetzmann, *Exploration and Empire,* 508.

"The brain reels": Ayres, *Thomas Moran's Watercolors,* 16.

147 "Hamlet": Marzio, *Chromolithography,* 107, 109.

"Willing to undertake": Kinsey, *Thomas Moran,* 88. For O'Sullivan's photographs, see Snyder, *American Frontier.*

149 "No finer specimens": Marzio, *Chromolithography,* 107, quoting the *Times* from *Printing Times and Lithographer* (London) Jan. 15, 1878: 13.

"Most awfully grand and impressive": Bassford and Fryxell, *Home-thoughts,* 39–40.

150 "Grand facade of storm-carved rocks": Wilkins, *Thomas Moran,* 87.

Information on Moran and the Grand Canyon: Kinsey, *Thomas Moran,* 125–29; Wilkins, *Thomas Moran;* Truettner, "Scenes of Majesty."

On cityviews, see Reps, *Cities on Stone* and *Views and Viewmakers.*

"Showed us several of his pictures": Reps, *Cities on Stone,* 24.

"Some drawings": *Galveston Daily News* Mar. 10, 1871: 3, col. 2.

152 *Sunset, Texas* is in the collection of the Amon Carter Museum in Fort Worth, Texas.

140 "Had no difficulty": Reps, *Views and Viewmakers,* 41.

"A sufficient number of subscribers": *Dallas Herald* Dec. 28, 1872: 2, col. 1.

Information on the Denison, Fort Worth, and San Antonio views: *Sunday Gazetteer* (Denison, Texas) Nov. 29, 1885: 1, col. 7; *Fort Worth Democrat* April 1, 1876: 3, col. 5; *San Antonio Daily Herald* Jan. 28, 1873: 3, col. 2.

Henry Wellge (attrib.), *Perspective Map of the City of Laredo, Texas,* in the collection of the Geography and Map Division, Library of Congress.

153 "Shows every house": *Dallas Herald* Dec. 28, 1872: 2, col. 1.

"Every individual house": *Austin Daily Democratic Statesman* Jan. 9, 1873: 3, col. 1.

"Subjected [Koch's drawing] to the inspection": *San Antonio Daily Herald* Jan. 28, 1873: 3, col. 2.

"Shows Fort Worth as it is": *Fort Worth Democrat* April 1, 1876: 3, col. 5.

"Most accurate and complete drawing": *Fort Worth Gazette* Dec. 25, 1885: 8, col. 1.

"Gullied with rains": Reps, *Views and Viewmakers,* 69. The view of Sumner is in the collection of the Kansas State Historical Society, Topeka.

154 Information on Quanah: Fowler's bird's-eye view *Quanah Texas, 1890;* the Sanborn-Perris May map of Quanah; Neal, *Last Frontier,* 50, 52, 53. See also Ristow, *American Maps,* 258.

156 Herman H. Henkle of Chicago has collected Glaser-Frey and other American view books over several years and provided much of the information that I have used. He is currently preparing a bibliographic history of the books. Bamber Gascoigne describes this lithographic process in *How to Identify Prints,* 56.

156 Russell quotations and information: Hassrick, *Charles M. Russell,* 139 ("when you look at his pictures"); 8 (clock in the Mint Bar); 110 ("Mr. Russell lives in the past").

"Romance of the West": Nancy Russell to Ralph Budd, Oct. 15, 1924, Britzman Collection, Colorado Springs Fine Arts Center, as quoted in Dippie, "The Moving Finger Writes," in Prown, *Discovered Lands,* 114.

For additional information on the cowboy, see Taylor and Maar, *American Cowboy.*

EPILOGUE

158 Estimate of the number of Bingham prints: Bernard Reilly, Jr., "Prints of Life in the West, 1840–1860," in Tyler, *American Frontier Life,* 188.

"Miserable cheat": *Tri-Weekly Alamo Express* (San Antonio) Mar. 29, 1861. The offending image is in *Harper's Weekly* Mar. 23, 1861. There is reason to believe that the artist, in this case probably Carl G. von Iwonski, got it right and the *Harper's* engraver changed the building to a frame structure, because another Iwonski drawing shows the building correctly. Since the original drawing is not known to exist, however, it is impossible to know.

On responsibility for print quality: Emory recommended engraver W. H. Dougal of Georgetown to print steel engravings for his *Mexican Boundary Survey* over a Mr. Seamen, who had bid on the illustrations using transfer lithography, which Emory considered an inferior method. Emory to R. W. Johnson, chairman of the Committee on Printing, Dec. 20, 1856, in possession of Fred White, Jr., Frontier America Corp., Albuquerque, N.M.

159 Jussim, *Frederic Remington,* 16.

Weber, "The Artist." See also Sandweiss, "Public Life of Western Art," in Prown, *Discovered Lands,* 121–26.

On Orr's engraving: *Reports of Explorations and Surveys* 5: 127; Karpenstein, "Illustrations of the West," 117.

On Fenderich, see Tyler, "Prints of the Mexican War."

"When it comes to the picture part": Cassin to Baird, Feb. 16, 1855, in Cassin, *Illustrations of the Birds of California,* I-28. Other information on Cassin: ibid., I-28, I-30.

160 Ewers, *Horse in Blackfoot Indian Culture,* 83–84.

"I would 'paint' you": Julie Schimmel, "Inventing the 'Indian,'" in Truettner, *West as America,* 150–51.

Goetzmann and Goetzmann, *West of the Imagination,* ix.

"Invalidated by the attitudes": Truettner, *West as America,* 44. See Schimmel, "Inventing æthe Indian,'" in Truettner, *West as America,* for white attitudes in the portraits.

"I knew his son": Ewers, "An Appreciation of Karl Bodmer's Pictures of Indians," in Ewers et al., *Views of a Vanishing Frontier,* 92.

BIBLIOGRAPHY

PRIMARY SOURCES

MANUSCRIPTS

Bodmer and Hoelscher correspondence with Maximilian (and translations) in the Harrison Library in Fair Oaks, California.

Letters Sent by the Topographical Bureau of the War Department and by Successor Division in the Office of the Chief of Engineers, Vol. II, Oct. 16, 1848-Sept. 15, 1849 (Microcopy No. 66, Roll 13, National Archives).

Records of the Accounting Offices of the Department of the Treasury, Office of the First Auditor: Misc. Treas.: Accounts 115908, #295; 117369, #881; 123661, # 333; 127113, #1532; 127338, #817; and 132891, # 663 and #665.

NEWSPAPERS

Austin Daily Democratic Statesman, 1873.

Ballou's Pictorial (Boston), Aug. 15, 1857.

Daily Missouri Republican (Saint Louis), 1847.

Daily National Intelligencer (Washington, D.C.), 1820, 1822, 1823, 1849.

Dallas Herald, 1972.

Fort Worth Democrat, 1876.

Fort Worth Gazette, 1885.

Galveston Daily News, 1871.

Harper's Weekly, 1859, 1861, 1882, 1889.

Leslie's Weekly, 1889.

San Antonio Daily Herald, 1873.

Saturday Courier (Philadelphia), 1843.

The Sunday Gazetteer (Denison, Texas), 1885.

Tri-Weekly Alamo Express (San Antonio), 1861.

Victoria Advocate, 1878, 1879.

BOOKS

Abert, James William. *Message from the President of the United States, in Compliance with a Resolution of the Senate, Communicating a Report of an Expedition led by Lieutenant Abert, on the Upper Arkansas and Through the Country of the Comanche Indians, in the year 1845* (1846) 29th Cong., 1st sess., S.D. 438.

———. *Report of the Secretary of War, Communicating, in Answer to a Resolution of the Senate, a Report and Map of the Examination of New Mexico . . .* (1848) 30th Cong., 1st sess., S.D. 23.

Audubon, John James. *The Birds of America.* 4 vols. London: John James Audubon, 1827–38.

———. *The Birds of America.* 7 vols. Philadelphia and New York: J. B. Chevalier and J. J. Audubon, 1840–44.

Audubon, John James, and John Bachman, *The Viviparous Quadrupeds of North America.* 2 vols. New York: John James Audubon, 1845–46.

Audubon, Maria A., ed. *Audubon and His Journals.* 2 vols. New York: Dover Publications, 1986.

Bailey, L. R., ed. *Survey of a Route on the 32nd Parallel for the Texas Western Railroad, 1854: The A. B. Gray Report, and Including the Reminiscences of Peter R. Brady, Who Accompanied the Expedition.* Los Angeles: Westernlore Press, 1963.

Bartlett, John Russell. *Personal Narrative of Explorations and Incidents in Texas, New Mexico, California, Sonora, and Chihuahua, Connected with the United States and Mexican Boundary Commission, During the Years 1850, '51, '52, and '53.* 2 vols. New York: D. Appleton & Co., 1854.

Bassford, Amy O., and Fritiof Fryxell, eds. *Home-Thoughts from Afar: Letters of Thomas Moran to Mary Nimmo Moran.* East Hampton, N.Y.: East Hampton Free Library, 1967.

Benson, Maxine, ed. *From Pittsburgh to the Rocky Mountains: Major Stephen H. Long's Expedition, 1819–1820.* Golden, Colo.: Fulcrum, 1988.

[Biddle, Nicholas.] *History of the Expedition under the Command of Captains Lewis and Clark . . .* 2 vols. Philadelphia: Bradford & Inskeep, 1814.

Bodmer, Karl. Correspondence with Maximilian (and translations). Harrison Library, Fair Oaks, Calif.

Bryant, William Cullen, and [Oliver Bell Bunce], eds. *Picturesque America; or, The Land We Live In.* 2 vols. New York: D. Appleton & Co., 1874.

Carroll, H. Bailey, ed. *Guadal P'a: The Journal of Lieutenant J. W. Abert, from Bent's Fort to St. Louis in 1845.* Canyon, Tex.: Panhandle-Plains Historical Society, 1941.

Carver, Jonathan. *Travels Through the Interior Parts of North-America, in the Years 1766, 1767, and 1768.* London: Printed for the author, 1781.

Cassin, John. *Illustrations of the Birds of California, Texas, Oregon, British and Russian America.* Austin: Texas State Historical Association, 1991.

Catlin, George. *Catlin's North American Indian Portfolio: Hunting Scenes and Amusements of the Rocky Mountains and Prairies of America.* London: George Catlin, 1844; New York: James Ackerman, 1845.

———. *Letters and Notes on the Manners, Customs, and Conditions of the North American Indians.* 2 vols. New York: Dover Publications, 1973.

———. *Nord-Amerikas Indianer och de, Under ett Attaarigt Vistande Bland de Vildaste af deras stammer, upplefvade Afventyr och Oden.* Stockholm: P. G. Berg, 1848.

Chamberlain, Samuel E. *My Confession.* Edited by Roger Butterfield. New York: Harper & Brothers, 1956.

Chatfield, W. H. *Twin Cities of the Border and the Country of the Lower Rio Grande.* New Orleans: E. P. Brando, 1893.

Choris, Louis. *Voyage pittoresque autour du monde, avec des Portraits de Sauvages d'Amerique, d'Asie, d'Afrique, et des iles du Grande Ocean,———des paysages, des vues maritimes, et plusieurs objets d'historie naturelle.* Paris: l'Imprimerie de Firmin Didot, 1822.

Cook, James. *A Voyage to the Pacific Ocean Undertaken by Command of His Majesty, for Making Discoveries in the Northern Hemisphere* [1776–78]. 3 vols. plus atlas. London, 1784.

Cooper, James Fenimore. *The Last of the Mohicans: A Narrative of 1757.* 2 vols. Philadelphia: H. C. Carey & I. Lea, 1826.

Darley, Felix O. C. *Scenes of Indian Life.* Philadelphia: J. & R. Colon, 1843.

Davy Crockett's Almanack 1, no. 3 (1837).

Dutton, Clarence E. *Tertiary History of the Grand Cañon District.* United States Geological Survey Monographs, no. 2. Washington, 1882.

Eastman, S[eth]. *Treatise on Topographical Drawing.* New York: Wiley & Putnam, 1837.

Eastman, Mary H. *Dahcotah; or, Life and Legends of the Sioux Around Fort Snelling.* New York: John Wiley, 1849.

Emory, William H. *Notes of a Military Reconnoissance, from Fort Leavenworth, in Missouri, to San Diego, in California, Including Part of the Arkansas, Del Norte, and Gila Rivers.* 30th Cong., 1st sess., S.D. 7, serial 505. Washington, 1848.

————. *Report on the United States and Mexican Boundary Survey.* 34th Cong., 1st sess., 1855, H.E.D. 135 and S.E.D. 108, serials 861–63, 832–34, vol. 2 published in two parts. Washington: Cornelius Wendell, 1857–59.

Everett, Edward. "Long's Expedition." *North American Review* April 1823.

Ferran, Augusto, and José Baturone. *Album californiano coleccion de tipos observados y dibujados.* Havana: Ferran y Baturone, 1849–50.

Flint, Timothy. *The First White Man of the West.* Cincinnati: Applegate & Co., 1856.

————. *The History and Geography of the Mississippi Valley.* 3d ed. Cincinnati: E. H. Flint; Boston: Carter, Hendee & Co., 1833.

Ford, Alice, ed. *Audubon's Animals: The Quadrupeds of North America.* New York: Thomas Y. Crowell Co., 1951.

Frémont, John Charles. *Report on an Exploration of the Country Lying Between the Missouri River and the Rocky Mountains, on the Line of the Kansas and Great Platte Rivers.* 27th Cong., 3d sess., S.D. Washington: Printed by Order of the U.S. Senate, 1843.

————. *Report of the Exploring Expedition to the Rocky Mountains in the Year 1842, and to Oregon and North California in the Years 1843–'44.* 28th Cong., 2d sess., S.E.D. 174. Washington, 1845.

French, B. B. *Frémont's Report.* 29th Cong., 1st sess., H.D. 118.

[Frey, Charles.] *Souvenir of Brownsville, Texas, Ft. Brown, and Matamoros.* N.p., c. 1890.

Fuller, Harlin M., and LeRoy R. Hafen, eds. *The Journal of Captain John R. Bell, Official Journalist of the Stephen H. Long Expedition to the Rocky Mountains, 1820.* Glendale, Calif.: Arthur H. Clark Co., 1973.

Galvin, John, ed. *Through the Country of the Comanche Indians in the Fall of the Year 1845: The Journal of a U.S. Army Expedition Led by Lieutenant James W. Abert.* San Francisco: John Howell--Books, 1970.

————. *Western America in 1846–1847: The Original Travel Diary of Lieutenant J. W. Abert.* San Francisco: John Howell--Books, 1964.

Gass, Patrick. *A Journal of the Voyages and Travels of a Corps of Discovery, Under the Command of Capt. Lewis and Capt. Clarke of the Army of the United States.* Philadelphia: Mathew Carey, 1810.

Gould, A. C. *Sport; or, Shooting and Fishing.* Boston: Whidden Publishing Co., 1889.

Gray, Andrew B. *Southern Pacific Railroad: Survey of a Route for the Southern Pacific R.R., on the 32nd Parallel.* Cincinnati: Wrightson & Co's. "Railroad Record") Print, 1856.

Griswold del Castillo, Richard. *The Treaty of Guadalupe Hidalgo: A Legacy of Conflict.* Norman: University of Oklahoma Press, 1990.

Harriot, Thomas. *A Briefe and True Report of the New Found Land of Virginia.* Frankfurt: Theodor de Bry, 1590.

————. *A Briefe and True Report of the New Found Land of Virginia.* New York: Dover Publications, 1972.

Harte, Bret. *The Heathen Chinee: Plain Language from Truthful James.* San Francisco: Book Club of California, 1934.

Hayden, Ferdinand Vandeveer. *The Yellowstone National Park, and the Mountain Regions of Idaho, Nevada, Colorado, and Utah.* Boston: L. Prang, 1876.

————. "The Wonders of the West————II: More About the Yellowstone." *Scribner's Monthly* Feb. 1872.

Heck, Johann Georg. *Iconographic Encyclopedia of Science, Literature, and Art.* Translated by Spencer F. Baird. 4 vols. plus atlas; New York: R. Garrigue, 1851.

Hennepin, Father Louis. *A New Discovery of a Vast Country in America, Extending Above Four Thousand Miles, Between New France and New Mexico.* London: M. Bentley, J. Tonson, H. Bonwick, T. Goodwin & S. Manship, 1698.

Henry, William Seaton. *Campaign Sketches of the War with Mexico.* New York: Harper & Bros., 1847.

Hodge, Frederick W. "The Narrative of Cabeza de Vaca." In *Spanish Explorers in the Southern United States,* edited by Hodge and Theodore H. Lewis. Reprint. Austin: Texas State Historical Association, 1990.

Hölscher, Jakob. Correspondence with Maximilian (and translations). Harrison Library, Fair Oaks, Calif.

Hough, Emerson. "Wild West Faking." *Collier's* Dec. 19, 1908.

An Interesting Account of the Voyages and Travels of Captains Lewis and Clarke, in the Years 1804–5, and 6. Baltimore: P. Mauro, 1813.

Irving, Washington. *Astoria, or Anecdotes of an Enterprise Beyond the Rocky Mountains.* 2 vols. Philadelphia: Carey, Lea & Blanchard, 1836.

Ives, Joseph Christmas. *Report upon the Colorado River of the West, Explored in 1857 and 1858.* 36th Cong., 1st sess., H.D. 90, S.D. unnumbered. Washington, 1861.

Jackson, Donald, ed. *The Journals of Zebulon Montgomery Pike: With Letters and Related Documents.* 2 vols. Norman: University of Oklahoma Press, 1966.

James, Edwin, comp. *Account of an Expedition from Pittsburgh to the Rocky Mountains, Performed in the Years 1818 and '20.* Philadelphia: H. C. Carey & I. Lea, 1823.

———. *Account of an Expedition from Pittsburgh to the Rocky Mountains, Performed in the Years 1818 and '20.* 3 vols. London: Longman, Hurst, Rees, Orme & Brown, 1823.

———. *Account of an Expedition from Pittsburgh to the Rocky Mountains Under the Command of Major Stephen H. Long.* Edited by Howard R. Lamar. Barre, Mass.: Imprint Society, 1972.

Kendall, George Wilkins. *The War Between the United States and Mexico, Illustrated.* New York: D. Appleton & Co., 1851.

Key, John Ross. *California Views.* Boston: Louis Prang, 1873.

King, Clarence. *Systematic Geology.* Professional Papers of the Engineer Department, U.S. Army, no. 18. Washington, 1878.

Lahontan, Louis Armand de Leon d'Arce, Baron de. *New Voyages to North America: Containing an Account of the Several Nations of that Vast Continent.* London: J. Osborn, 1735.

Langford, Nathaniel P. "The Wonders of the Yellowstone." *Scribner's Monthly* May and June 1871: 1–17, 113–28.

Letters Sent by the Topographical Bureau of the War Department and by successor division in the Office of the Chief of Engineers, vol. 2, Oct. 16, 1848–Sept. 15, 1849. Microcopy 66, roll 13. National Archives, Washington, D.C.

Lewis, Henry. *Das illustrirte Mississippithal.* Düsseldorf: Arnz & Comp., 1854.

———. *The Valley of the Mississippi Illustrated.* Translated by A. Hermina Poatgieter, edited by Bertha L. Heilbron. St. Paul: Minnesota Historical Society, 1967.

Lewis, J. O. *The Aboriginal Port-Folio.* Philadelphia: J. O. Lewis, 1835–36.

———. *The Aboriginal Port-Folio.* London: J. O. Lewis, 1838.

Lisiansky, Urey. *A Voyage Round the World, in the Years 1803, 4, 5 & 6; Performed, by Order of His Imperial Majesty Alexander the First, Emperor of Russia, in the Ship Neva.* London: Printed for John Booth, 1814.

Long, Stephen H. See James, Edwin.

Lopez de Gomara, Francisco. *La historia general de las Indias.* 2d ed. N.p., 1554.

Ludlow, Fitz Hugh. *The Heart of the Continent: A Record of Travel Across the Plains and in Oregon, with an Examination of the Mormon Principle.* New York: Hurd & Houghton, 1870.

Madsen, Brigham, ed. *A Forty-Niner in Utah: Letters and Journals of John Hudson, 1848–1850.* Salt Lake City: University of Utah Library, 1981.

———. *Exploring the Great Salt Lake: The Stansbury Expedition of 1849–50.* Salt Lake City: University of Utah Press, 1989.

Marcy, Randolph B. *Exploration of the Red River of Louisiana, in the Year 1852 . . . with Reports on the Natural History of the Country, and Numerous Illustrations.* 32nd Cong., 2d sess., S.E.D. 54. Washington: Robert Armstrong, 1853.

———. *The Prairie Traveler: A Hand-book for Overland Expeditions.* New York: Harper & Bros., 1859.

Marryat, Frank. *Mountains and Molehills: or, Recollections of a Burnt Journal.* London: Longman, Brown, Green & Longmans, 1855.

Mathews, Alfred E. *Gems of Rocky Mountain Scenery, Containing Views Along and Near the Union Pacific Railroad.* New York: Published by the author, 1969.

———. *Pencil Sketches of Colorado: Its Cities, Principal Towns, and Mountain Scenery.* [New York: the author], 1866.

———. *Pencil Sketches of Montana.* New York: the author, 1868.

Maximilian, Prince of Wied-Neuwied. See Wied.

McDermott, John Francis, ed. *Audubon in the West.* Norman: University of Oklahoma Press, 1965.

McKenney, Thomas L. *Memoirs, Official and Personal; with Sketches of Travel Among the Northern and Southern Indians; Embracing a War Excursion and Descriptions of Scenes Along the Western Borders.* 2d ed. New York: Paine & Burgess, 1846.

————. *Sketches of a Tour to the Lakes, of the Character and Customs of the Chippeway Indians, and of Incidents Connected with the Treaty of Fond du Lac.* Baltimore, 1827.

McKenney, Thomas L., and James Hall. *History of the Indian Tribes of North America with Biographical Sketches and Anecdotes of the Principal Chiefs.* Philadelphia: Edward C. Biddle, parts 1–5; Frederick W. Greenough, parts 6–13; J. T. Bowen, part 14; Daniel Rice & James G. Clark, parts 15–20; [1833]–44.

————. *The Indian Tribes of North America, with Biographical Sketches and Anecdotes of the Principal Chiefs.* Edited by Frederick Webb Hodge. 3 vols. Edinburgh: John Grant, 1933.

Möllhausen, Heinrich Balduin. *Reisen in die Felsengebirge Nord-Amerikas bis zum Hoch-Plateau von Neu-Mexico, unternommen als Mitglied der im Auftrage der Regierung der Vereinigten Staaten Ausgesandten Colorado-Expedition.* Leipzig: Otto Purfurst, 1860.

————. *Tagebuch einer Reise vom Mississippi nach den Küsten der Südsee.* Leipzig: Hermann Mendelssohn, 1858.

Morgan, Dale L., and Eleanor Towles Harris, eds. *The Rocky Mountain Journals of William Marshall Anderson: The West in 1834.* San Marino: Huntington Library, 1967.

Muir, John, ed. *Picturesque California and the Region West of the Rocky Mountains, from Alaska to Mexico.* San Francisco: J. Dewing Co., 1888.

Orr, William J., and Joseph C. Porter, eds. "A Journey Through the Nebraska Region in 1833 and 1834: From the Diaries of Prince Maximilian of Wied." *Nebraska History* 64 (1983).

Ousley, Clarence. *Galveston in 1900.* Atlanta: William C. Chase, 1900.

Pacific Railroad Reports. See *Reports of Explorations and Surveys.*

Parker, John, ed. *The Journals of Jonathan Carver and Related Documents, 1766–1770.* St. Paul: Minnesota Historical Society Press, 1976.

Piercy, Frederick. *Route from Liverpool to Great Salt Lake Valley.* Edited by James Linforth. Liverpool: Franklin D. Richards; London: Latter-Day Saints' Book Depot, 1855.

————. *Route from Liverpool to Great Salt Lake Valley.* Edited by Fawn M. Brodie. Cambridge: Harvard University Press, 1962.

Pike, Zebulon M. *The Expeditions of Zebulon Montgomery Pike.* Edited by Elliott Coues. 2 vols. New York: Dover Publications, 1987.

Preuss, Charles. *Exploring with Frémont: The Private Diaries of Charles Preuss, Cartographer for John C. Frémont on His First, Second, and Fourth Expeditions to the Far West.* Translated and edited by Erwin G. and Elisabeth K. Gudde. Norman: University of Oklahoma Press, 1958.

Ramusio, Giovanni Battista. *Delle navigationi et viaggi nel quale si contengono le navitationi al Mondo Nuouo.* Vol. 3. Venice, 1556.

Records of the Accounting Offices of the Department of the Treasury, Office of the First Auditor: Misc. Treas. Accounts 115908, 295; 117369, 881; 123661, 333; 127113, 1532; 127338, 817; and 132891, 663 and 665.

Remington, Frederic. *A Bunch of Buckskins.* New York: R. H. Russell, 1901.

————. "A Cracker Cowboy." *Harper's New Monthly Magazine* 91 (1895): 339–45.

————. "A Few Words from Mr. Remington." *Collier's* March 18, 1905.

————. *Western Types.* New York: Charles Scribner's Sons, 1902.

Reports of Explorations and Surveys, to Ascertain the Most Practicable and Economical Route for a Railroad from the Mississippi River to the Pacific Ocean. 12 vols. Washington, 1855–61.

Revere, Joseph Warren. *A Tour of Duty in California; Including a Description of the Gold Region . . .* Edited by Joseph N. Balestier. New York, 1849.

[Rindisbacher, Peter.] *Views in Hudson's Bay.* London, 1825.

Roehm, Marjorie Catlin, ed. *The Letters of George Catlin and His Family: A Chronicle of the American West.* Berkeley: University of California Press, 1966.

Rollins, C. B., ed. "Letters of George Caleb Bingham to James S. Rollins, Pt. 2: October 3, 1853–August 10, 1856." *Missouri Historical Review* Jan. 1938.

Roosevelt, Theodore. *Ranch Life and the Hunting-Trail.* New York: Century Co., 1888.

Russell, Charles M. *Studies of Western Life.* New York: Albertype Co., 1890.

Sage, Rufus B. *Scenes in the Rocky Mountains, and in Oregon, California, New Mexico, Texas, and the Grand Prairies.* Philadelphia: Carey & Hart, 1846.

Savage, Charles R. "A Photographic Tour of Nearly 9000 Miles." *Philadelphia Photographer* Sept.–Oct. 1867.

Schoolcraft, Henry Rowe. *Historical and Statistical Information Respecting the History, Condition, and Prospects of the Indian Tribes of the United States.* 6 vols. Philadelphia: Lippincott, Grambo, 1851–57.

Shelvocke, George. *A Voyage Round the World by Way of the Great South Sea, Perform'd in the Years 1719, 20, 21, 22, in the Speedwell of London.* London: J. Senex, 1726.

Simpson, James H. *Journal of a Military Reconnaissance from Santa Fe, New Mexico, to the Navaho Country.* Philadelphia: Lippincott, Grambo & Co., 1852.

Siringo, Charles A. *A Texas Cow Boy; or, Fifteen Years on the Hurricane Deck of a Spanish Pony.* Chicago: M. Umbdenstock & Co., 1885.

Sitgreaves, Lorenzo. *Report of an Expedition Down the Zuni and Colorado Rivers.* 32nd Cong., 2d sess., S.D. 59. Washington: Robert Armstrong, 1853.

Splete, Allen P., and Marilyn D. Splete, eds. *Frederic Remington--Selected Letters.* New York: Abbeville Press, 1988.

Stansbury, Howard. *Exploration and Survey of the Valley of the Great Salt Lake of Utah, Including a Reconnoissance of a New Route Through the Rocky Mountains.* Philadelphia: Lippincott, Grambo & Co., 1852.

———. *Exploration of the Valley of the Great Salt Lake.* Washington: Smithsonian Institution Press, 1988.

Tanner, Henry S., *A New American Atlas . . .* Philadelphia, 1823.

Thomas, Davis, and Karin Ronnefeldt, eds. *People of the First Man: Life Among the Plains Indians in Their Final Days of Glory.* New York: E. P. Dutton & Co., 1976.

Thorpe, Thomas Bangs. *"Our Army" on the Rio Grande.* Philadelphia: Carey & Hart, 1846.

Thwaites, Reuben Gold. *Early Western Travels, 1748–1846.* 32 vols. Cleveland: Arthur H. Clark Co., 1905–7.

The Travels of Capts. Lewis and Clark, by Order of the Government of the United States, Performed in the Years 1804, 1805, and 1806. Philadelphia: Hubbard Lester, 1809.

Vancouver, George. *A Voyage of Discovery to the North Pacific Ocean, and round the world: in which the Coast of North-West America has been carefully examined and accurately surveyed.* 3 vols. London: G. G. & J. Robinson . . . & J. Edwards, 1798.

Walke, Henry. *Naval Portfolio No. 1.* New York: 1848.

Warre, Henry James. *Overland to Oregon in 1845: Impressions of a Journey Across North America.* Ottawa: Public Archives of Canada, 1976.

———. *Sketches in North America and the Oregon Territory.* London: Dickinson & Co., 1848.

———. *Sketches in North America and the Oregon Territory.* Barre, Mass.: Imprint Society, 1970.

Webber, Charles W. *The Hunter-Naturalist: Romance of Sporting; or, Wild Scenes and Wild Hunters.* Philadelphia: J. W. Bradley, 1851.

———. *The Hunter-Naturalist: Wild Scenes and Song-Birds.* New York: George P. Putnam & Co., 1854; Riker, Thorne & Co., 1854.

Westermeier, Clifford P., ed. *Trailing the Cowboy: His Life and Lore as Told by Frontier Journalists.* Caldwell, Idaho: Caxton Printers, 1955.

Whiting, Daniel Powers. *Army Portfolio No. 1.* New York: G. & W. Endicott, 1848.

Wied, Maximilian, Prinz von. Correspondence with Karl Bodmer and Jakob Hölscher, and translations. Harrison Library, Fair Oaks, Calif.

———. *Reise in das innere NordAmerica in den Jahren 1832 bis 1834.* 2 vols. plus atlas. Koblenz: J. Hölscher, 1839[–41].

———. *Travels in the Interior of North America, 1832–1834.* Early Western Travels, 1748–1846, edited by Reuben Gold Thwaites, vols. 22–24. Cleveland: Arthur H. Clark Co., 1905–7.

Wilkes, Charles. *Narrative of the United States Exploring Expedition, During the Years 1838, 1839, 1840, 1841, 1842.* 5 vols. Philadelphia: C. Sherman, 1844.

SECONDARY SOURCES

Allen, John Logan. *Lewis and Clark and the Image of the American Northwest.* New York: Dover Publications, 1991.

Anderson, Nancy K., and Linda S. Ferber. *Albert Bierstadt: Art and Enterprise.* New York: Brooklyn Museum, Hudson Hills Press, 1990.

Ayres, Linda. *Thomas Moran's Watercolors of Yellowstone.* Washington: National Gallery of Art, 1984.

Baker, T. Lindsey, comp. and ed. "The Survey of the Headwaters of the Red River, 1876." *Panhandle-Plains Historical Review* 58 (1985).

Ballinger, James K. *Frederic Remington.* New York: Harry N. Abrams, 1989.

———. *Frederic Remington's Southwest.* Phoenix: Phoenix Art Museum, 1992.

Bannon, Lois Elmer, and Taylor Clark. *Handbook of Audubon Prints.* Gretna, La.: Pelican Publishing Press, 1985.

Bell, Whitfield J. Jr., et al. *A Cabinet of Curiosities: Five Episodes in the Evolution of American Museums.* Charlottesville: University of Virginia Press, 1967.

Bender, J. H. "Catalogue of Engravings and Lithographs after George C. Bingham." *Print Collector's Quarterly.*

Bennett, Whitman. *A Practical Guide to American Nineteenth-Century Color Plate Books.* Reprint. Ardsley, N.Y.: Haydn Foundation for the Cultural Arts, 1980.

Berkhofer, Robert F. Jr. *The White Man's Indian: Images of the American Indian from Columbus to the Present.* New York: Alfred A. Knopf, 1978.

Blair, Walter, and Franklin J. Meine. *Half Horse, Half Alligator: The Growth of the Mike Fink Legend.* Chicago: University of Chicago Press, 1946.

Bloch, E. Maurice. *George Caleb Bingham: The Evolution of an Artist.* 2 vols. Berkeley and Los Angeles: University of California Press, 1967.

Bloom, John Porter. " 'American Turf Register and Sporting Magazine,' 1829–44." in McDermott, *Travelers on the Western Frontier.*

Bossen, Howard. "A Tall Tale Retold: The Influence of the Photographs of William Henry Jackson on the Passage of the Yellowstone Park Act of 1872." *Studies in Visual Communication* 8 (Winter 1982): 98–109.

Brosse, Jacques. *Great Voyages of Discovery: Circumnavigators and Scientists, 1764–1843.* Translated by Stanley Hochman. New York: Facts on File Publications, 1983.

Brust, James, and Wendy Shadwell. "The Many Versions and States of the Awful Conflagration of the Steam Boat Lexington." *Imprint* 15 (1990): 2–13.

———. "The Many Versions and States of the Awful Conflagration of the Steam Boat Lexington: An Update." *Imprint* 18 (1993): 27–31.

Cadbury, Warder H. *Arthur Fitzwilliam Tait, Artist in the Adirondacks.* Newark: University of Delaware Press, 1986.

Chiappelli, Fredi, ed. *First Images of America: The Impact of the New World on the Old.* 2 vols. Berkeley: University of California Press, 1976.

Clark, Carol. *Thomas Moran: Watercolors of the American West.* Austin: University of Texas Press, 1980.

Clarke, Dwight L. *Stephen Watts Kearny, Soldier of the West.* Norman: University of Oklahoma Press, 1961.

Clokey, Richard M. *William H. Ashley: Enterprise and Politics in the Trans-Mississippi West.* Norman: University of Oklahoma Press, 1980.

Cutright, Paul Russell. *A History of the Lewis and Clark Journals.* Norman: University of Oklahoma Press, 1976.

DeVoto, Bernard. *Across the Wide Missouri.* Boston: Houghton Mifflin Co., 1947.

Dippie, Brian W. *Catlin and His Contemporaries: The Politics of Patronage.* Lincoln: University of Nebraska Press, 1990.

———. *The Vanishing American: White Attitudes and U.S. Indian Policy.* Middletown, Conn.: Wesleyan University Press, 1982.

Evans, Jodene K. "A Reunion of Images: Reassembling Peale's Vision." *Palimpsest* 74 (1993): 82–83.

Ewers, John C. *Artists of the Old West.* Garden City, N.Y.: Doubleday & Co., 1973.

———. "Not Quite Redmen: The Plains Indian Illustrations of Felix O. C. Darley." *American Art Journal* 3 (1971): 88–98.

Ewers, John C., et al. *Views of a Vanishing Frontier.* Omaha: Center for Western Studies, Joslyn Art Museum, 1984.

———. *The Horse in Blackfoot Indian Culture, with Comparative Material from Other Western Tribes.* Reprint. Washington: Smithsonian Institution, 1980.

Exman, Eugene. *The House of Harper: One Hundred and Fifty Years of Publishing.* New York: Harper & Row, 1967.

Field, Thomas W. *An Essay Towards an Indian Bibliography: Being a Catalogue of Books, Relating to the*

History, Antiquities, Languages, Customs, Religion, Wars, Literature, and Origin of the American Indians. Reprint. New Haven: William Reese Co., 1991.

Fletcher, Angus, ed. *The Literature of Fact: Selected Papers from the English Institute.* New York: Columbia University Press, 1976.

Flores, Dan. *Caprock Canyons: Journeys into the Heart of the Southern Plains.* Austin: University of Texas Press, 1990.

Ford, Alice. *John James Audubon: A Biography.* 2d ed. New York: Abbeville Press, 1988.

Fussell, Edwin. *Frontier: American Literature and the American West.* Princeton: Princeton University Press, 1965.

Gardien, Kent. "Take Pity on Our Glory: Men of Champ d'Asile." *Southwestern Historical Quarterly* 87 (1984): 241–68.

Gascoigne, Bamber. *How to Identify Prints: A Complete Guide to Manual and Mechanical Processes from Woodcut to Ink Jet.* New York: Thames & Hudson, 1986.

Glanz, Dawn. *How the West Was Drawn: American Art and the Settling of the Frontier.* Ann Arbor: UMI Research Press, 1982.

Goetzmann, William H. *Army Exploration in the American West.* Reprint. Austin: Texas State Historical Association, 1991.

———. *Exploration and Empire: The Explorer and the Scientist in the Winning of the West.* New York: Alfred A. Knopf, 1967.

———. "The Grand Reconnaissance." *American Heritage* 23 (1972): 44–59, 92–95.

———. Introduction to *Karl Bodmer's America,* by David C. Hunt and Marsha V. Gallagher. Lincoln: Joslyn Art Museum and University of Nebraska Press, 1984.

———. *The Mountain Men.* Cody, Wyo.: Buffalo Bill Historical Center, 1978.

———. *New Lands, New Men: America and the Second Great Age of Discovery.* New York: Viking Penguin, 1986.

———. *Sam Chamberlain's Mexican War: The San Jacinto Museum of History Paintings.* Austin: Texas State Historical Association, 1993.

———. "The United States-Mexican Boundary Survey, 1848–1853." *Southwestern Historical Quarterly* 62 (1958): 164–90.

Goetzmann, William H., and William N. Goetzmann. *The West of the Imagination.* New York and London: W. W. Norton and Co., 1986.

Goetzmann, William H., and Glyndwr Williams. *The Atlas of North American Exploration: From the Norse Voyages to the Race to the Pole.* New York: Prentice Hall General Reference, 1992.

Gruber, Francis S. *William Ranney, Painter of the Early West.* New York: Clarkson N. Potter, 1962.

Hales, Peter B. *William Henry Jackson and the Transformation of the American Landscape.* Philadelphia: Temple University Press, 1988.

Haltman, Kenneth. "Between Science and Art: Titian Ramsay Peale's Long Expedition Sketches, Newly Recovered at the State Historical Society of Iowa." *Palimpsest* 74 (1993): 62–81.

———. "Figures in a Western Landscape: Reading the Art of Titian Ramsay Peale from the Long Expedition to the Rocky Mountains, 1819–1820." Ph.D. dissertation, Yale University, 1992.

———. "Private Impressions and Public Views: Titian Ramsay Peale's Sketchbooks from the Long Expedition, 1819–1820." *Yale University Art Gallery Bulletin* Spring 1989: 39–53.

Hammell, Peter Herbert. "Images of the American Indian Reflected in Prints, 1830–1860." Master's thesis, University of Delaware, 1979.

Hammond, John H., and Jill Austin. *The Camera Lucida in Art and Science.* Bristol: Adam Hilger, 1987.

Haskell, Daniel C. *The United States Exploring Expedition, 1838–1842, and Its Publications, 1844–1874.* New York: Greenwood Press, 1968.

Hassrick, Peter H. *Charles M. Russell.* New York: Harry N. Abrams, 1989.

———. *Frederic Remington, the Late Years.* Denver: Denver Art Museum, 1981.

———. *Frederic Remington: Paintings, Drawings, and Sculpture in the Amon Carter Museum and the Sid W. Richardson Foundation Collections.* New York: Harry N. Abrams, 1973.

Henry, John Frazier. *Early Maritime Artists of the Pacific Northwest Coast, 1741–1841.* Seattle: University of Washington Press, 1984.

Hewitt, Harry P. "The Mexican Boundary Survey Team: Pedro García Conde in California." *Western History Quarterly* 21 (1990): 171–96.

———. "The Mexican Commission and Its Survey of the Rio Grande River Boundary, 1850–1854." *Southwestern Historical Quarterly* 94 (1991): 555–80.

Hine, Robert. *Bartlett's West: Drawing the Mexican Boundary.* New Haven: Yale University Press, 1968.

Honour, Hugh. *The European Vision of America.* Cleveland: Cleveland Museum of Art, 1976.

Horan, James D. *The McKenney-Hall Portrait Gallery of American Indians.* New York: Crown Publishers, 1972.

Hubach, Robert R. *Early Midwestern Travel Narratives: An Annotated Bibliography, 1634–1850.* Detroit: Wayne State University Press, 1961.

Hulton, Paul. *America 1585: The Complete Drawings of John White.* Chapel Hill: University of North Carolina Press, British Museum, 1984.

———. *The Work of Jacques Le Moyne de Morgues: A Hugenout Artist in France and England.* 2 vols. London: British Museum Publications, 1977.

Hunt, David C., and Marsha V. Gallagher. *Karl Bodmer's America.* Lincoln: Joslyn Art Museum and University of Nebraska Press, 1984.

Huseman, Ben W. "Romanticism and the Scientific Aesthetic: Balduin Möllhausen's Artistic Development and the Images of the Whipple Expedition." Master's thesis, University of Texas at Austin, 1992.

Jackson, Christine E. *Bird Etchings: The Illustrators and Their Books, 1655–1855.* Ithaca: Cornell University Press, 1985.

———. *Bird Illustrators: Some Artists in Early Lithography.* London: H. F. & G. Witherby, 1975.

Jackson, Donald. *Thomas Jefferson and the Stony Mountains: Exploring the West from Monticello.* Urbana: University of Illinois Press, 1981.

Jackson, William Henry. *Time Exposure: The Autobiography of William Henry Jackson.* New York: G. P. Putnam's Sons, 1940.

Jackson, W. Turrentine. *Wagon Roads West: A Study of Federal Road Surveys and Construction in the Trans-Mississippi West, 1846–1869.* Reprint. Lincoln: University of Nebraska Press, 1979.

Johns, Elizabeth. *American Genre Painting: The Politics of Everyday Life.* New Haven: Yale University Press, 1991.

Johnson, Elden. "Carl Bodmer Paints the Indian Frontier." *Indian Leaflets 8-9-10.* St. Paul: Science Museum, 1955.

Jones, Howard Mumford. *O Strange New World: American Culture: The Formative Years.* New York: Viking Press, 1964.

Jordan, Terry G. *Trails to Texas: Southern Roots of Western Cattle Ranching.* Lincoln: University of Nebraska Press, 1981.

Josephy, Alvin M. Jr. *The Artist Was a Young Man: The Life Story of Peter Rindisbacher.* Fort Worth: Amon Carter Museum, 1970.

———. "The Boy Artist of Red River." *American Heritage* 21 (1970): 30–49.

Jussim, Estelle. *Frederic Remington, the Camera, and the Old West.* Fort Worth: Amon Carter Museum, 1983.

———. *Visual Communication and the Graphic Arts.* New York: R. R. Bowker Co., 1974.

Karpenstein, Katherine. "Illustrations of the West in Congressional Documents, 1843–1863." Master's thesis, University of California, Berkeley, 1939.

Kindred, Marilyn Anne. "The Army Officer Corps and the Arts: Artistic Patronage and Practice in America, 1820–85." Ph.D. dissertation, University of Kansas, 1980.

Kinsey, Joni Louise. *Thomas Moran and the Surveying of the American West.* Washington: Smithsonian Institution Press, 1992.

Lamar, Howard R., ed. *The Reader's Encyclopedia of the American West.* New York: Thomas Y. Crowell Co., 1977.

Lipton, Leah. "Chester Harding and the Life Portrait of Daniel Boone." *American Art Journal* 16 (1984): 5–19.

Marzio, Peter C. *Chromolithography, 1840–1900: The Democratic Art, Pictures for a 19th-Century America.* Boston: David R. Godine, 1979.

Mattes, Merrill J. *The Great Platte River Road: The Covered Wagon Mainline Via Fort Kearny to Fort Laramie.* Lincoln: University of Nebraska Press, 1969.

McCracken, Harold. *George Catlin and the Old Frontier.* New York: Bonanza Books, 1959.

———. *The Charles M. Russell Book.* Garden City, N.Y.: Doubleday & Co., 1957.

McCusker, John J. "How Much Is That in Real Money? A Historical Price Index for Use as a Deflator of Money Values in the Economy of the United States." *Proceedings of the American Antiquarian Society* 101 (1991).

McDermott, John Francis. *George Caleb Bingham: River Portraitist.* Norman: University of Oklahoma Press, 1959.

———. "George Caleb Bingham and the American Art-Union." *New-York Historical Society Quarterly* 62 (1958): 60–69.

———. "Henry Lewis's 'Das illustrite Mississippithal'." *Papers of the Bibliographical Society of America* 45 (1951): 1–4.

———. "Jolly Flatboatmen: Bingham and His Imitators." *Antiques* 73 (1958): 267–68.

———, ed. *The Frontier Re-examined.* Urbana: University of Illinois Press, 1967.

———. *Seth Eastman, Pictorial Historian of the Indians.* Norman: University of Oklahoma Press, 1961.

———, ed. *Travelers on the Western Frontier.* Urbana: University of Illinois Press, 1970.

McGrath, Daniel F. "American Colorplate Books, 1800–1900." Ph.D. dissertation, University of Michigan, 1966.

McKelvey, Susan Delano. *Botanical Exploration of the Trans-Mississippi West, 1790–1850.* Jamaica Plain, Mass.: Arnold Arboretum of Harvard University, 1955.

Meigs, John, ed. *The Cowboy in American Prints.* Chicago: Sage Books, Swallow Press, 1972.

Meyers, Amy R. Weinstein. "Sketches from the Wilderness: Changing Conceptions of Nature in American Natural History Illustrations: 1680–1880." 2 vols. Ph.D. dissertation, Yale University, 1985.

Miles, Ellen G. "Saint-Mémin's Portraits of American Indians, 1804–1807." *American Art Journal* 20 (1988): 3–33.

Miller, Lillian B. *Patrons and Patriotism: The Encouragement of the Fine Arts in the United States, 1790–1860.* Chicago: University of Chicago Press, 1966.

Morand, Anne R., and Nancy Friese, eds. *The Prints of Thomas Moran in the Thomas Gilcrease Institute of American History and Art.* Tulsa, Okla.: Thomas Gilcrease Museum Association, 1986.

Morand, Anne R., Joni L. Kinsey, and Mary Panzer. *Splendors of the American West: Thomas Moran's Art of the Grand Canyon and Yellowstone.* Birmingham: Birmingham Museum of Art, 1990.

Moritz, Albert F. *America the Picturesque in Nineteenth-Century Engraving.* Toronto: New Trend Publishers, 1983.

Morse, John D., ed. *Prints in and of America to 1850.* Charlottesville: University Press of Virginia, 1970.

Moure, Nancy Dustin Wall. "Five Eastern Artists Out West." *American Art Journal* 5 (1973): 15–31.

Murat, Ines. *Napoleon and the American Dream.* Translated by Frances Frenaye. Baton Rouge: Louisiana State University Press, 1981.

Naef, Weston J., and James N. Wood. *Era of Exploration: The Rise of Landscape Photography in the American West, 1860–1885.* Albright-Knox Art Gallery, Metropolitan Museum of Art, 1975.

Native North Americans: Six Portraits by Henry Inman. Atlanta: High Museum of Art, n.d..

Neal, Bill. *The Last Frontier: The Story of Hardeman County.* Quanah: Quanah Tribune-Chief, 1966.

Nevins, Allan. *Fremont, the West's Greatest Adventurer.* 2 vols. New York: Harper & Bros., 1928.

Nostrand, Jeanne Van. *The First Hundred Years of Paintings in California, 1775–1875.* San Francisco: John Howell——Books, 1980.

Novak, Barbara. *American Painting of the Nineteenth Century: Realism, Idealism, and the American Experience.* New York: Praeger Publishers, 1969.

———. *Nature and Culture: American Landscape and Painting, 1825–1875.* New York: Oxford University Press, 1980.

Nugent, Walter. "Where Is the American West? Report on a Survey." *Montana* 42 (1992): 2–23.

Nunes, Jadviga da Costa. "Red Jacket: The Man and His Portraits." *American Art Journal* 12 (1980): 5–20.

Nygren, Edward J., with Bruce Robertson. *Views and Visions: American Landscape Before 1830.* Washington: Corcoran Gallery of Art, 1986.

Parry, Elwood. *The Image of the Indian and the Black Man in American Art, 1590–1900.* New York: George Braziller, 1974.

Patrick, Darryl. "The Iconographical Significance in Selected Western Subjects Painted by Thomas Moran." Ph.D. dissertation, North Texas State University, 1978.

Peters, Harry T. *America on Stone: The Other Printmakers to the American People.* Garden City, N.Y.: Doubleday, Doran & Co., 1931.

———. *Currier and Ives: Printmakers to the American People.* Garden City, N.Y.: Doubleday, Doran & Co., 1942.

Pierce, Sally, and Catharine Slauterback. *Boston Lithography, 1825–1880.* Boston: Boston Athenaeum, 1991.

Prichard, James Cowles. *Natural History of Man, Comprising Inquiries into the Modifying Influence of Physical and Moral Agencies on the Different Tribes of the Human Family.* Edited and enlarged by Edwin Norris. 4th ed. London: H. Bailliere, 1855.

Prown, Jules David, ed. *Discovered Lands, Invented Pasts: Transforming Visions of the American West.* New Haven: Yale University Press, 1992.

Rash, Nancy. *The Paintings and Politics of George Caleb Bingham.* New Haven: Yale University Press, 1991.

Reilly, Bernard F. Jr. *Currier and Ives, a Catalogue Raisonne . . . 1834–1907.* 2 vols. Detroit: Gale Research Co., 1984.

Reps, John W. *Cities on Stone: Nineteenth-Century Lithograph Images of the Urban West.* Fort Worth: Amon Carter Museum, 1976.

———. *Views and Viewmakers of Urban America: Lithographs of Towns and Cities in the United States and Canada, Notes on the Artists and Publishers, and a Union Catalog of Their Work, 1825–1925.* Columbia: University of Missouri Press, 1984.

Reveal, James L. *Gentle Conquest: The Botanical Discovery of North America, with Illustrations from the Library of Congress.* Washington: Starwood Publishing, 1992.

Richardson, Edgar P., Brooke Hindle, and Lillian B. Miller. *Charles Willson Peale and His World.* New York: Harry N. Abrams, 1982.

Ristow, Walter W. *American Maps and Mapmakers: Commercial Cartography in the Nineteenth Century.* Detroit: Wayne State University Press, 1985.

Rubinstein, Charlote Streifer. "The Early Career of Frances Flora Bond Palmer (1812–1876)." *American Art Journal* 17 (1985): 71–88.

Rudisill, Richard. *Mirror Image: The Influence of the Daguerreotype on American Society.* Albuquerque: University of New Mexico Press, 1971.

Russell, Don. *The Wild West: or, A History of the Wild West Shows . . .* Fort Worth: Amon Carter Museum of Western Art, 1970.

Samuels, Peggy, and Harold Samuels. *Frederic Remington: A Biography.* Garden City: Doubleday & Co., 1982.

———. *Remington: The Complete Prints.* New York: Crown Publishers, 1990.

Sandweiss, Martha A., Rick Stewart, and Ben W. Huseman. *Eyewitness to War: Prints and Daguerreotypes of the Mexican War, 1846–1848.* Washington: Smithsonian Institution Press, 1989.

Schimmel, Julie. "John Mix Stanley and Imagery of the West in Nineteenth-Century American Art." Ph.D. dissertation, New York University, 1983.

Schinz, Heinrich Rudolf. *Naturgeschichte und Abbildungen des Menschen der verschiedenen Rassen und Stamme nach den neuesten Entdeckungen und vorzuglichsten Originalien.* 3d ed. Zurich: J. Honegger, 1846.

Shapiro, Michael Edward. *George Caleb Bingham.* New York: St. Louis Art Museum, Harry N. Abrams, 1990.

Shapiro, Michael Edward, and Peter H. Hassrick. *Frederic Remington: The Masterworks.* New York: Harry N. Abrams, 1988.

Slotkin, Richard. *The Fatal Environment: The Myth of the Frontier in the Age of Industrialization, 1800–1890.* New York: Atheneum, 1985.

———. *Regeneration Through Violence: The Mythology of the American Frontier, 1600–1860.* Middletown, Conn.: Wesleyan University Press, 1973.

Smith, Bernard. *European Vision and the South Pacific.* 2d. ed. New Haven: Yale University Press, 1985.

Snyder, Joel. *American Frontier: The Photographs of Timothy O'Sullivan, 1867–1874.* Millerton, N.Y.: Aperture, 1981.

Stafford, Barbara Maria. *Voyage into Substance: Art, Science, Nature, and the Illustrated Travel Account, 1760–1840.* Cambridge: MIT Press, 1984.

Stanton, William. *The Great United States Exploring Expedition of 1838–1842.* Berkeley: University of California Press, 1975.

Stegner, Wallace. *Beyond the Hundredth Meridian: John Wesley Powell and the Second Opening of the West.* Boston: Houghton Mifflin Co., 1954.

Stewart, Rick. *The American West: Legendary Artists of the Frontier.* Dallas: Hawthorne Publishing, 1986.

Stewart, Rick, Joseph D. Ketner II, and Angela L. Miller. *Carl Wimar: Chronicler of the Missouri River Frontier.* Fort Worth: Amon Carter Museum, 1991.

Sweeney, J. Gray. *The Columbus of the Woods: Daniel Boone and the Typology of Manifest Destiny.* St. Louis: Washington University Gallery of Art, 1992.

Taft, Robert. *Artists and Illustrators of the Old West, 1850–1900.* New York: Charles Scribner's Sons, 1953.

Taylor, Lonn, and Ingrid Maar. *The American Cowboy.* Washington: Library of Congress, 1983.

Trenton, Patricia, and Peter H. Hassrick. *The Rocky Mountains: A Vision for Artists in the Nineteenth Century.* Norman: University of Oklahoma Press, 1973.

Truettner, William H. *The Natural Man Observed: A Study of Catlin's Indian Gallery.* Washington: Smithsonian Institution Press, 1979.

———. " 'Scenes of Majesty and Enduring Interest': Thomas Moran Goes West." *Art Bulletin* 58 (1976): 241–59.

———, ed. *The West as America: Reinterpreting Images of the Frontier, 1820–1920.* Washington: Smithsonian Institution Press, 1991.

Turner, Katharine C. *Red Men Calling on the Great White Father.* Norman: University of Oklahoma Press, 1951.

Twyman, Michael. *Lithography, 1800–1850: The Techniques of Drawing on Stone in England and France and Their Application in Works of Topography.* London: Oxford University Press, 1970.

Tyler, Ron. "Approaches to Using Museum Collections." *Texas Libraries* 33 (1971).

———. *The Cowboy.* New York: William Morrow & Co., 1975.

———. *The Mexican War: A Lithographic Record.* Austin: Texas State Historical Association, 1973.

———, ed. *Alfred Jacob Miller: Artist on the Oregon Trail.* Fort Worth: Amon Carter Museum, 1982.

———, ed. *American Frontier Life: Early Western Painting and Prints.* New York: Abbeville Press, 1987.

———, ed. *Prints of the American West: Papers Presented at the Ninth Annual North American Print Conference.* Fort Worth: Amon Carter Museum, 1983.

Viola, Herman J. *Diplomats in Buckskins: A History of Indian Delegations in Washington City.* Washington: Smithsonian Institution Press, 1981.

———. *The Indian Legacy of Charles Bird King.* Washington: Smithsonian Institution Press, Doubleday & Co., 1976.

———. *Thomas L. McKenney, Architect of America's Early Indian Policy: 1816–1830.* Chicago: Sage Books, Swallow Press, 1974.

Viola, Herman J., and Carolyn Margolis, eds. *Magnificent Voyages: The U.S. Exploring Expedition, 1838–1842.* Washington: Smithsonian Institution Press, 1985.

Vorpahl, Ben Merchant. *Frederic Remington and the West.* Austin: University of Texas Press, 1978.

———, ed. *My Dear Wister———The Frederic Remington–Owen Wister Letters.* Palo Alto: American West Publishing Co., 1972.

Wagner, Henry R., and Charles L. Camp. *The Plains and the Rockies: A Critical Bibliography of Exploration, Adventure, and Travel in the American West.* Edited by Robert H. Becker. San Francisco: John Howell———Books, 1982.

Wainwright, Nicholas B. *Philadelphia in the Romantic Age of Lithography.* Philadelphia: Historical Society of Pennsylvania, 1958.

Ward, Gerald W. R., ed. *The American Illustrated Book in the Nineteenth Century.* Winterthur, Del.: Henry Francis du Pont Winterthur Museum, 1987.

Warner, Robert Coombs. *The Fort Laramie of Alfred Jacob Miller.* Laramie: University of Wyoming Publications, Vol. 43, No. 2, 1979.

Warren, Harris Gaylord. *The Sword Was Their Passport: A History of American Filibustering in the Mexican Revolution.* Baton Rouge: Louisiana State University Press, 1943.

Watkins, T. H. *Gold and Silver in the West: The Illustrated History of an American Dream.* Palo Alto: American West Publishing Co., 1971.

Watson, Douglas S. *California in the Fifties: Fifty Views of Cities and Mining Towns in California and the West.* San Francisco: John Howell, 1936.

Wax, Carol. *The Mezzotint: History and Technique.* New York: Harry N. Abrams, 1990.

Weber, David J. "The Artist, the Lithographer, and the Desert Southwest." *Gateway Heritage* 5 (1984–85): 32–41.

―――. *Richard H. Kern, Expeditionary Artist in the Far Southwest, 1848–1853.* Albuquerque: University of New Mexico Press, 1985.

Werne, Joseph Richard. "Major Emory and Captain Jimenez: Running the Gadsden Line." *Journal of the Southwest* 29 (1987): 203–21.

―――. "Surveying the Rio Grande, 1850–1853." *Southwestern Historical Quarterly* 94 (1991): 535–80.

Wheat, Carl I. *Mapping the Trans-Mississippi West, 1540–1876.* 6 vols. San Francisco: Institute of Historical Cartography, 1957–64.

Wilkins, Thurman. *Thomas Moran: Artist of the Mountains.* Norman: University of Oklahoma Press, 1966.

Wilson, Raymond L. "Painters of California's Silver Era." *American Art Journal* 16 (1984): 71–92.

Wishart, David J. *The Fur Trade of the American West, 1807–1840.* Lincoln: University of Nebraska Press, 1979.

Witthot, Brucia. "The History of James Smillie's Engraving After Albert Bierstadt's 'The Rocky Mountains'." *American Art Journal* 19 (1987): 40–51.

Wood, Richard G. *Stephen Harriman Long, 1784–1864: Army Engineer, Explorer, Inventor.* Glendale, Calif.: Arthur H. Clark Co., 1966.

Woodhouse, S. W. *A Naturalist in Indian Territory: The Journals of S. W. Woodhouse, 1849–50.* Edited by John S. Tomer and Michael J. Brodhead. Norman: University of Oklahoma Press, 1992.

Yost, Karl, and Frederic G. Renner. *A Bibliography of the Published Works of Charles M. Russell.* Lincoln: University of Nebraska Press, 1971.

For those who wish to contact the Library of Congress about specific illustrations in this book, the following information on the divisions in which the material is housed, the call number of the material, and/or the Library of Congress negative number (where a negative is available) will expedite inquiries. Information is listed according to the page on which the illustration appears. Divisions housing the material are listed as follows: RBC (Rare Book and Special Collections Division); P&P (Prints and Photographs Division); G&M (Geography and Map Division); GC (General Collections). Library of Congress negative numbers have the following prefixes: LC-USZ62- (b/w negatives); LC-USZC2- or LC-USZC4- (color transparencies). All other numbers indicate the call number of the original materials.

(ii) P&P, LC-USZC4-668; (x) RBC, E77.M13, Vol. I; (2) RBC, F592.6 1809; (3) P&P, LC-USZ62-1345; (4) RBC, E165.W64 Atlas; (5) RBC, F597.C35; (7) RBC, F454.B748; (8) P&P, PAGA LC-USZ62-2527; (10) RBC, G420.553 1726; (12) RBC, G159.P2 Vol. III 1565; (13) RBC, F1030.L182; (14) RBC, F229.H7 1590 & RBC, E141.G63; (15) RBC, G420.V22; (16) G&M, G1036.C69 1784 Atlas & RBC, G420.L73; (18) P&P, LC-USZ62-3253; (19) RBC, F597.C35; (20) RBC, F597.C35; (22) P&P, LC-USZ62-11953; (24) P&P, LC-USZ62-17372; (25) P&P, LC-USZ62-19230; (26) RBC, F592.6 1809; (27) RBC, F592.4 1814; (28) P&P, LC-USZ62-38605; (29) RBC, F592.J3; (31) RBC, F592.J3; (32) RBC, F592.J31; (33) RBC, QL1.C12; (34) RBC, AP2.C257; (36) RBC, SF277.A6; (38) RBC, E77.M14; (39) RBC, AP2.C257; (40) RBC, E77.M1304; (41) RBC, E77.M1304; (42) RBC, E89.L66; (44) RBC, E89.L66; (47) RBC, E77.C38; (49) P&P, LC-USZ62-56018; (50) RBC, NE2527.C4 1845; (51) RBC, NE2527.C4 1845; (52) RBC, Atlas. E165.W64; (53) RBC, E77.C3818 1848; (54) RBC, E165.W64 Atlas; (56) RBC, E165.W64 Atlas; (57) RBC, E165.W64 Atlas; (59) RBC, AP2.G73, Vol. XXVI (60) RBC, SK33.W38; (64) RBC, QL674.A9 1840, Vol. VII; (65) RBC, QL715.A9, Vol II; (68) GC, F593.U58, Vol. XII; (71) P&P, LC-USZ62-8185; (72) RBC, F592.F82 Toner; (76) P&P, LC-USZ62-659; (77) RBC, F786.U57; (78) RBC, F786.U57; (79) RBC, F786.U57; (80) P&P, LC-USZ62-17606; (81) GC, F788.U57 1962 & GC, F826.U557; (82) RBC, F801.558; (83) RBC, F801.558; (84) GC, F826.U557; (85) RBC, F786.B28; (86) RBC, E166.P66 1855; (87) RBC, F786.445, Vol. II; (88) GC, F377.R3U5; (89) GC, F593.U58, Vol. III; (89) GC, F593.U58, Vol. III; (90) GC, F593.U58, Vol. II; (96) P&P, LC-USZ62-1087; (97) RBC, F788.U58 1861; (98) RBC, F786.M82, Vol. II; (99) GC, E77.5381, Vol. I; (100) GC, E77.5381, Vol. I; (101) RBC, F1060.8.W29; (102) P&P, PAGA D size, Hanhart (M&N); (103) P&P, LC-USZ62-9065; (108) RBC, *Davy Crockett's Almanac,* Vol. I, No. 3; (110) Microfilm Reading Room; (112) P&P, LC-USZ62-2034; (113) P&P, LC-USZC2 1748; (114) P&P, LC-USZ62-741; (117) GC, AP4.H935 & P&P, PAGA D size-Doney; (118) RBC, AP2.G73; (120) P&P, LC-USZC2-2646; (121) RBC, F865.M3 1855b & P&P, LC-USZ62-1; (122) P&P, LC-USZ62-99158; (123) P&P, AP2.H32, Vol. XXVI; (124) P&P, LC-USZ62-94301; (125) P&P, LC-USZ62-99352; (126) P&P, AP2.L52 & RBC, AP2.M2 35; (128) GC, AP2.C65 & RBC, F596.C873 18802; (129) GC, AP2.C65; (132) P&P, LC-USZ62-12736; (134) P&P, LC-USZ62-2512; (135) P&P, LC-USZ62-24182; (136) P&P, SC-USZC4-683; (137) P&P, PAGA Prang A size; (141) GC, AP2.C42 & RBC, F722.H377 1876; (142) GC, AP2.C42; (143) GC, N1.A18 Folio; (144) RBC, F722.H377 1876 (145) RBC, F722.H377 1876 (147) GC, AP2.C42; (148) G&M, G4194.O4A3,R8; (149) G&M, G4334.P5A3 1885.D9; (151) P&P, PAGA C size, Parsons, Charles & RBC, F780.M3 Folio; (155) G&M, Sanborn #8707.

INDEX

ILLUSTRATIONS ARE INDICATED BY BOLD-FACE NUMBERS.